STEAM

AROUND YORK &
THE EAST RIDING

MIKE HITCHES

AMBERLEY

To Hilary

First published 2012

Amberley Publishing
The Hill, Stroud
Gloucestershire, GL5 4EP

www.amberleybooks.com

British Library Cataloguing in Publication Data.
A catalogue record for this book is available from the British Library.

ISBN 978 1 84868 444 7

Typesetting and Origination by Amberley Publishing.
Printed in Great Britain.

CONTENTS

INTRODUCTION

Stronghold of the Romans, and later the Vikings, York was to become the powerbase of the infamous 'Railway King', George Hudson, whose empire would eventually extend from the far north of England to the south and south-west. Indeed, York was the birthplace of Hudson, whose family were drapers in the city, and an inheritance of some £30,000 allowed him to take an interest in railway companies at the time of the 'railway mania' of the mid-nineteenth century. It was from this point that Hudson eventually controlled railways from York to Hull and well beyond.

Born in 1800, Hudson inherited his fortune from a great-uncle in 1837 and his York & North Midland Railway was opened two years later on 29 May. It ran from York to a junction with the Leeds & Selby Railway at Gascoigne Wood, and was later extended to Normanton on 1 July 1840, the same day as the North Midland Railway was opened. The NMR itself was promoted in October 1835 and was authorised to build a line from Derby to Leeds, which would create a continuous railway from London and Birmingham to Leeds. The Y&NMR provided a branch to York, by which time Hudson had become chairman. With the opening of a section between Whitwood and Methley Junction, the Y&NMR could run through to Leeds, via the NMR, having obtained running powers. A second section of line, from Milford Junction to Gascoigne Wood, opened on 9 November 1840, and gave the York company direct access from Leeds and Normanton to Selby and Hull (and its seaport). The Y&NMR now had a railway from Leeds to York, Selby and Hull via Methley Junction. However, the older Leeds & Selby Railway offered a shorter route, so Hudson leased the L&SR on favourable terms and closed it to passengers west of Gascoigne Wood.

The Hull & Selby Railway had also opened on 1 July 1840 and, in 1844, it entered into an agreement with the Manchester & Leeds Railway (later to become the Lancashire & Yorkshire Railway). Although the two companies were not directly connected, it looked likely that they soon would be, by means of the projected London & York Railway, which would eventually become the Great Northern Railway. This projected line was to cross over the Wakefield, Pontefract & Goole Railway of the M&LR (L&YR) and connect it at Selby. To thwart such ambitions, the Y&NMR offered an attractive lease for the Hull

& Selby Railway, which took effect from 1 July 1845, thereby giving Hudson control of all railways in the East Riding of Yorkshire.

Meanwhile, the Y&NMR had promoted its line from York to Scarborough, along with its branch to Pickering connecting with the Whitby & Pickering Railway, which had been absorbed by Hudson's company in 1845. This new line took a year to build and was opened on 7 July 1845. At around the same time, the Hull & Selby Railway promoted a branch to Bridlington, which the Y&NMR took control of and made an end-on connection, with its own line from Seamer to Bridlington.

At the same time, the M&LR (L&YR) supported two projects which would threaten Hudson's monopoly in the East Riding. The first was a direct Leeds & York Railway, while the second was a proposed York, Hull, East & West Yorkshire Railway which would continue the proposed Leeds & York line, via Market Weighton, to Hull and so reach the East Coast port – this would circumvent the ambitions of the Y&NMR. In answer, Hudson purchased the 12,000-acre Londesborough Park Estate for his personal use and to supplement land recently bought at Octon, near Bridlington, and Newby Park near Ripon. By these means he blocked any chance of a rival railway being promoted through Market Weighton. When the Y&NMR promoted its own line through Market Weighton, Hudson sold the required land at a handsome profit. To prevent any more railway rivalry speculation in the East Riding, the Y&NMR obtained powers for the Selby to Market Weighton line and also took an interest in the Malton to Driffield line. A branch was also planned from Arram to Hornsea, although nothing came of it.

The Y&NMR was only a small part of the Hudson Empire. In 1841, he had been elected chairman of the Newcastle & Darlington Junction Railway, which, by a series of amalgamations, became the York, Newcastle & Berwick Railway. In 1842, he took control of the North Midland Railway and, two years later, he created amalgamations to form the Midland Railway, whose line would eventually run from Carlisle to Bristol and London (St Pancras). In 1845, he became chairman of the Eastern Counties Railway and thus controlled over a quarter of England's railway mileage.

As the Y&NMR was expanding its territory, there was considerable pressure for a direct line from York to London, which was bitterly opposed by Hudson, whose own route to the capital relied on the goodwill of the London & North Western Railway for access to Euston station. However, the Great Northern Railway obtained its Act in 1846 and began construction of its route from Askern (just north of Doncaster) to London, via Retford, Lincoln, Boston and Peterborough. Access to York was via the L&YR from Askern to a junction with the Y&NMR at Knottingley.

Despite Hudson's bitter opposition, the GNR had reached the heart of the Y&NMR Empire because his influence had begun to fade. As the 'railway mania' years began to wane, share values started to fall and questions began to

be asked about Hudson's financial management. Thus, on 20 February 1849, the YN&BR appointed a Committee of Inspection to investigate share dealings. The Eastern Counties and Midland Railways followed suit and it was discovered that share dividends were being paid out of capital which kept share prices artificially high and was also illegal. On 17 May, Hudson resigned as chairman of the Y&NMR and recriminations followed. In the post-mania years, projects had to be abandoned or postponed. In the case of the Y&NMR, its Market Weighton–Beverley line was postponed and its Leeds–York line, along with the branch to Hornsea, was abandoned. From this point on, the Y&NMR was forced to consolidate its position.

Only a few years later, on 31 July 1854, the Y&NMR was merged with the YN&BR and Leeds Northern Railway to form the North Eastern Railway. Thus, the major stations at York, Hull, Bridlington, etc. came under the control of the NER, with the GNR having access to York. Also, the L&YR maintained a presence in Hull, Goole, and Selby.

The period prior to the First World War saw the railways at the peak of their powers. The NER, GNR and L&YR in York and the East Riding were handling most freight traffic with massive tonnages of coal exports from the coalfields in South Yorkshire to Hull and Goole and imports from the ports to the rest of the UK. Fish traffic from places like Filey and Bridlington also brought revenue to the NER. Likewise, passenger numbers remained high with rolling stock becoming larger and more comfortable. Speeds were steadily increasing and locomotives were becoming larger to cope with the increasing weight of coaches, all culminating in the 'Railway Races' between London and Edinburgh in 1888 and to Aberdeen in 1895. The race to Edinburgh was started by the GNR who announced, in December 1887, that it would admit third class passengers to its 10 a.m. expresses between King's Cross and Scotland, then taking 9 hours to reach Edinburgh. LNWR trains from Euston had admitted third class passengers the previous year, but its trains took an hour longer to reach the Scottish capital. However, the LNWR did not retaliate until the following year when the Euston Company announced an 8-hour service from 2 June on the 10 a.m. express. By 13 August, the East Coast train was reaching Edinburgh in 7 hours 45 minutes and the LNWR reached the Scottish capital in 7 hours 38 minutes, but the East Coast companies topped this by 6 minutes the following day. After this, the LNWR and GNR agreed that trains from London would take 8 hours to reach Edinburgh by the West Coast route and East Coast services would take 7 hours. However, on 31 August, the East Coast service had improved on its previous best time. The station at York was important in these races as engine changes between the GNR and NER took place here. Indeed, it was an NER Worsdell compound that arrived in Edinburgh in record time on 31 August.

Railway rivalry was sparked again in 1895, following opening of the Forth Railway Bridge in 1890, which shortened the East Coast route by 16 miles less than that of the western route. Both lines actually converged at Kinnaber

Junction, 38 miles from Aberdeen, the East Coast service having to run over metals of the Caledonian Railway (a West Coast company). For 19 August, competition was at its most fierce, but sporting instincts prevailed (a very British practice) and when the signalman, employed by the Caledonian, was offered both East and West Coast trains at the same time, he gave clearance to the East Coast trains, which reached Aberdeen in 8 hours 40 minutes. By 22 August the best times for both companies were achieved. The East Coast train reached Aberdeen in 8 hours 38 minutes, while the West Coast service achieved a time of 8 hours 32 minutes, despite stops at Crewe, Carlisle, Sterling and Perth. Again, East Coast locomotive changes were at York. By 18 June 1896, due to a high-speed derailment at Preston, it was agreed to reduce timings to an average of 8 hours for services between London, Glasgow and Edinburgh, reduced by an agreement of 1 December 1900. These services would not be accelerated until after the 'Grouping' when the LNER and LMS agreed to relax this constraint in 1932.

As the new century dawned, the railways continued to prosper, but changes were afoot. The outbreak of the First World War brought the railways under the control of a Railway Executive Committee in August 1914 (effectively nationalisation) for the duration. During this period, the railways were put under strain with endless coal trains to serve navy ships and movement of soldiers to France and Belgium – along with their equipment – many of whom had volunteered from the railways leaving them short of staff in all parts of Great Britain. During the war, passenger services were curtailed and efforts were made to reduce civilian travel, with little effect. Restaurant cars were taken off trains but never totally disappeared. By 1917, cheap fares were abolished and ordinary fares were increased by 50 per cent, with services being drastically cut. These measures, however, had little effect in persuading the public not to travel.

State control of the railways continued after the war ended in 1918 and was not removed until August 1921. Grants were paid towards maintenance costs arising from extra traffic due to wartime demands, but these were only slowly distributed and did not meet the true costs. At the same time, there were demands for nationalisation of the railways, something the government was opposed to in peacetime. However, wholesale amalgamations were considered, culminating in the Railways Act of 1921, which brought about four different railway groups (the London Midland & Scottish Railway, the Southern Railway, the Great Western Railway and the London & North Eastern Railway). The NER, GNR, Great Eastern, Hull & Barnsley (which had merged with the NER in 1922), North British and Great North of Scotland were brought together from 1 January 1923 to form the LNER. Stations at York, Hull, Scarborough, Bridlington and branches in-between became part of this new group.

The post-grouping period was driven with competition from road transport and an economic downturn. A railway strike of 1919 sent many passengers to look for alternatives and the motor coach offered to fill the gap. Although

journey times were longer, much cheaper fares made them attractive. Also, there was a demand for private cars between 1920 and 1938, many ex-soldiers having learned to drive during the war. It was in this period that the railways offered cheap excursions to attract passengers. All of the railway companies offered 'Save to Travel' schemes, the LNER offering such a scheme in 1936, even adding interest of a halfpenny a month for a year on every 10s (50p) saved. By 1938, some 85 per cent of receipts were derived from cheap fares, compared to 34.4 per cent in 1924.

Freight also suffered during this period. Small loads were increasingly going by road as motor lorries began to proliferate, although bulk loads were still the preserve of the railways. However, the 1930s economic depression reduced this traffic substantially. Closure of coal mines due to the Depression and industrial action in the north-east of England did much damage to LNER revenues, as it did for the LMB and GWR. Matters did not really improve until the end of the 1930s.

Despite the economic climate in the interwar years, the 'Races to the North' began again when the LNER launched a non-stop service from King's Cross to Newcastle in 1927, via the advance portion of the *Flying Scotsman*. The LMS responded by giving its 'Royal Scot' service the appearance of being non-stop, despite a halt at Carnforth to change engines and at Syminton to divide the Glasgow and Edinburgh portions. The LNER immediately contemplated a non-stop express to Edinburgh. As this would mean a crew change at the halfway point and involve a stop, Nigel Gresley devised a new version of his eight-wheeled tender with a side corridor so that the crew could be changed, the resting crew riding in the first coach. It took only seven weeks for the first of these new tenders to be delivered from Doncaster works and the non-stop service commenced on 1 May 1928. However, the LMS spiked LNER guns by running non-stop to Glasgow and Edinburgh three days earlier, with two crews on the footplate and large capacity tenders attached to the locomotives. The LMS could not really repeat such a feat on a regular basis, so the honours for non-stop running from London to Edinburgh belonged to the LNER.

The 1930s brought further high-speed competition between the LNER and LMS from London to the North and brought about streamlining of steam locos in the same period. In 1935, the LNER introduced the 'Silver Link' train, a four-hour service from King's Cross to Newcastle, using new Gresley streamlined A4 Pacifics, after earlier runs by A1 Pacific 4472 *Flying Scotsman* in 1934, when the loco attained 100 mph. The LMS responded by operating Princess Royal Pacific No. 6201 *Princess Elizabeth* non-stop to Glasgow in 1936. Such was its success that the Euston Company introduced Stanier streamlined Pacific *Coronation* on such trains to Glasgow in 1937. This rivalry brought about steam speed records for both the LMS and LNER in 1937. On 29 June Princess Coronation Pacific No. 6220 *Coronation* reached a speed of 114 mph, a new world record, the LNER A4 coming close the day after. However, the high speed honours would

go to the LNER the following year when A4 Pacific achieved 126 mph on 3 July 1938. The A4 *Mallard* then held the world record, which has never been broken since and ensured that she would find a future in preservation. There is little doubt that high-speed express services would have continued into the 1940s had the Second World War not intervened.

The outbreak of the Second World War on 3 September 1939 brought the railways back under government control and passenger services were drastically cut after the evacuation of children to the relative safety of the country and seaside from the expected bombing of major cities. Again, soldiers and their equipment had to be moved as the British Expeditionary Force was sent back to France. Invasion of the Low Countries by Germany in the spring of 1940, culminating in the Dunkirk evacuation, meant that the railways were pressed into transferring some 300,000 men from Dover to other parts of the UK. From that point on, the railways were put under ever-increasing pressure from excessive demands, blitz damage, and movement of war materials. The result was a great deterioration in the railway infrastructure. The seaport at Hull suffered severe bomb damage as the Luftwaffe attempted to prevent import of war materials into Britain, and the railway in the area took some of this damage.

After the war was over, the railways were left in a very run-down state and it would cost several millions of pounds to bring it back to pre-war standards, only a fraction of which would be recovered from the government. Even if there had been full funding, the railways would still have had to take their turn to obtain scarce resources needed. There were more pressing needs and the railway could still operate and was in a useable condition. A landslide victory for the Labour Party in the General Election of 1945 brought about plans for large-scale nationalisation of essential industries, including the railways. This was realised on 1 January 1948 following the 1947 Transport Act, and the new British Railways was formed. York and the network in the East Riding became part of the north-eastern region of British Railways, with the city being headquarters of the new region. Despite experiments with new forms of traction in the 1930s, and further developments after the war, the new BR remained committed to steam traction and continued to build examples from the old 'Big Four' including ex-LNER Thompson B1 4-6-0s into the early 1950s and then began introducing their own 'Standard' classes.

During the 1950s, BR experienced something of a railway 'boom' thanks to holidays with pay, which had come into effect just before war broke out, and the determination of a war-weary nation to enjoy themselves. During the summer months, many railway excursions were run to seaside resorts at Scarborough, Bridlington, Hornsea, Withernsea and to the new Butlin's holiday camp at Filey. Many of these trains operated through York and along many of the branches in the East Riding. Shortage of oil also brought extra freight traffic back to the railways, but this was a short boom. By the 1960s, road competition was growing. Motor coaches were competing with the railways for passengers as

they could pick up and set down at destinations without the need for connecting services. Road lorries were increasing in size, able to take larger loads from the railways and, as the world entered the 1960s, private car ownership expanded rapidly, not least because the new 'Mini', introduced in 1958, offered cheap motoring.

By the mid-1950s, British Railways was seen as dirty and old fashioned because, no doubt, of the commitment to stream traction, which in itself failed to attract employees when new, cleaner, work was available. In an effort to make the railway more attractive to the travelling public, the 'Modernisation Plan' was introduced in 1955, envisaging electrification of the main trunk routes and introduction of Diesel Multiple Units on local and secondary services. While electrification was underway, diesel-electric locomotives would be introduced. The famous 'Deltic' diesel-electric locos were introduced to the East Coast main line in 1959 as hopes of expensive electrification faded. These locos were introduced on King's Cross–Edinburgh trains through York and DMU trains began to appear on local services from the late 1950s, displacing many steam engines on such lines. Indeed, steam traction had disappeared from York and the East Riding by 1967. Electrification of the ECML did not begin until the mid-1980s, reaching York by 1988. In the meantime, 'InterCity 125' sets appeared on the ECML from 1978.

Not only did steam traction disappear from the East Riding and York, but several branches were closed following the Beeching Report of 1963. The report envisaged closure of many branches and stations, with traffic being concentrated on the main trunk routes. Branches between Driffield, Market Weighton, Selby and Beverley were closed and the major stations at York and Hull were rationalised. Several local stations also faced the axe, such as Carnaby and Burton Agnes on the Bridlington line, and the railway is now a shadow of its former self.

Although steam traction has largely disappeared from the British railway scene, steam can still be seen at York during the summer months when 'The Scarborough Spa Express' operates between the city and the seaside resort. Steam has even found its way back on to the Seamer–Bridlington–Hull branch when an ex-LMS 'Black Five' 4-6-0 operated an excursion in October 2011. York is also the home of the National Railway Museum where many old steam locos are on display, along with diesel and electric types from Britain and abroad. Indeed, the NRM provides many of the steam locos operating excursion trains to Scarborough.

In writing this work, I hope that the glorious days of steam traction around York and the East Riding have been recaptured; the days when the railway was an important part of the infrastructure in the area and thousands of passengers used the trains for holidays to local seaside resorts and beyond, via the docks at Hull and Goole. Finally, I will be happy if this helps the old steam days to be fondly remembered.

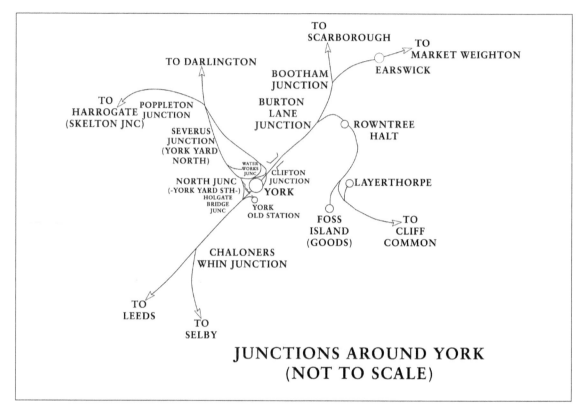

TO
SCARBOROUGH

TO
MARKET WEIGHTON

TO DARLINGTON

EARSWICK

BOOTHAM
JUNCTION

TO
HARROGATE
(SKELTON JNC)

POPPLETON
JUNCTION

BURTON
LANE
JUNCTION

SEVERUS
JUNCTION
(YORK YARD
NORTH)

ROWNTREE
HALT

WATER
WORKS
JUNC

CLIFTON
JUNCTION

NORTH JUNC
(-YORK YARD STH-)

YORK

LAYERTHORPE

HOLGATE
BRIDGE
JUNC

YORK
OLD STATION

FOSS
ISLAND
(GOODS)

TO
CLIFF
COMMON

CHALONERS
WHIN JUNCTION

TO
LEEDS

TO
SELBY

JUNCTIONS AROUND YORK
(NOT TO SCALE)

A map of the railway around York station and the junctions connecting York with the rest of the local railway network. (Author)

ONE

YORK

The first Y&NMR trains, in May 1839, ran into a temporary station just outside York's city walls. By 4 January 1841, a new permanent station was opened. Designed by Y&NMR architect G. T. Andrews, the new station was built jointly by the Y&NMR and the Great North of England Railway, whose line ran from York to Darlington, and comprised two platforms, with a total of five tracks between them. An overall roof comprised three arches, with a narrow one in the middle covering one line, and two outer ones each spanning a platform and two adjoining lines. An additional platform covered by a glass roof was added on the north side of the station when the line from Scarborough was opened in 1845. This new station was approached by laying lines through an archway in the city walls.

Over the years, this station became totally inadequate for increasing volumes of traffic. The method of operation was for arriving trains to stop at ticket platforms on both lines converging from the north and south, just before they joined to go under the city walls. While inspectors dealt with tickets, locomotives could run round their coaches and propel them into the platforms. The inadequacy of these arrangements prompted the NER to apply for powers to construct a much larger station. These powers were granted by an Act of July 1866. The plan involved a new line, 1¾ miles long, from Holgate Bridge Junction to Severas Junction, together with a connection on to the Scarborough line. A trade recession in this period delayed construction of the new station until 1877.

The new station had thirteen platforms, comprising two long through ones with six bays at the north end and a further five at the south end. There were two additional tracks between the through platform lines. This new station was covered by a three-arch curved roof, which still exists today. Although the old station had been superseded in 1877, the platforms remained in use for carriage storage, which was to last for a further ninety years. The buildings at the old station were used for offices. When York Railway Museum was opened in 1928, a small exhibits section was housed in the former first class refreshment room at the old station. In the 1960s, a new office block, 'Hudson House', was built on the site of the old platforms.

Additions to York station were made following the 1877 construction. In 1900, an additional platform, No. 14, was built outside the west wall. Further accommodation was provided in 1938 with the opening of platforms 15 and 16 – a through island on the west side of the station layout. Communication between the platforms was originally by a subway, but this was replaced by a footbridge in 1904, which was moved a few yards further north in the 1930s.

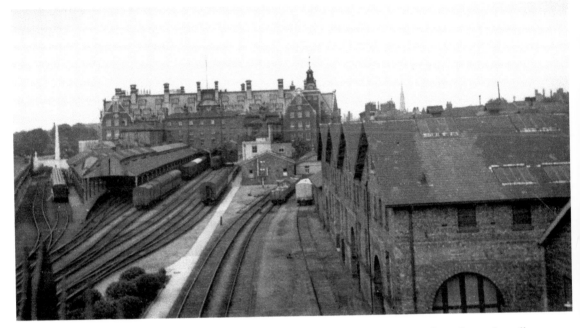

Above: The original Y&NMR York station as it appeared in 1950, looking from the castle wall. Travel between Leeds and York was made possible from 1839, although there would be no direct line for another thirty years. From 29 May 1839 until November 1840, the line ran from Marsh Lane, Leeds, on the Leeds & Selby Railway, which had been open since 22 September 1834, with passengers changing at Gascoigne Wood (York Junction). This was the point where the Y&NMR met the L&S (near Sherburn-in-Elmet). York Junction was closed in 1840, but reopened again in 1850, under the name of 'Old Junction', becoming Milford Old Junction in 1867 and Gascoigne Wood in 1879. The station here was closed at the end of 1901 but reopened in 1907 as a staff halt serving a local marshalling yard until 1959. There was also a station at Milford Junction until 1904, at a point where the south curve from Gascoigne Wood joined the Y&NMR. The station on the L&S was just called Milford until changed to South Milford in 1867. From 9 November 1840, the Y&NMR offered a service from Hunslet Lane, Leeds, via Methley Junction and Castleford. In 1846, the Leeds terminus was moved to Wellington, closer to the city centre. (R. Carpenter)

Opposite above: Ex-GER class J66 0-6-0 No. 68435 sits at the site of York Old station on 1 September 1956. By an Act of 26 June 1846, the Y&NMR was granted powers to build a direct line between Leeds and York. The proposed route was to leave the existing line at Copmanthorpe and join the Wetherby to Church Fenton branch just north of Tadcaster station before leaving it again near Sutton and then heading for Crossgates. Such plans were thwarted by the post-railway mania recession in 1849 and a viaduct over the River Wharfe at Tadcaster, then already completed, stood as a monument to the abandoned project. A better link between York and Leeds was achieved on 1 April 1869 with the simultaneous opening of the Church Fenton to Micklefield line and its connecting routes, mainly on a viaduct, from Marsh Lane into Leeds where 'New station' was built jointly with the London & North Western Railway adjacent to Wellington station. (H. Casserley)

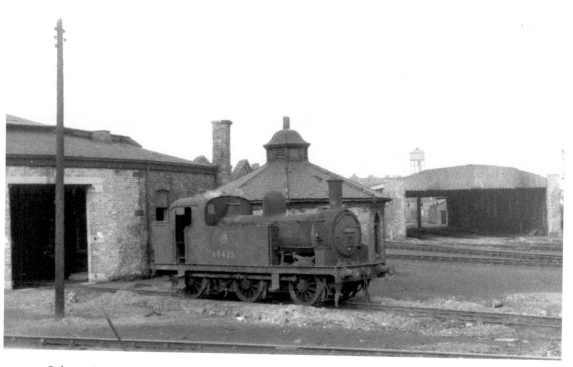

Below: The new York station as it appeared in NER days. The station, looking north, appears to be rather busy and examples of NER locos and rolling stock are in view. On the left foreground is the signal box controlling the south side of the station and the famous York Minster is visible in the background. (LOSA)

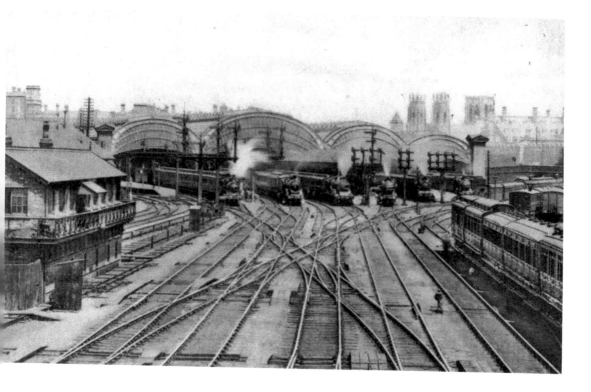

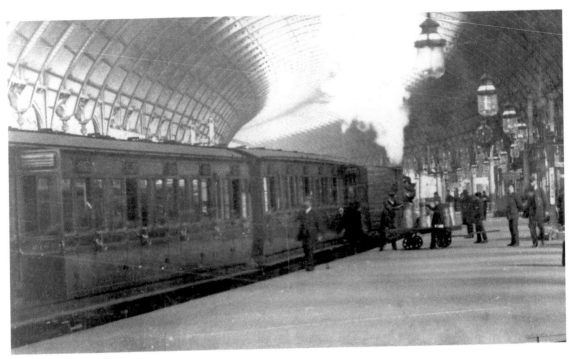

The interior of York station in the early years of the twentieth century with a train about to depart. Plenty of station staff are present and milk churns are being unloaded from the train. The roof, which is on a curve, remains quite a spectacular sight. (LOSA)

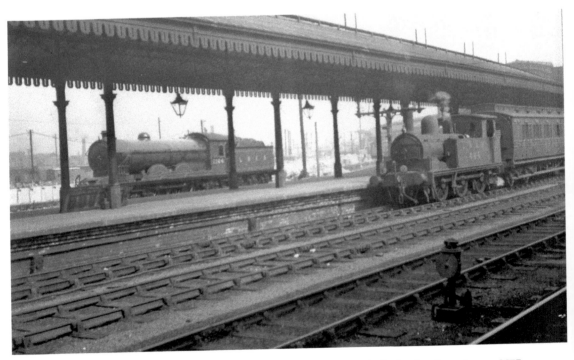

A 1930s view of York station with an ex-NER 0-6-0T at the head of a local train and an ex-NER Raven 4-4-2 Atlantic at rest. (LOSA)

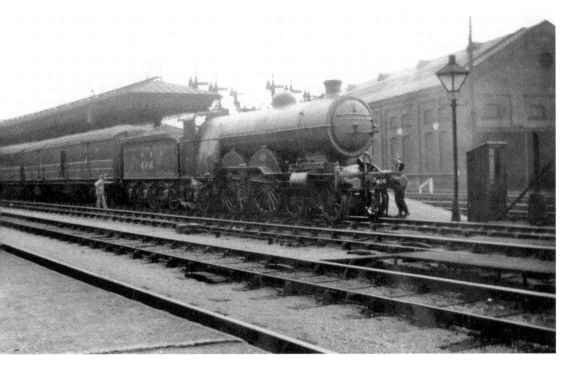

Ex-GNR Ivatt class C1 Atlantic No. 4416 waits at York station at the head of a Scottish express in the 1930s. (LOSA)

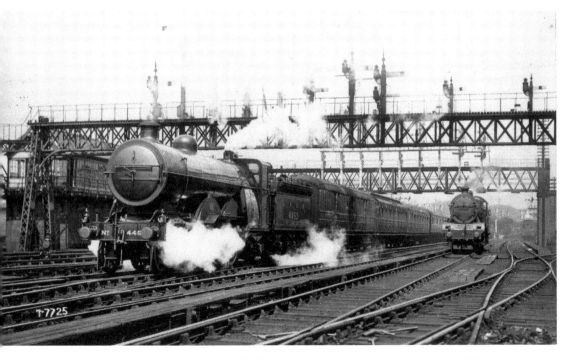

Another ex-GNR C1 Atlantic, No. 4453, built at Doncaster in September 1910 (works No. 1277) is seen leaving York on an Aberdeen–King's Cross express in the 1930s. (R. Carpenter)

York station looking south in the late 1920s with its array of signals controlling the station and the junctions here. The south locoshed is just visible on the left. An ex-NER loco is seen at the platform end. In order to reduce cost of local traffic, the NER converted a bus to run on rails in 1911. This vehicle seated twenty-six passengers. The 'bus' was numbered 130 and had the driving position at the rear end and doors on both sides. This vehicle ran additional trips to Strensall, Earswick, Poppleton and Copmanthorpe, a maximum distance of 6½ miles from York. The following year, the vehicle was transferred to Selby and replaced by a larger vehicle, numbered 2105, which had a bogie at one end, to support the engine, and a single axle at the other end. It seated forty passengers and went as far as Blaxton, Church Fenton, Pocklington and Alne to connect with the Easingwold Railway. (LOSA)

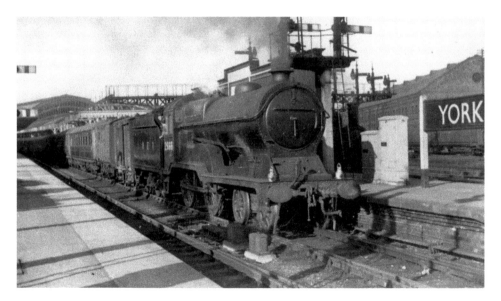

York station on 21 May 1948, shortly after nationalisation, with ex-GCR D11/1 class 4-4-0 No. 2666 *Zeebrugge* on an express service. Some twenty years earlier, between 1929 and 1931, a large number of local passenger services were closed, following the granting of powers to railway companies to become involved in bus operations. Closure involved withdrawal of regular passenger trains on branch lines which remained open for goods and occasional excursion trains. (R. Carpenter)

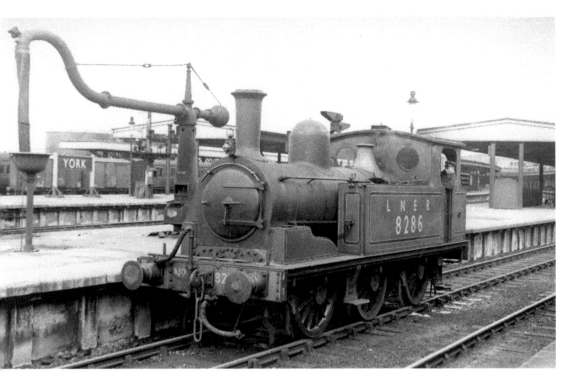

On station pilot duty at York is ex-NER class J71 0-6-0T No. 8286 seen here on 3 October 1948. Station closures affected the line between Church Fenton and York, which lost some local services to buses in the 1930s. (H. Casserley)

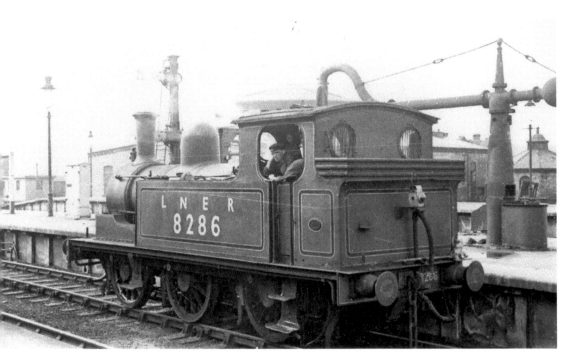

Another view of the J71 0-6-0T station pilot in 1948. (H. Casserley)

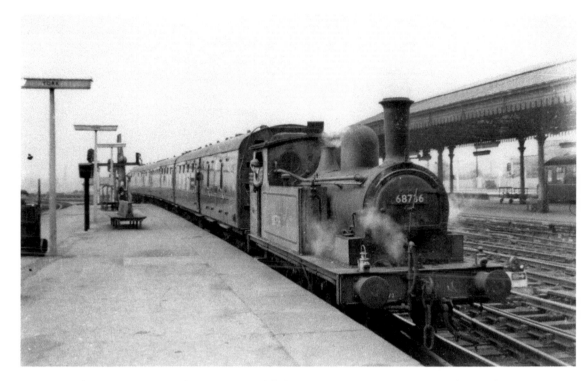

York station in 1958 with ex-NER Worsdell class J72 0-6-0T acting as station pilot. At this time this loco, No. 68736, was painted in apple-green livery and bore the crests of both British Railways and the North Eastern Railway. (LOSA)

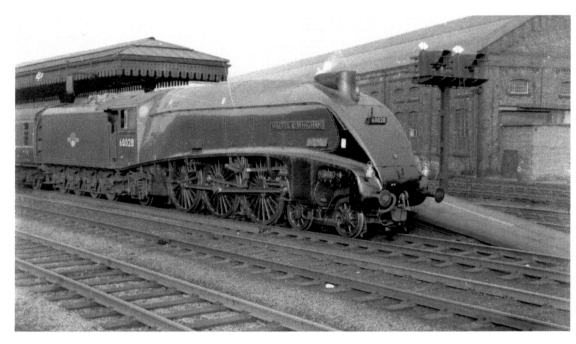

At the head of an Edinburgh–King's Cross express is an example of Nigel Gresley's famous A4 Pacific, No. 60028 *Walter K. Whigham*, seen at York station in the early 1960s. (LOSA)

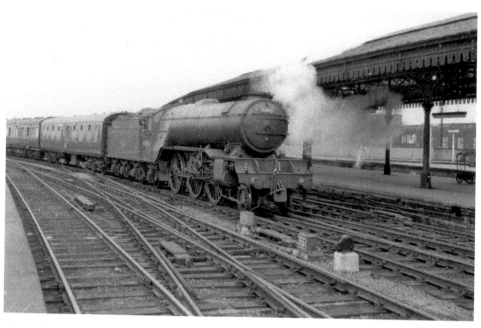

Also at York station in the early 1960s is ex-LNER V2 class 2-6-2 No. 60966 at the head of an express service. (LOSA)

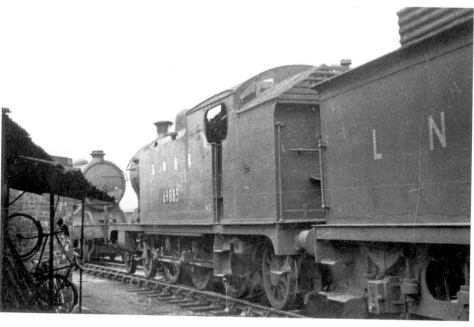

Standing outside York locoshed on 3 October 1948 is ex-NER A8 class 4-6-2T in LNER livery but with her new BR number of 69885 below the old company name. The loco appears to be fitted for oil burning, as does the engine behind. This was an ill-fated experiment by BR to save on coal, which could then be exported. However, it was found that the UK did not have the hard currency to pay for this oil and it was as, if not more, expensive than the money it hoped to save on coal. (H. Casserley)

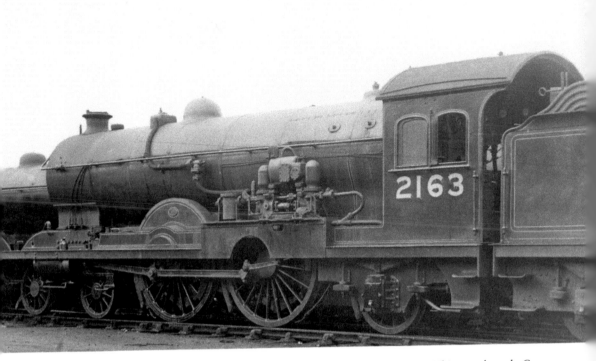

Ex-NER class C7, as LNER No. 2163 at York locoshed on 28 August 1932. This was the only C7 Atlantic fitted with a Dabeg feed-water system, seen above the second driving wheel. (H. Casserley)

When the Y&NMR opened its line from York to Gascoigne Wood, a workshop was built on the south side of the line and a two-road engine shed with a capacity for six engines was built on the north side. This shed was demolished in 1875/76 to make way for the current station. The Y&NMR built its first permanent locoshed in 1850 in the triangle between the GNE curve, which joined the Y&NMR at Hob Moor. This eventually led to a very large shed, made up of three roundhouses and two straight sheds. After the 1850 shed had been opened, a similar shed was authorised in October the same year at an estimated cost of £1,600. This second roundhouse opened in late 1851 or early 1852. These two sheds were only a few feet apart and they each had sixteen stalls and were served by a 42-foot turntable. By 1921, the first shed was only being used for repair of wagon sheets. One of the NER petrol engine's inspection saloons was kept in the shed; both saloon and shed were destroyed by fire on 21 October 1921. The second roundhouse remained in use until May 1961 when the practice of stabling pilot engines at south shed ceased, although surplus engines were stored there for some time longer. The building was eventually demolished at the end of 1963. The third roundhouse was much larger than the other two. It had a 45-foot turntable serving eighteen roads and the shed was also of different

construction with each stall having its own ridged roof. The central roof was circular and the whole was surmounted by a large weathervane, with a 2-2-2 loco in place of the usual cockerel.

Construction of the new roundhouse was authorised on 5 June 1863, at an estimated cost of £5,271 6s and excess expenditure of £555 15s 11d was authorised on 2 December 1864, shortly after the shed was completed. The shed was opened early in 1878, together with a new coaling stage. The roundhouse survived until demolition at the end of 1963. In conjunction with the new station layout at York, which involved building a new through station instead of the old terminus, a shed to hold sixty engines was authorised on 5 May 1875, at an estimated cost of £36,700, this being erected at Clifton, on the west side of the line at the north end of the new station. The new shed consisted of three adjoining roundhouses, each with twenty roads and a 45-foot turntable. The shed at Clifton had its original 45-foot turntable in No. 2 shed replaced by one of 50 feet in 1891.

By 1911, two new electric turntables were ordered from Cowan Sheldon of Carlisle at a cost of £2,170 for the pair. One of these replaced the 45-foot turntable in No. 3 shed while the other went to the new No. 4 shed, which had been authorised on 9 February 1911 at a total estimated cost of £28,700. In addition to the turntables, this also included the cost of a new coaling stage to replace the one demolished to make way for the new shed and a hot water washing out plant. Two 25-ton wheel drops and a six-ton hoist were also authorised at an additional cost of £860. Works were completed in 1915 and cost £1,809 more than the original estimate. This new shed was built on to the north end of the existing building. The next major alterations at north shed were provision of a 70-foot Mundt non-balancing electric turntable, which could be hand-operated in an emergency, supplied by Ransome & Rapier Ltd, and a mechanical coaling plant with four coal chutes and a bunker capacity of 500 tons, built by Mitchell Conveyor & Transport Company Ltd, both in 1933. On 29 October 1942, the shed suffered bomb damage when the city was attacked. One bomb dropped between A4 Pacific No. 4469 *Sir Ralph Wedgewood* and B16 4-6-0 No. 925; both were considered to be beyond repair. The shed was later rebuilt, along with other damaged engines on shed at the time.

Meanwhile, No. 4 shed received a 70-foot turntable to allow Pacific locos undercover, although York did not receive its first Pacific until A2 No. 2401 *City of Kingston Upon Hull* was transferred there on 9 February 1934 to work the 8.12 p.m. York–Newcastle express. The first Gresley Pacifics were the 2570 *Tranquil* and 2573 *The White Knight* to replace withdrawn Raven Pacifics. Final alterations at York took place in 1957/58 when Nos 1 and 2 roundhouses were demolished and replaced by a straight shed. At the same time, Nos 3 and 4 sheds were remodelled and rerofed, remaining as roundhouses. These buildings were destined to become the new National Railway Museum complex.

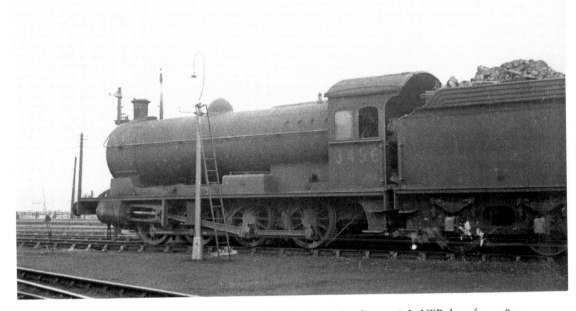

Ex-NER Q6 0-8-0 freight loco No. 3456 at York shed on 3 October 1948. In NER days, from 1854, Fletcher locos predominated in the allocation until the influence of Locomotive Superintendants began to have an effect, these being McDonnell in 1882, T. W. Worsdell in 1885, Wilson Worsdell in 1890, and Vincent Raven in 1910. After the Grouping, LNER locos began to appear as previously mentioned. By 1949, pre-grouping and ex-LNER locos were at the shed as the allocation below shows. (H. Casserley)

York Shed Codes

LNER Code: YK
BR Code: 50A

Class A1 4-6-2	60121 *Silurian* 60138 *Boswell* 60153 *Flamboyant*
Class A2 4-6-2	60501 *Cock o' the North* 60502 *Earl Marischal* 60503 *Lord President* 60522 *Straight Deal* 60524 *Herringbone* 60526 *Sugar Palm*
Class V2 2-6-2	60837, 60839, 60843, 60847, 60856, 60864, 60901, 60904, 60907, 60918, 60925, 60929, 60933, 60934, 60941, 60946, 60954, 60960, 60961, 60962, 60963, 60968, 60974, 60975, 60976, 60977, 60978, 60979, 60981, 60982

Class B1 4-6-0	61015 *Duiker,* 61016 *Inyala,* 61038 *Blacktail,* 61071, 61084, 61115, 61239, 61288, 61337
Class B16 4-6-0	61416, 61417, 61418, 61419, 61420, 61421, 61422, 61423, 61424, 61426, 61430, 61434, 61435, 61436, 61437, 61438, 61439, 61441, 61443, 61444, 61448, 61449, 61450, 61451, 61452, 61453, 61454, 61455, 61456, 61457, 61458, 61459, 61460, 61461, 61462, 61463, 61464, 61465, 61466, 61467, 61468, 61472, 61473, 61474, 61475, 61476, 61477
Class D20 4-4-0	62369
Class D49 4-4-0	62726 *The Meynell* 62727 *The Quorn* 62736 *The Bramham Moor* 62740 *The Bedale* 62742 *The Braes of Derwent* 62744 *The Holderness* 62745 *The Hurworth* 62759 *The Craven* 62760 *The Cotswold* 62761 *The Derwent*
Class Q5 0-8-0	63270
Class J21 0-6-0	65043, 65067, 65075, 65076
Class J24 0-6-0	65619
Class J25 0-6-0	65656, 65700, 65708, 65723
Class J27 0-6-0	65845, 65849, 65883, 65885, 65888, 65890, 65894
Class J94 0-6-0ST	68017, 68031, 68032, 68040, 68044, 68046, 68061
Class Y8 0-4-0T	68091
Class J21 0-6-0T	68230, 68238, 68240, 68246, 68250, 68253, 68275, 68280, 68282, 68286, 68292, 68293, 68294, 68297, 68310, 68313
Class J77 0-6-0T	68436
Class J72 0-6-0T	68695, 68699, 68715, 68722, 68726, 68735, 68739, 68741, 68745, 69020
Class WD/07 2-8-0	90056, 90069, 90099, 90100, 90200, 90235, 90424, 90432,
	Total: 169

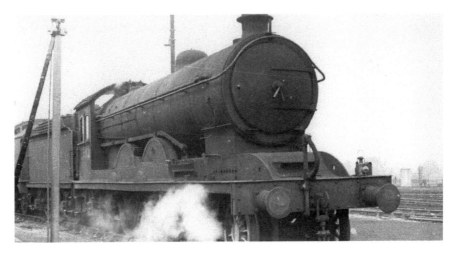

Ex-NER Raven Atlantic No. 2992 at York on 3 October 1948. Along with ex-NER types, York played host to locos from other railway companies over the years. Indeed, LNWR engines commenced working to York from Leeds from 1 July 1893, but ceased at the end of 1904. However, they continued to work through York on excursions and specials bound, mainly, for Scarborough. The Great Eastern began working their own trains into York from 1 November 1892, the Great Central from 15 March 1899 and the Lancashire & Yorkshire Railway from 1 May 1894. The GNR locos on trains from King's Cross to York included 2-2-2s, 2-4-0s and the famous Stirling 8-foot singles. Later on, 4-4-0 and 4-4-2 types appeared (as previous pictures show). Some ten GNR 4-4-0s and two 4-4-2s were based at York in 1923 with two more Atlantics joining the fleet soon afterwards. While LNWR engines were not based at York, three locos were a common sight, these being 2-2-2 No. 1 *Saracen* and 1434 *Eunomia* along with 2-4-0 No. 1220 *Belted Will*. GER types included 2-2-2, 4-2-2 and 2-4-0s followed by various classes of 4-4-0. Various GE 0-6-0 engines would also appear at various times. (H. Casserley)

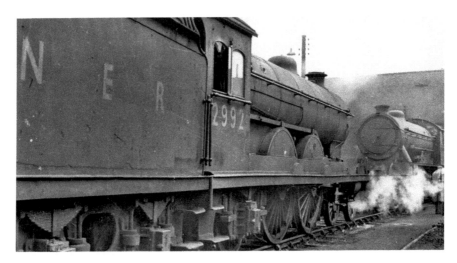

Another view of Raven Atlantic No. 2992 at York shed in 1948. Along with the running sheds at York, there was also a small corrugated-iron building which was erected to house Sentinel loco No. 45. The engine was provided in 1930 to shunt in the engineers' yard, situated on the Down side of the main line north of the station. The Sentinel was replaced by Department No. 84, a Ruston Hornsby diesel-mechanical loco, in 1959. (H. Casserley)

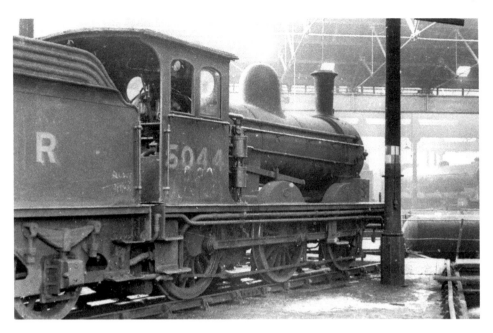

Ex-Manchester, Sheffield & Lincolnshire Railway (Great Central Railway) class J10, a Parker design dating from 1892, 0-6-0 No. 5044 inside York roundhouse in 1948. At the grouping, York had thirteen top-link workings to Newcastle and back, mainly express passenger trains, although there were some parcels workings, and braked goods in one direction. There were also ten local workings. York also supplied five J71 0-6-0T pilot locos: south end Up side, south end Down side, Scarborough side, north end Down side, and Clifton carriage sidings. Four of these engines worked from 6 a.m. Monday to 6 a.m. Sundays, while the fifth worked continuously. However, the engines spent one or two spells of sixty to ninety minutes on shed each day for coaling, firecleaning, watering, etc. (H. Casserley)

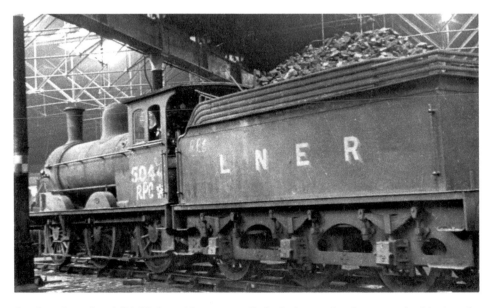

Another view of ex-MS&LR loco. No. 5044 at York shed on 3 October 1948. At this time she appears ready to meet her fate. (H. Casserley)

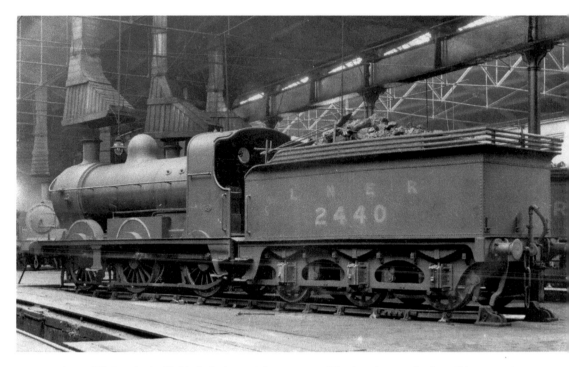

An ex-H&B 0-6-0 inside York shed on 28 August 1932. Numbered 2440, the loco did not survive into BR ownership. These engines found new homes in various sheds in the north-east and Yorkshire after the H&B had been absorbed into the NER, and later the LNER, but very few survived after the Second World War. (H. Casserley)

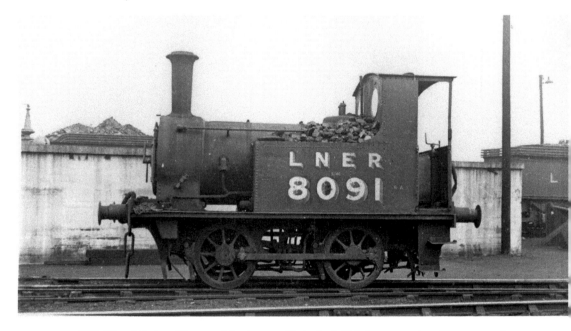

Ex-NER Worsdell class Y8 0-4-0 No. 8091 at York shed. This loco went into Departmental use at York and was renumbered D55 and withdrawn in 1956. Her sister loco was based at Hull Dairycoates shed. (H. Casserley)

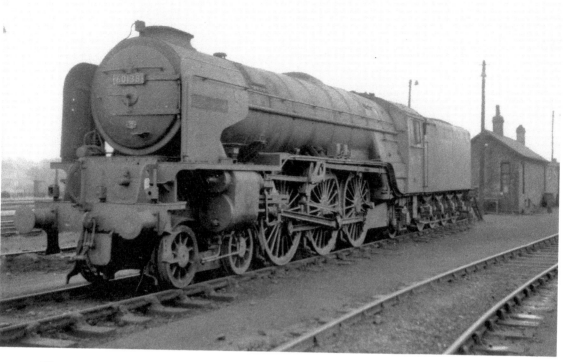

Waiting at York shed is Peppercorn class A1 Pacific No. 60138 *Boswell*, which was one of York's allocation of the class, seen here in 1965. (LOSA)

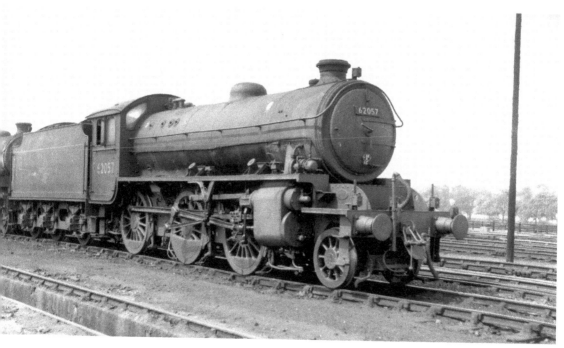

Also at York shed is ex-LNER Gresley K1 class 2-6-0 No. 62057 in 1963/64. (LOSA)

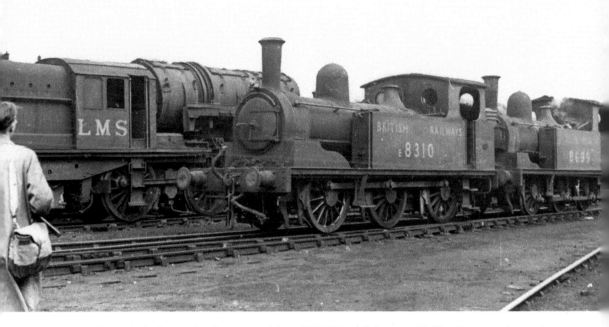

York South shed on 3 October 1948 with ex-NER Worsdell J72 0-6-0Ts Nos E8310 and 8699 in both BR and LNER livery. Behind is an ex-LMS Beyer-Garratt loco. The opening of the Swinton & Knottingley joint line on 19 May 1879 brought an influx of Midland Railway locos on passenger services to York. The following month, the MR requested shed accommodation for their engines which remained at York overnight. Discussions with the NER brought one of the circular sheds in the new building into MR use. However, this was not brought into effect because a third roundhouse at the south end of York station, which opened in 1864, became the MR shed. In January 1883, an agreement was reached between the NER and MR whereby the MR paid the NER £25 a year for each engine stabled at York, plus gas and water at cost, the agreement being backdated to 17 May 1879, two days prior to the opening of the S&K joint line. Locos of the MR used the roundhouse at the south end of the station until the grouping when they then joined the ex-Lancashire & Yorkshire shed at Queen Street. The four roads shed at Queen Street was opened in 1909 when alterations and extensions were carried out at the south end of the station which included provision of a new Locomotive Yard signal box with 295 levers. The shed had previously been the boiler shop of York Locomotive works, which had been developed from the Y&NMR works. In addition to the L&YR, Great Central and Great Eastern locos also used Queen Street shed until the Grouping when the two LNER constituents moved across to the roundhouse in exchange for the MR engines. Engines of the LMS remained at Queen Street until 1932 when they moved across the main line to the south shed and Queen Street became redundant for locomotive purposes. For a short period in BR days, part of the building was used for maintenance purposes of diesel shunters, but had latterly been used to accommodate various inspection saloons provided for the use of Regional and District Officers. For a time, the shed yard at Queen Street was used by LNER engines from other sheds, which required turning and watering before taking up return workings. The turntable remained in frequent use until the advent of diesels made it obsolete. The yard was also used by an emergency engine provided as a replacement for any main line trains that suffered engine failure. (H. Casserley)

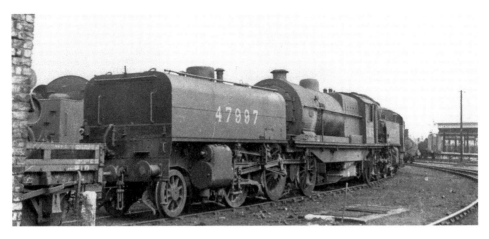

Ex-LMS Beyer-Garratt loco No. 47997 at York South shed on 3 October 1948 with old LMS style numbering. Along with the shed mentioned previously, there were two straight sheds at York South. One shed was built for the Great North of England Railway in 1841, which was a three-road shed and lasted until demolished in 1963. Prior to nationalisation and transfer of former LMS locos to north shed, the building was used by the Euston Company, but before 1923 it was a GNR shed. Agreement to stable four GNR locos was signed on 5 May 1850, shortly after the route from Doncaster via Knottingley and Burton Salmon was opened. This shed was built in the style of the GNE shed at Darlington and was noted for its large clerestory on the roof, which was replaced by a curved structure, built on the old walls in the 1930s, giving an appearance of a Dutch barn rather than a locoshed. The other shed at the south end was also a three-road affair, its origins not being known. It was later used as a signal fitting shop until demolished in 1936/37 to make way for platforms 15 and 16 at the station. The shed stood at about 45 degrees to the running lines through the present station, but its position was almost parallel to the GNE line at the north of the original station. In alterations made in 1909, the building had one corner removed to give more space beyond platform 14. (H. Casserley)

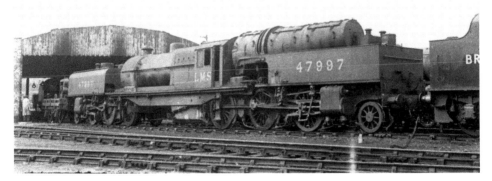

Midland locos at York South were usually class 2P, 3P, and 4P 4-4-0s, with occasional 4F 0-6-0s on excursions. The locos transferred from Queen Street when it closed were 4-4-0 types Nos 400, 401, 402, 563, 727, 728, 729, and 1091, the first eight being 2Ps, while the remainder was a three-cylinder compound (class 4P). Also transferred was ex-MR 3F 0-6-0 No. 3715. LMS Stanier Black Five 4-6-0s began working into York shortly after their introduction; by 1939, LMS Garratts began to appear on iron ore trains from Northamptonshire. One such example, No. 47997, is portrayed here in 1948. In BR days, some Stanier and Fairburn 2-6-4Ts began to appear. Even a Jinty 3F 0-6-0T was used as a station pilot at York for a while in place of J71 and J72 0-6-0Ts. (H. Casserley)

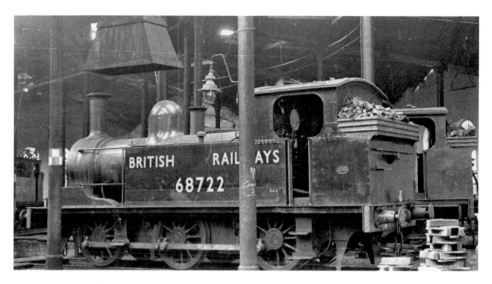

Ex-NER Worsdell J72 0-6-0T No. 68722 in the new BR livery is seen inside York South shed in October 1948. (H. Casserley)

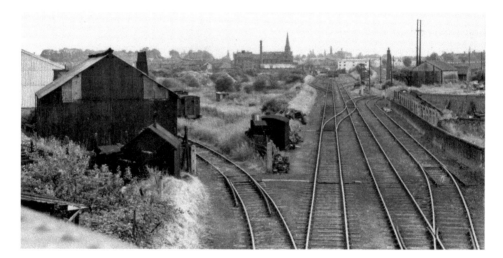

The little line at Layerthorpe off the Derwent Valley line from Burton Lane Junction to Cliff Common, via Rowntree Halt as it appeared on 25 June 1961. The old DVR locoshed is on the left and the Foss Island branch goods depot can be seen in the distance. The Foss Island branch was opened in December 1879; its 1½-mile goods line ran to a point near the cattle market on the east side of York, just outside the city wall at Walmgate Bar, from Burton Lane. Traffic on the branch included coal for the gasworks, material to and from Rowntree's chocolate factory, and from 1913 agricultural traffic from the Derwent Valley Railway. There was also a siding about halfway along the branch serving a laundry where the NER washed linen from restaurant cars and hotels. The branch never carried passengers, except along the first few yards around the curve from Burton Lane. In 1927, the LNER agreed with Rowntree's to provide a halt adjacent to the factory for the benefit of people travelling to work and the occasional parties of visitors to the works. The single platform was served by a siding alongside the two main running lines. It survived until 1988, with only one train from Selby in the morning, returning in the late afternoon. Withdrawal of passenger trains was the prelude to complete abandonment of the Foss Island branch following loss of Rowntree's goods traffic. (R. Carpenter)

YORK, ELVINGTON, and CLIFF COMMON.—Derwent Valley Light.
Gen. Man., W. T. D. Grundy, York.

Up. — Week Days only.

Miles		mrn		b aft		aft	aft		aft	aft	
—	York (Layerthorpe)..dep.	9 20	1230	1 20	4 20	6 0	6 0
2½	Murton Lane ¶	9 26		1236		1 26	4 26		6 6	6 6	
4¼	Dunnington, for Kexby	9 32		1242		1 32	4 32		6 12	6 12	
6½	Elvington, for Sutton	9 38		1248		1 45	4 38		6 18	6 18	
9	Wheldrake	9 45		1255		1 57	4 45		6 25	6 25	
10½	Cottingwith	9 48				2 0	4 48		6 28		
11½	Thorganby	9 52				2 4	4 52		6 32		
13	Skipwith and N. Duffield	9 56				2 8	4 56		6 36		
16	Cliff Common 761 ..arr.	10 6				2 18					

Except Saturdays. / Saturdays only. / Except Saturdays.

Down. — Week Days only.

| Miles | | mrn | mrn | | mrn | aft | | aft | aft | | aft | aft | |
|---|---|---|---|---|---|---|---|---|---|---|---|---|---|---|
| — | Cliff Commondep. | | 1020 | | 1050 | 3 0 | | 4 15 | | | | 6 45 | |
| 3 | Skipwith and N. Duffield | 7 50 | 1020 | | 11 0 | | | 4 20 | 5 5 | | | 6 45 | |
| 4½ | Thorganby | 7 54 | 1024 | | 11 4 | | | 4 24 | 5 9 | | | 6 49 | |
| 5½ | Cottingwith | 7 58 | 1028 | | 11 8 | | | 4 28 | 5 13 | | | 6 53 | |
| 7 | Wheldrake | 8 1 | 1031 | | 11 11 | | | 4 34 | 5 16 | | 6 45 | 6 56 | |
| 9½ | Elvington, for Sutton | 8 8 | 1038 | | 11 18 | | | 4 41 | 5 23 | | 6 52 | 7 3 | |
| 11½ | Dunnington, for Kexby ¶ | 8 14 | 1044 | | 11 24 | | | 4 47 | 5 29 | | 6 58 | 7 9 | |
| 13½ | Murton Lane | 8 20 | 1050 | | 11 30 | | | 4 53 | 5 35 | | 7 4 | 7 15 | |
| 16 | York ‡ 728arr. | 8 26 | 1056 | | 11 40 | 3 45 | | 5 0 | 5 41 | | 7 10 | 7 20 | |

Except Mondays and Saturdays. / Mondays and Saturdays. / Saturdays only. / Mondays only. / Saturdays only. / Except Saturdays.

a Mondays and Saturdays.

b For parties of 10 or more, arrangements will be made to run beyond Wheldrake.

n Stops when required to take up for York or to set down from Cliff Common.

‡ York (Layerthorpe); 1¼ miles to York, North Eastern Station.

¶ "Halt" at Dunnington between Murton Lane and Dunnington (for Kexby).

A timetable for trains along the Derwent Valley Railway in 1922. As can be seen, services were very infrequent even in those days. (Author)

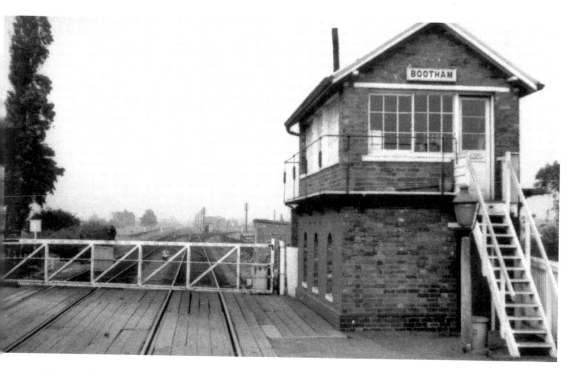

The signal box and level crossing at Bootham Junction on 10 September 1968, looking towards Malton on the Scarborough line. The line to Market Weighton can be seen turning off to the right. (R. Carpenter)

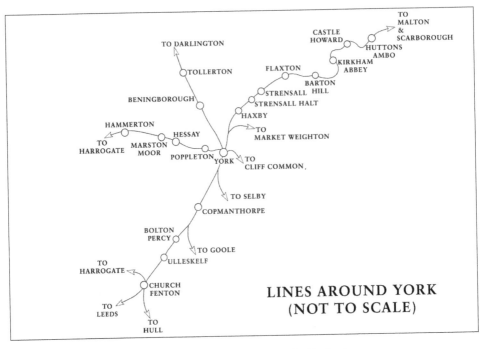

A map showing the lines and branches emanating from York. (Author)

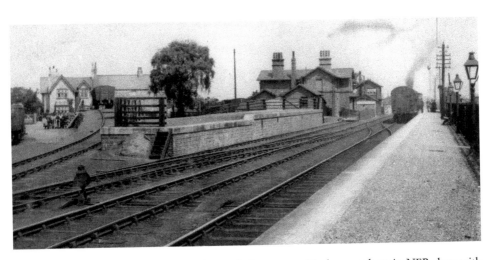

The first station from York on the Scarborough line was at Haxby, seen here in NER days with a train waiting at the station. In 1844, the Y&NMR obtained powers to build its 42-mile line from York to Scarborough, together with a 6½-mile branch to Pickering. It took only a year to complete the line, and the Pickering branch was opened on 7 July 1845. Celebrations included a public breakfast, procession through York and locos *Hudson* and *Lion* took thirty-five carriages to Scarborough where luncheon was taken. A dinner was served at York after the special train had returned. The main engineering feature of the line was a bridge over the River Ouse at York, comprising two 75-foot cast-iron girders. Also, a timber viaduct, 400 feet in length across the River Derwent at Hutton Ambo, and a five-arch brick viaduct just outside Scarborough. Trains arriving at York from Scarborough had to join the Darlington line at North Junction to gain entry into the station by reversing. It was not until the opening of the new station at York in 1877 that direct access from Scarborough was possible. (LOSA)

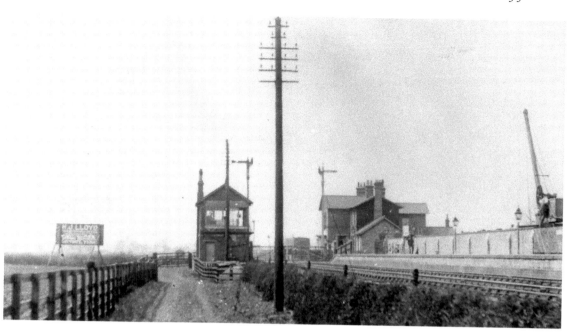

The next station on the line to Scarborough was at Strensall, seen here in the early years of the twentieth century complete with the Y&NMR main station building of a substantial nature, common on those days of confidence that the railways would make money at all times, along with its NER signal box. Between Haxby and Strensall, a halt was opened in 1926 at Strensall No. 2 level crossing. It was provided with short timber platforms to accommodate a railcar, but it was very short-lived. (LOSA)

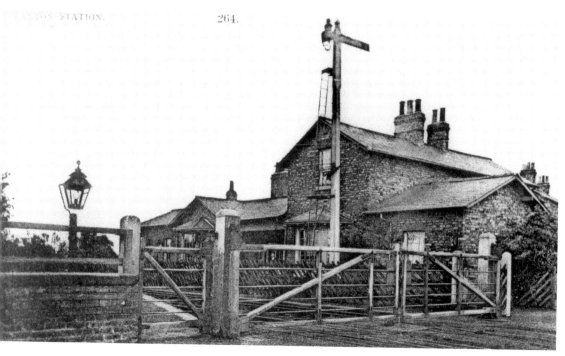

Flaxton station building and level crossing in NER days. (LOSA)

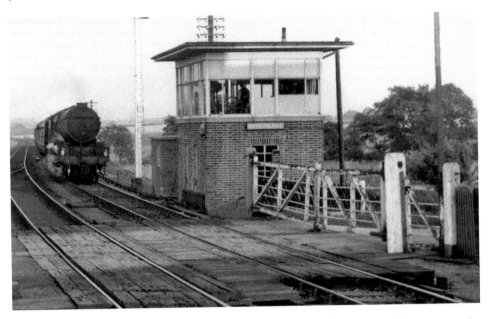

Approaching Barton Hill signal box in the 1960s is ex-LNER Gresley V2 2-6-2 No. 60941 at the head of an excursion returning to Leeds from Scarborough. (R. Carpenter)

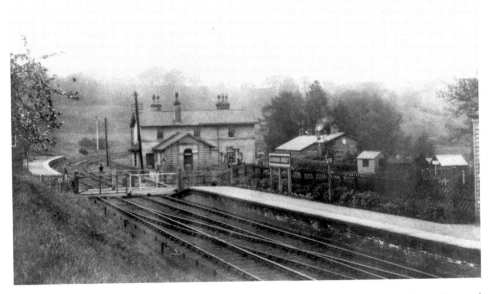

The rather substantial station at Kirkham Abbey, complete with the usual level crossing and substantial station building. Unusually the platforms at Kirkham Abbey were staggered. (LOSA)

Opposite above: Castle Howard station, which served the famous stately home, and, in the late twentieth century and early twenty-first century, was used to film both the television series and film of *Brideshead Revisited*, adapted from Evelyn Waugh's novel. Castle Howard station had facing points so that carriages could be propelled into the siding when special excursion trains ran, or people of importance visited the castle. The station house remains *in situ* with station signs on the wall as a reminder that this was once an important destination for the railway. (LOSA)

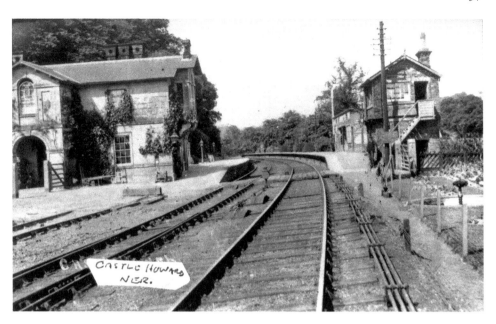

Below: Huttons Ambo station in NER days. In the period when the LNER closed many local stations around York, the line to Scarborough lost all stations between York and Malton, along with stations between Malton and Seamer. This was the first time that a string of local stations had closed, leaving just Malton and Seamer between York and Scarborough as the only intermediate stops on the whole 42-mile length of the line. These stations closed from September 1930 because villages, particularly east of Malton, were consistently further away from the railway than they were from the main roads which served them. There were, also, constraints imposed by the handful of stopping trains on the capacity of the line, which was being worked block-to-block at the busiest times, particularly in the summer when the line could be very busy with expresses and excursions. The closed stations remained *in situ* until the 1960s and were available for excursion traffic, while goods yards still had pick-up goods services. Castle Howard station waiting room was converted into a camping cottage and let to holidaymakers. (LOSA)

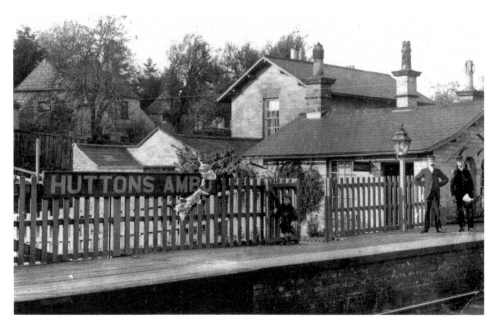

YORK, CASTLE HOWARD, MALTON, and SCARBOROUGH.—North Eastern.

Left: A timetable for trains operating over the York–Scarborough line in 1910, showing all of the intermediate stations that existed on the line until the 1930 closure. (Author)

Below: A 1922 timetable for York–Scarborough trains in the final year of NER ownership. The line would become part of the LNER a year later. (Author)

YORK, MALTON, and SCARBOROUGH.—North Eastern.

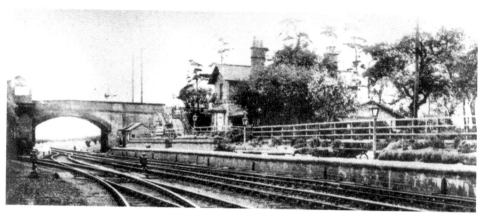

Beningborough station on the GNE line from Darlington to York as it appeared at the end of the nineteenth century. (LOSA)

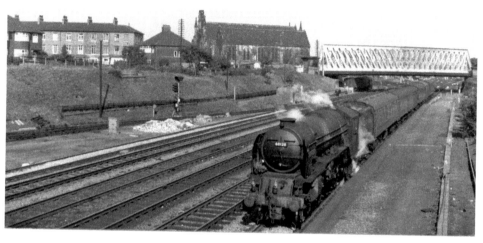

BR Eastern Region Peppercorn A1 Pacific No. 60128 *Walter K. Whigham* passes Holgate near York on the 24 September 1964 with an empty stock train. (R. Carpenter)

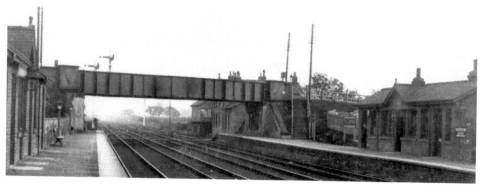

On the line to Darlington stood Tollerton station, seen here in NER days with station buildings, footbridge and signal box in view. While substantial, the one-storey platform buildings give the impression that only local trains called here. (LOSA)

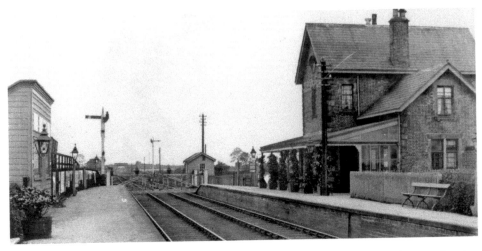

The first station on the line from York to Harrogate was at Poppleton. The smart platforms and station buildings, along with its potted plants, give the impression that the station was well looked-after in those NER days. The main station building is typical of those built by the Y&NMR while the wooden structure on the left gives the station the appearance of one which served only local traffic. (LOSA)

YORK, HAMMERTON, KNARESBOROUGH, and HARROGATE.—North Eastern.

A 1922 timetable for NER local services between York and Harrogate. (Author)

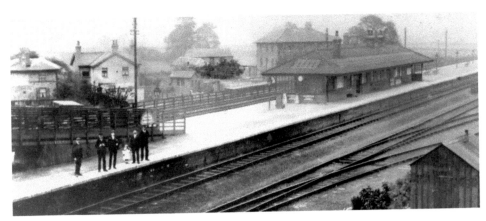

Between York and Church Fenton there were stations at Copmanthorpe, Bolton Percy – seen here in this pre-First World War view with station staff – and Ulleskelf. When the line was widened, through powers granted in 1900, the three intermediate stations at Ulleskelf, Bolton Percy and Copmanthorpe were rebuilt (as shown here) each with a single island platform between the east side pair of tracks. (LOSA)

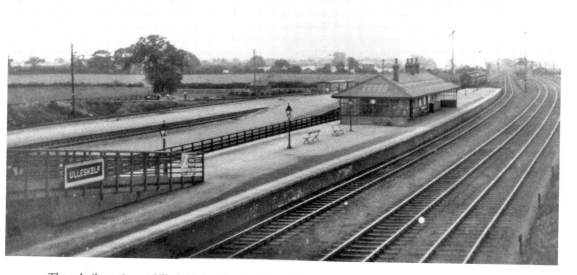

The rebuilt station at Ulleskelf shortly after the widening was complete, with a train departing in the background. Competition from the roads after the Second World War meant that some stations were closed before the infamous Beeching Report. One such was Copmanthorpe, which closed in 1959. Bolton Percy followed in 1965 but consent to close Ulleskelf was refused by the Minister of Transport and it now only exists as a halt served by a few Sheffield/Leeds–York trains. (LOSA)

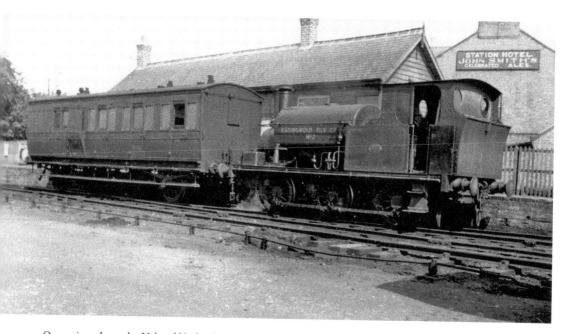

Operating along the Vale of York, the 2½-mile Easingwold Railway ran from Easingwold to Alne on the main ECML. Here, Saddle Tank No. 2 is attached to an ex-NER coach at Easingwold in 1930. (LOSA)

EASINGWOLD and ALNE.—Easingwold.																					
Miles.	**Down.**		**Week Days only.**							**Miles.**	**Up.**		**Week Days only.**								
		mrn	mrn	mrn	mrn	aft	aft	aft	aft			mrn	mrn	mrn	aft	aft	aft	aft	aft		
	Easingwold...dep.	7 36	8 34	1015	1115	1 20	3 15	5 0	6 45		Alne.........dep	8 10	9 6	1040	1227	1 38	3 37	5 45	7 18
2¼	Alne 728, 762 arr.	7 44	8 42	1023	1123	1 28	3 23	5 8	6 53	2¼	Easingwold .. arr.	8 18	9 14	1048	1235	1 46	3 45	5 53	7 26

A 1922 timetable for services along the Easingwold Railway. (Author)

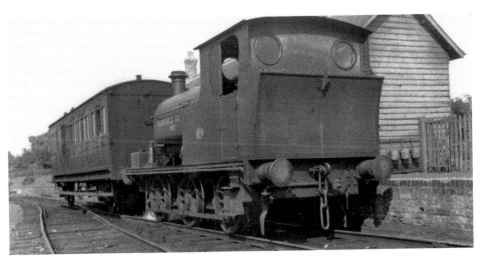

Another view of No. 2 at Easingwold in 1930. A line to connect Easingwold to Alne had been proposed as early as 1836, but it was not until 23 August 1887 that the Easingwold Railway Company was formed, with the line opening on 27 July 1891 and costing some £17,000 to build. The line made small profits for most of its life, but eventually fell victim to road competition and passenger services ended on 29 November 1948, the line closing on 30 December 1957. (LOSA)

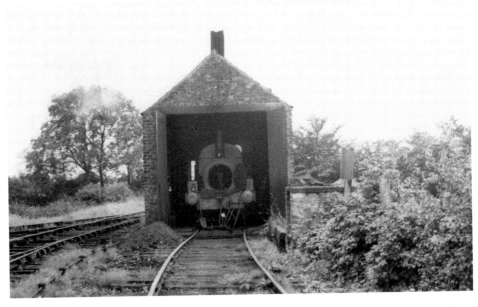

A view of Easingwold locoshed on 6 August 1939 with 0-6-0ST No. 2 on shed. (R. Carpenter)

TWO

THE HULL & SELBY RAILWAY

Construction of the Leeds & Selby Railway, between 1830 and 1834, offered the prospect of a complete route to Hull. However, much to the disappointment of Hull businessmen, there were no plans to extend the line to the port despite the obvious advantages of linking Hull with Leeds and Manchester. There ensued much debate on the subject of a line from Selby to Hull, led by Customs Officer John Exley, and several articles on the subject appeared in local newspapers. Hull bankers George Liddell and James Henwood took the initiative in raising the £20,000 required to have a Bill sponsored in Parliament.

Following efforts to raise finance, a survey was undertaken and a prospectus was issued for a line between Hull and Selby on 26 June 1834. The necessary capital was raised and landowners to the west of Hull were reassured so that a Bill could be presented to Parliament. This Bill succeeded and the Hull & Selby Railway Company Act received the Royal Assent on 21 June 1836. Opposition from the Raikes family at Welton meant that the line had to take a more southerly route than originally planned, with a station at Brough rather than stations originally proposed at Welton, North Cave, and South Cave.

Despite being constructed on level ground, the 30¾-mile line took four years to complete. To gain access to Selby station a swing bridge had to be built over the River Ouse. The Hull & Selby Railway finally opened on 1 July 1840. The H&S Hull terminus was west of the Humber Dock, with the main station entrance in Railway Street. From 1 July 1845, the H&S was leased to the Y&NMR, although it retained a separate identity until incorporated into the NER in 1872.

When a new station was authorised in Paragon Street on 22 July 1847, three new sections of track were constructed that connected the new station with the Hull–Selby and Hull–Scarborough lines. When Paragon station was opened on 8 May 1848, Railway Street station was closed to regular passenger traffic and became Hull's main goods depot, later becoming known as Manor House Street Goods station. The section of line from their goods station to Dairycoates locoshed became known as the Manor House Branch.

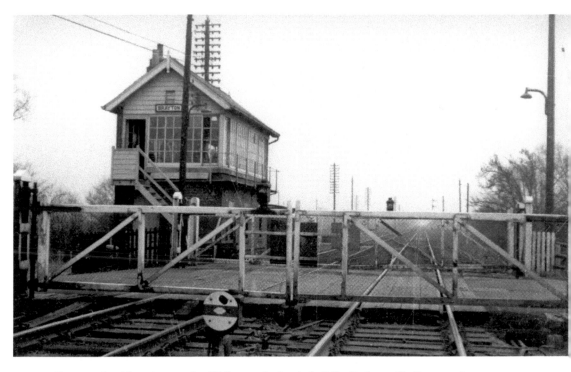

Brayton signal box, just south of Selby, on the Leeds & Selby Railway. (R. Carpenter)

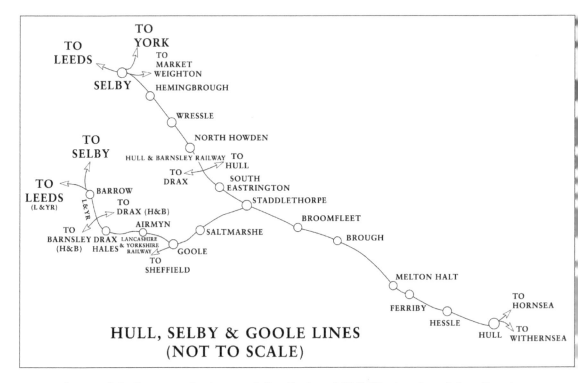

A map of the lines operating between Selby, Goole and Hull. The junction of these lines is at Staddlethorpe. (Author)

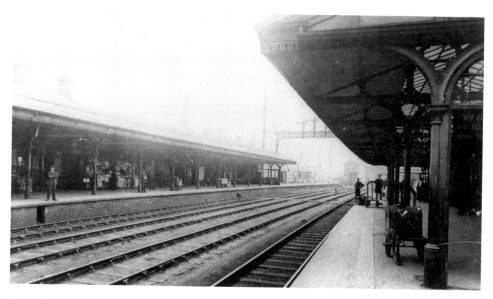

An early twentieth-century view of Selby station, terminus of the Leeds & Selby Railway until the extension to Hull was opened. In 1834, capital raised for construction of the Hull & Selby Railway was to be £350,000 in shares of £50 each, and a deposit of £1 was to be paid on application. The Act for the Hull & Selby Railway received Royal Assent on 21 June 1836, with powers to raise £400,000 in shares and a further £133,333 through loans. This proved to be insufficient and, in 1843, a further Act was obtained to raise a further £117,000 in shares and £30,000 in loans. When the 31-mile line was opened, its station was at Kingston Street. Two-thirds of the route was straight from Selby to Brough, and only two road crossings were necessary. The main engineering works were bridging over the River Ouse and River Derwent, along with crossing of the Market Weighton Canal at Newport. The Raikes family objected to a station at Welton and also gained a promise that no station would be built between Ferriby and Brough. They were also paid £10,000 in compensation.

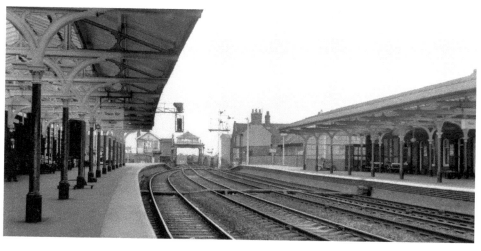

A later view of Selby station in 1966, with an ex-LMS Black Five 4-6-0 approaching the station on an excursion. Selby was also the terminus of the branch from Market Weighton. The prospectus for its construction planned to raise capital of £80,000 in £10 shares, with a deposit of £1 15s (£1.75) on application. (R. Carpenter)

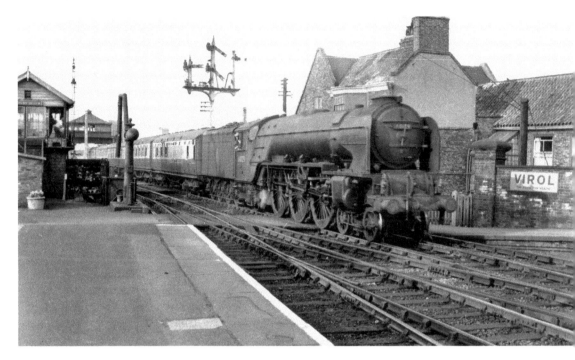

Approaching Selby station in the mid-1950s is Eastern Region A1 Pacific No. 60129 *Guy Mannering* at the head of an express to Hull from Leeds. (R. Carpenter)

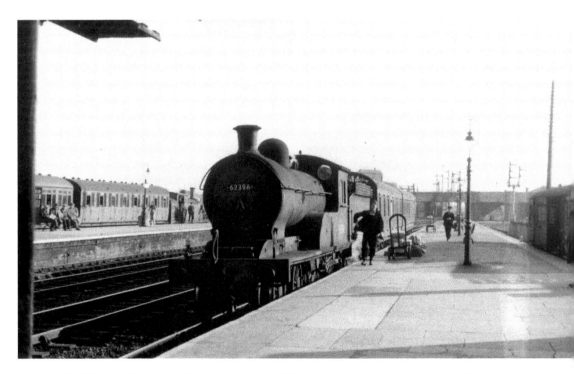

Ex-NER class D20 4-4-0 No. 62396 waits at Selby station on 31 August 1956 with the 5.47 p.m. train to Bridlington. The train will run along the branch to Market Weighton and Driffield before running along the line from Hull to reach the seaside town. (H. Casserley)

Right: An 1877 poster of the MR and NER for an excursion to London from Hull via Selby and York. (Author)

Below: Approaching Selby station in 1950 is an unidentified ex-LNER B16 class 4-6-0 at the head of a southbound freight. The swing bridge over the River Ouse can be seen in the background. (R. Carpenter)

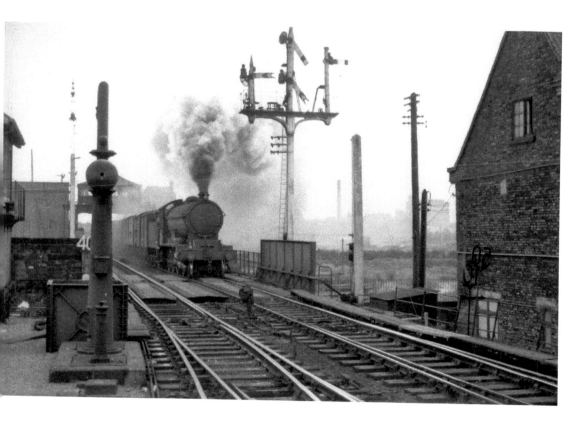

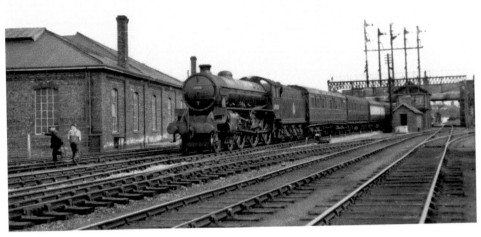

Departing from Selby station in May 1953 is ex-LNER Thompson B1 class 4-6-0 No. 61020 *Gemsbok* with a southbound express. Built at Darlington in 1947, the loco entered traffic as LNER No. 1020, becoming 61020 on 9 July 1948. When this picture was taken she was allocated to Leeds Neville Hill shed, ending life at York, having been transferred there on 11 September 1960. The engine was condemned on 26 November 1962 and was cut up in Darlington in January 1963. (R. Carpenter)

The locoshed at Selby as it appeared on 29 September 1963. (R. Carpenter)

The first roundhouse at Selby was built in 1871. It had eighteen stalls and two access roads, grouped around a 42-foot turntable. In November 1896, there were forty-six locos allocated to Selby and a second roundhouse was authorised at an estimated cost of £14,980. This extension was opened in 1898 and consisted of two access roads and twenty-two stalls around a 50-foot turntable. The sheds adjoined each other and were known as Old and New shed. In 1908, two petrol-electric bogie railcars, Nos 3170 and 3171, were transferred to Selby to work the Cawood branch and in 1912 a single-road lean-to shed was built at the rear

of the coal stage to house these vehicles. In 1923, Leyland bus, No. 110 (later 1307), fitted with railway wheels, was moved from York to Selby to work the Goole and Cawood branches. This vehicle was also stabled in the railcar shed until early in November 1926 when a naked flame was used to check if there was any fuel in the vehicle. The burning bus was manhandled out of the shed without damaging the shed but the vehicle was a total loss. After the NER took control of the Cawood branch, the company's 0-6-0ST was disposed of and class H2 (later LNER J79), along with class E (LNER J71) 296 and 1197, were all fitted with Westinghouse brake equipment. With standardisation of vacuum braking on the LNER, Westinghouse fitted engines became redundant and in April 1929 vacuum fitted J71 locos Nos 495 and 1157 were sent to Selby to operate the branch for the last nine months of passenger services. Class J71, J72, and J77 0-6-0Ts continued to operate goods services over the branch for many years, being withdrawn on 2 May 1960 after 204hp diesel locos had taken over.

Prior to the First World War, Selby had a loco at the Lancashire & Yorkshire shed at low Moor, Bradford, to work Halifax–Hull trains between Selby and Halifax. The loco shunted at Selby between arrival at 12.13 p.m. and departure at 4.12 p.m., the loco usually being a Tennant 2-4-0, McDonnell 4-4-0, or class F 4-4-0 provided. Between the wars, more than twenty mineral locos were allocated to Selby and used for collecting coal from Castleford, Normanton, and Pontefract area collieries and working these trains to marshalling yards at Gascoigne Wood, ready to be collected for Hull for shipment. The two T1 4-8-0Ts, later replaced by two Q1 0-8-0Ts, were used for hump shunting at Gascoigne Wood yard. Ex-H&B 0-8-0s Nos 1929, 2499 and 2509 were transferred to Selby on 2 November 1929 for trials. Although not popular, a further six arrived on 18 November, allowing the six Q6 0-8-0s to be transferred to Dairycoates, freeing up six 04 2-8-0s for Springhead. Problems with the H&B 0-8-0s led to four Q6s coming from Stockton in July 1930, followed by four Q7s also from Stockton in November 1930, allowing the eight H&B Q10s to go into store. No. 2503 was sent from Hull to Selby on 29 December 1930 in exchange for 2511 so that improved sanding arrangements could be tested while at Selby. May 1931 saw withdrawal of H&B 0-8-0s and all had gone by the end of the year. In 1939, Selby had seven passenger turns working as far as Bridlington, Hull, Leeds, Doncaster, Wetherby, Castleford, and Pontefract. Three turns were booked for D20 4-4-0s and one for J21 0-6-0. The latter worked the 4.45 p.m. light engine to Doncaster and then the 6 a.m. workmen's train from Doncaster to Brough (for the Blackburn aircraft factory), returning as far as Goole with empty stock and the crew going home as passengers to Selby after a four-hour wait at Goole. The second crew travelled to Goole by the 11.13 a.m. from Selby and after a six-hour wait worked the 6.30 p.m. goods back home; the actual footplate time was only forty-three minutes. Summer Saturdays saw four turns to Scarborough and, at one time, Selby borrowed B16 4-6-0s from York. In BR days, Selby engines were run in pairs. The locos used in the 1950s were D20 and D49 4-4-0s, along with 4MT 2-6-0s and would be paired in any combination.

Another view of Selby shed in 1963 with the main line running off to the left. (R. Carpenter)

The Allocation at Selby at Nationalisation in 1948

BR Code: 50C

Class D20 4-4-0	62340, 62341, 62348, 62361, 62363, 62366, 62374, 62376, 62378, 62381, 62382, 62386, 62395
Class Q5 0-8-0	63280, 63285, 63319, 63336
Class Q6 0-8-0	63348, 63378, 63382, 63387, 63395, 63406, 63408, 63429, 63431, 63436, 63440, 63448, 63449, 63451, 63456
Class J27 0-6-0	65793, 65827 , 65844, 65848, 65874, 65875, 65881, 65882, 65891
Class J21 0-6-0	65105
Class G5 0-4-4T	67250, 67286
Class Y3 0-4-0T	68158, 68161
Class J71 0-6-0T	68268
Class J73 0-6-0T	68356, 68357, 68362
Class J77 0-6-0T	68399, 68433
Class A8 4-6-2T	69867, 68879
Class Q1 0-8-0T	69931
	Total: 55

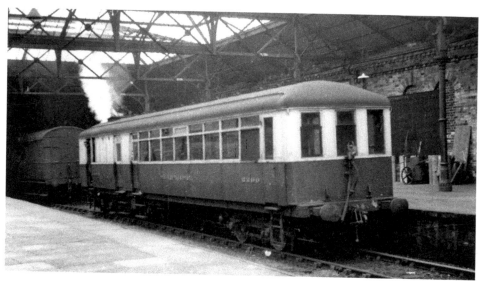

LNER Sentinel steam railcar No. 2200 *Surprise*, which entered traffic in August 1929, based at Selby and used on the Selby–Bridlington service, was one of the longest operated by a Sentinel car, covering a distance of over 42 miles. This railcar went to Leeds Starbeck from June 1936 and was withdrawn in September 1943. Another of these railcars based at Selby was involved in a collision with a Leeds–London excursion on 9 June 1929, after the railcar had run past signals set at danger at Marshgate Junction, Doncaster. The car, No. 222 *Waterwitch*, was working the Sunday-only service between Doncaster and Staddlethorpe. It was broken in two at the articulated joint, and although the passenger compartment remained intact at the top of the embankment, the engine and boiler compartment was thrown down the bank and damaged beyond repair. (LOSA)

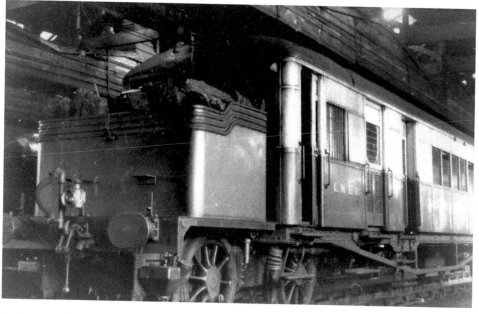

A Clayton railcar, one of a small number operated by the LNER, one of which found its way to Selby on various passenger trains. All of these cars were withdrawn by 1936, after only eight years in service. (LOSA)

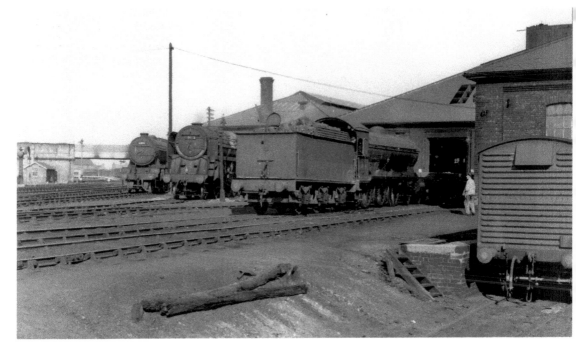

Selby locoshed in the early 1960s with an ex-NER 4-6-0, a BR 9F 2-10-0 and an 0-8-0 freight engine in view. (R. Carpenter)

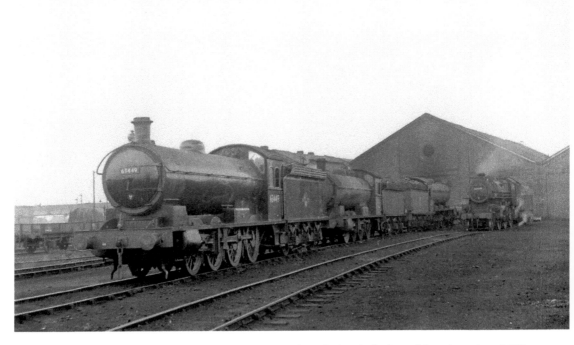

Another view of Selby locoshed in the same period. At the head of a line of three locos is ex-NER Q6 0-8-0 No. 63449, while an imposter, in the shape of an ex-LMS Ivatt 2MT 2-6-0, is in steam on the left. (R. Carpenter)

HULL, SELBY, NORMANTON, CHURCH FENTON, and LEEDS.—North Eastern.

Up.	Week Days—*Continued.*		Sundays.

(Timetable of departure and arrival times, partly illegible)

Hull (Paragon).........dep. 2 45 4 0 ... 4 50 5 52 8 0 ... 8 40 ...
Hessle ... 2 55 6 3 8 10 ...
Ferriby ... 3 1 6 10 8 16 ...
Brough ... 3 7 6 17 8 23 ...
Staddlethorpe ... 3 20 6 31 8 35 ...
South Eastrington ‖ ... 3 27 6 39 8 40 ...
North Howden †† 774 ... 3 34 6 46 8 47 ...
Wressle ... 3 40 6 52 8 53 ...
Hemingbrough ... 3 46 6 58 9 0 ...
Selby 333, 338, 750 arr. 4 52 4 38 7 4 8 26 ... 9 6 ...
326 York 333 ... arr. 4 33 5 46
333 London (King's C.) ‖ ... 9 30 ...
Selbydep. 3 59 4 42 5 22 ... 6 5 ... 7 11 8 18 8 30 8 48 ...
Hambleton ... 4 7 ... 5 30 ... 6 13 ... 7 19 ...
Sherburn-in-Elmet 6 21 ...
Church Fenton 770 arr. 6 25 6 31 ... 8 34 ...
668 York 767 ... arr. 7 35 ... 9 6 ...
Church Fentondep. 6 50 ... 8 42 ...
Sherburn-in-Elmet 6 55 ...
Monk Fryston 7 1 ... 8 50 ...
Burton Salmon 7 5 ...
Castleford** 371 7 12 ... 9 4 ...
Normanton 518, 616 arr. 7 21 ... 9 12 ...
518 Wakefield § ... arr. 7 46 ... 10 6 ...
518 Halifax ... ‖ 8 49 ... 11 16 ...
616 Sheffield* 669 ... ‖ 8 46 ... 11 2 ...
617 London (St. Pan.) ‖ 4 20 ...
518 Manchester (Vic.) ‖ 9 A 30 ...
518 Liverpool (Exch.) ‖ 10 20 A ...
Church Fentondep. 6 33 ... 8 40 ...
South Milford ... 4 15 ... 5 39 ...
Micklefield † 772) ... 4 23 ... 5 47 ... 6 44 7 35 8 51 ...
Garforth † 750 ...P. ... 4 30 ... 5 53 ... 6 50 7 41 8 57 ...
Cross Gates 750 ... 4 39 ... 6 3 ... 6 57 7 48 9 4 ...
Marsh Lane ... 4 51 ... 6 14 ... 7 9 7 59 9 15 ...
Leeds (New) ‖ 489 arr. 4 54 5 11 6 17 ... 7 12 8 2 9 18 9 ...
672 Leeds (Wellington) dep. 5 10 5 43 6 32 ... 8 28 4 0 9 28 ...
672 Bradford (Mrkt St.) arr. 5 56 6 26 7 18 ... 8 27 9 26 9 55 ...
489 Manchester (Exc.) arr. ... 6 57 9 20 ...
489 Liverpool (Lime St.) ‖ ... 7 52 10 43 ...

A Arrives Manchester (Vic.) at 9 18 and
 Liverpool (Exch.) at 10 8 aft. on Sats.
b Via Monk Fryston.
c Stops when required to set down for
 York or beyond.
h Stops when required to set down.
K Arrives Liverpool (Lime Street) at
 3 55 mrn. on Sundays.

***** For other Trains**

			BETWEEN	PAGE
Hull, Eastrington, and Howden..	774			
Hull and Brough............	765, 768			
Hull and Staddlethorpe	765			

BETWEEN	PAGE
Church Fenton and Normanton,	
and Church Fenton and Leeds	766
Church Fenton & Burton Salmon	669

An NER timetable of 1922 for trains operating between Hull and Selby, showing connections to Manchester and Liverpool. (Author)

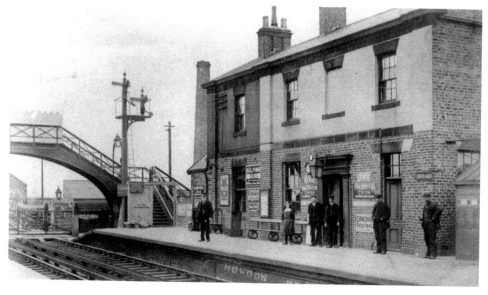

From Selby, the line to Hull passed through Howden station, seen here in the early twentieth century, showing the level crossing and the standard NER footbridge. (LOSA)

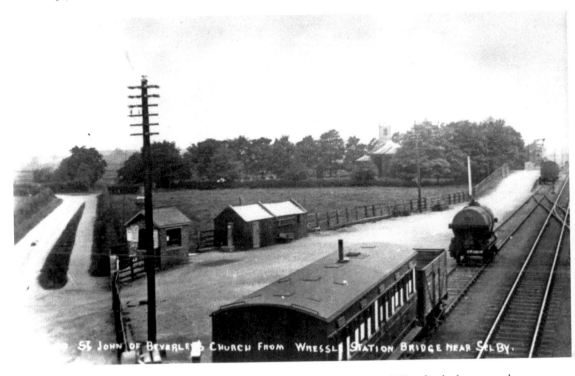

ST. JOHN OF BEVERLEY CHURCH FROM WRESSLE STATION BRIDGE NEAR SELBY.

Between Selby and Howden there were stations at Hemingbrough and Wressle, the latter seen here in a rather rural setting with shunting in progress. (LOSA)

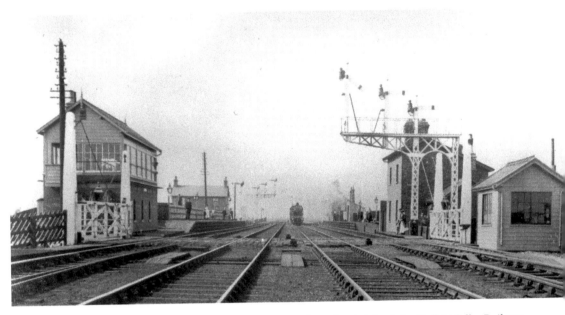

Between South Eastrington and Broomfleet, the line from Goole joined the Hull & Selby Railway at Gilberdyke for access to Hull. The Hull & Selby Railway became four track at this point to serve increasing traffic demand with the opening of the branch to Goole and Doncaster from 1904. Broomfield station is seen here, after the widening and rebuilding. In the background, a train is seen on the through line. (LOSA)

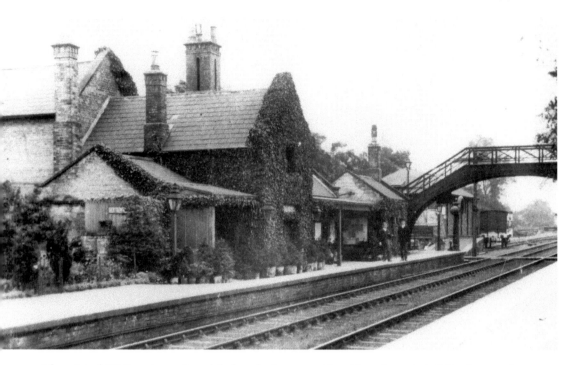

The original H&S station at Brough before the line was widened here; its main building is covered in ivy, which gives it a rather attractive appearance. This rather attractive building would be removed when the line was widened and replaced by a more utilitarian structure. (LOSA)

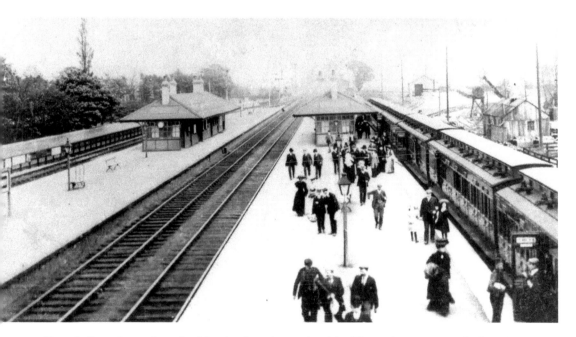

The rebuilt station at Brough with a local service on the right. The station appears to be busy in this Edwardian view as the wealthy moved out of Hull and into more rural locations, providing the NER with a new source of revenue – commuters and those who went shopping in the city. (LOSA)

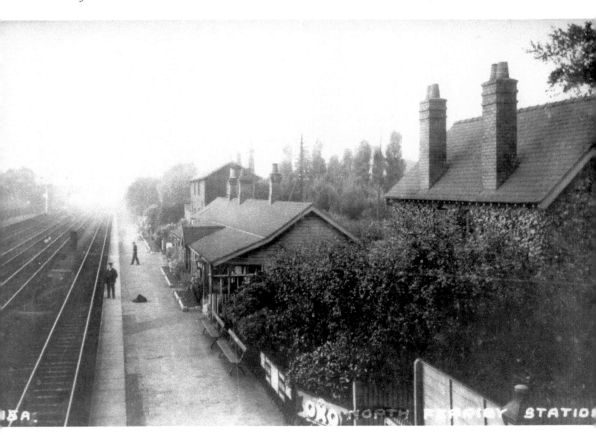

Following Brough, there was a station at Ferriby, seen here after widening of the line. As can be seen, the old station buildings were retained on the north side, the whole area retaining a rural atmosphere. Note the 'Oxo' enamel advertisement in the right foreground; these and other enamel advertising signs were part of the railway scene for many years. In 1920, a small halt between Ferriby and Brough was opened at Melton to serve the Earles Cement Works and was used by employees on workmen's trains from Hull. At the same time, workmen's trains also continued to Brough to serve the Blackburn aircraft works. As affluent families moved out of Hull, a more intensive suburban train service was required and, from 8 April 1929, the LNER introduced a regular half-hourly service between Hull, Hessle, Ferriby and Brough. (LOSA)

Opposite above: Hessle station looking west after the widening. New buildings are on the right and the original station building is just visible on the left. The goods shed and sidings are visible in the left background. (LOSA)

Opposite below: Passing through what appears to be a rather neglected Hessle station (when compared to the previous view) is ex-WD 2-8-0, No. 90016, at the head of a cement train from Earles Cement Works in around 1965–66. These ex-WD locos were a common sight in the Hull area on goods trains to and from the docks at both Goole and Hull. (R. Carpenter)

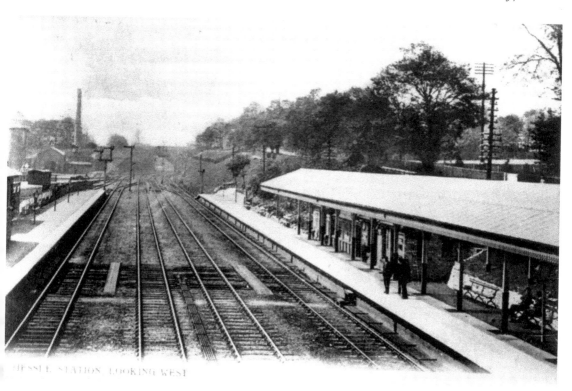

HESSLE STATION LOOKING WEST

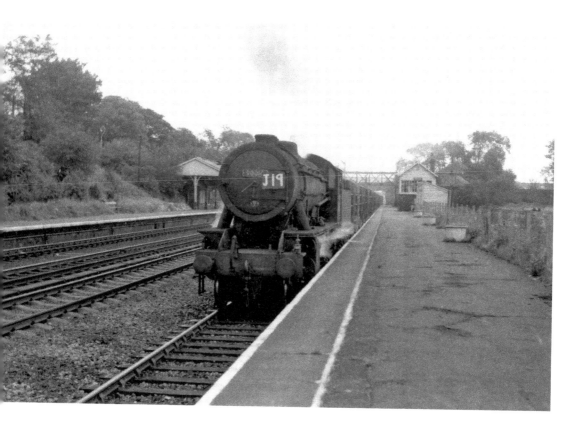

THREE

HULL

The arrival of the railway in Hull allowed development and growth of the city and seaport. The first railway to reach Hull was the Hull & Selby Railway, which connected directly with the Leeds & Selby Railway, giving the port a rail link to both the West Riding and Manchester. The H&S station in Hull was at Railway Street, opened in 1840, but this soon became inadequate, particularly after the opening of the line to Bridlington in 1846. Trains from Bridlington did not run to Railway Street station. Due to its situation west of Hull city centre, the railway company preferred to take passengers to the centre by coach. Therefore, the H&B urged provision of a new station and an Act was obtained by the Y&NMR to construct a new station at Paragon Street, along with a hotel.

The Y&NMR architect, G. T. Andrews, designed the new station and a tender of £51,500 for construction was accepted on 1 March 1847. Hull Paragon station was opened on 8 May 1848 with the adjoining 'Royal Station Hotel', also designed by G. T. Andrews, opening in 1851. As if to cement the 'Royal' in the hotel's name, Queen Victoria, Prince Albert and five of their children stayed at the hotel while on a visit to the city on 13/14 October 1854. The original Railway Street station became a goods depot following closure to passengers after Paragon station was opened.

By the beginning of the twentieth century, Paragon station was becoming too small for the volume of traffic being handled there, extra passenger services having been generated following opening of branches to Withernsea in 1854 and Hornsea in 1864, along with services to Doncaster (from 1869) and local trains to Beverley, Driffield and York. In 1902, tenders totalling £75,098 were accepted by the NER for alterations and additions to the station, which involved rebuilding the original platforms, adding new ones and construction of an overall roof. Nine full-length platforms, and one short one, were under the new roof, with a further four outdoor platforms on the south side which were intended to be used by excursion trains. These new station improvements came into use from 12 December 1904.

Following the formation of British Railways, and competition from road transport, some rationalisation of local passenger services was undertaken. In

1955, the Hull–South Howden service was withdrawn, followed, in 1964, by withdrawal of the Hull–Withernsea and Hull–Hornsea trains. In 1965, Hull–Market Weighton–York trains were withdrawn, leading to closure of platforms 1, 2, 3 and 14 at Paragon station.

Along with passenger traffic, the port at Hull also generated much freight traffic for the railway system, which could handle large quantities of freight exported and imported through the docks complex in the city. The port also had a thriving fishing industry, which generated even more freight traffic as fish trains distributed catches throughout England. Indeed, at its peak, Hull was the third-largest port for commercial traffic, and the largest deep sea fishing port in the UK. The port area consisted of eleven docks, with a water area of 200 acres, two riverside quays and three oil jetties. In total there were some 300 miles of standard gauge railway tracks in and around the docks.

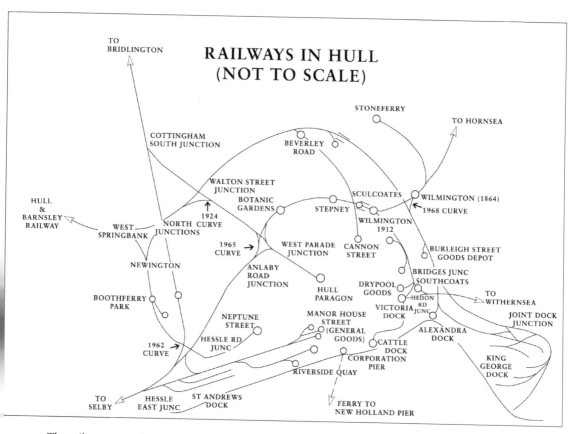

The railway network in Hull, showing alterations undertaken over the years. (Author)

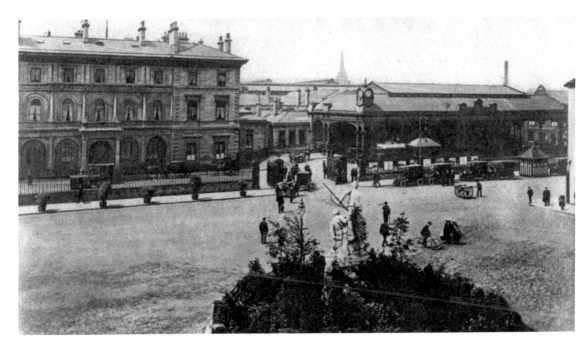

Above: The exterior of Paragon station in the early years of the twentieth century, with motor taxis waiting for business from railway passengers after arrival. Paragon station was always busy and this is reflected in passenger figures over the years. The number of trains using the station showed an increase from 86 in and out in 1870, to 192 in 1904, and 268 in 1931, but declining to 204 in 1957 and 167 in 1991. When Paragon station opened in 1848, it equalled York as the second largest on the NER network, only Newcastle being larger. The front exterior of Paragon station was modernised from 1960, with the building of a new office block to accommodate the BR Hull Divisional Offices which opened in 1962. (Beverley Record Office)

Opposite above: Trackwork being undertaken at Hull Paragon station in the late 1930s, showing the signal gantry which controlled traffic in and out of the station. As part of continuing works at Hull, a new Inward Yard was opened in December 1935. The yard was equipped with a hump, wagon retarders, floodlights, and control tower. Each of the six reception roads could hold 100 wagons and the thirty sidings offered total capacity for 3,000 wagons. In early BR years, the line between Hull, Selby and Goole was well used. The mid-1950s saw an average of 122 passenger and 80 freight trains a day, the signal boxes along the route being manned for a full twenty-four hours on a three-shift system. Even under Beeching recommendations, only two stations were listed for closure, at Hemingborough (closed 1967) and Wressle (which remains open). On 1 February 1974, Staddlethorpe was renamed Gilberdyke. Following Beeching, however, there was a drastic reduction in the amount of retail freight traffic from Hull's docks in favour of road transport. In July 1964, fish trains were reduced from eight to two per day. At its peak, fish traffic was carried in insulated vans and were hauled by 'TopLink' locos and even had priority over some passenger trains. By 1965, fish trains were reduced to one a day to London and they ceased altogether in the same year. Loss of freight traffic led to the gradual closure of the goods yards in Hull. The last of the original pre-war yards, the 'New Inward Yard' closed in March 1984, coinciding with the opening of a new yard linked to the main line. In recent times, there has been further rationalisation, including removal of sections of track and some signal boxes. From 1989, all but Brough station became unmanned. The line between Hull and Gilberdyke reverted back to double track, except the section between Ferriby and Melton Cement Works sidings which had three tracks. The level crossing at Anlaby Road was replaced by a flyover in April 1965 and the two bridges that carried the Hull and Barnsley lines High Level branch were dismantled when the line was brought down to join the NER line prior to building of the Hessle Road flyover which was opened in 1962. (R. Carpenter)

Below: Awaiting her turn of duty, ex-GNR class C12 4-4-2T No. 7395 stands at the entrance to Hull Paragon station on 17 April 1947. (H. Casserley)

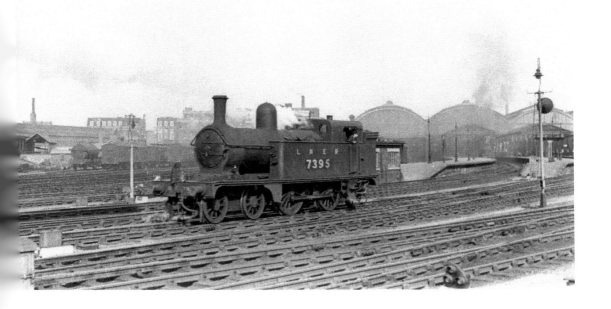

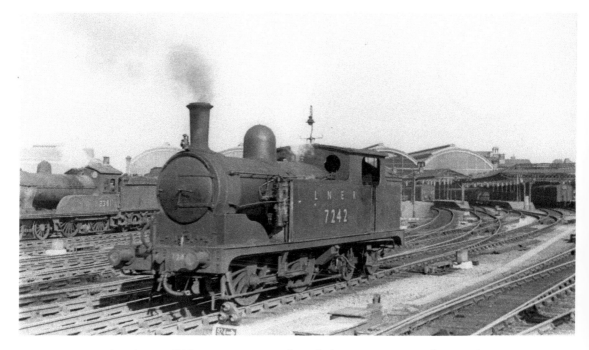

Ex-NER class G5 0-4-4T No. 7242 simmers at the end of Paragon station on the same day. Waiting to depart with an express is ex-NER D20 4-4-0 No. 2361. As can be seen, the railway appeared to be rather run down and the locos looked unkempt in this early post-war period. However, the station is full of traffic as road competition had yet to have its effect on railway traffic. (H. Casserley)

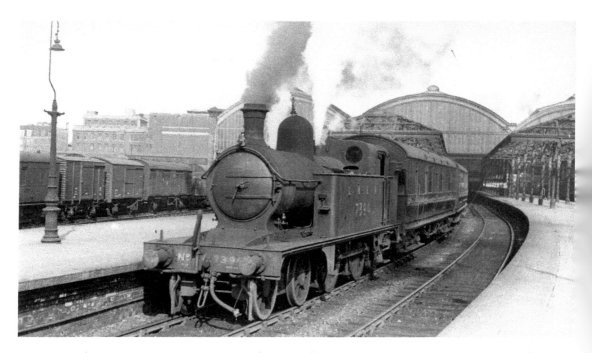

Another ex-GNR C12 4-4-2T No. 7394 departs Hull Paragon station with a local train. Plenty of freight wagons are seen in the goods yard beyond. (H. Casserley)

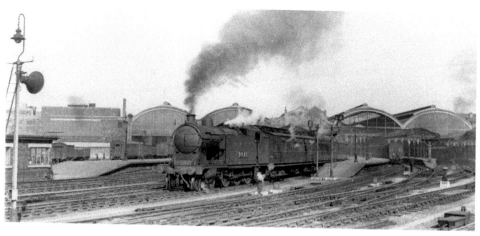

Ex-NER class A8 4-6-2T No. 9881 is seen departing from Paragon station in 1947 with a passenger train for Bridlington and Scarborough. (H. Casserley)

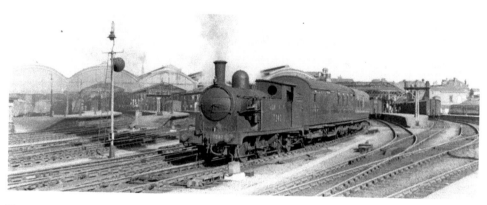

Yet another G5 0-4-4T, No. 7242, is waiting to depart with another local train. (H. Casserley)

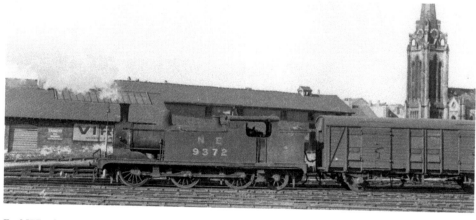

Ex-NER class N8 0-6-2T, one of a class built by T. W. Worsdell between 1896 and 1890, with running number 9372, is seen leaving Hull with a freight train. All of these engines had been scrapped by 1956. (H. Casserley)

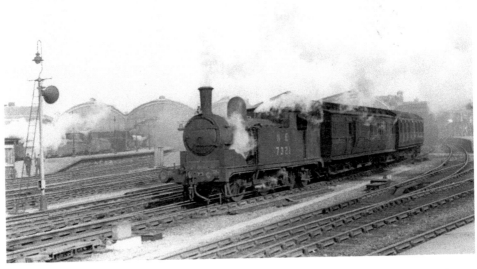

Ex-NER G5 class 0-4-4T No. 7321 is seen departing from Hull Paragon station on 17 April 1947 with the 5.22 p.m. service for North Cave, which was situated on the Hull & Barnsley Railway, which opened in 1885 to connect the seaport with the South Yorkshire coalfields. Although the H&B never made money from its passenger services, coal traffic was very profitable. The H&B was taken over by the NER in 1922, a few months before the grouping of 1923, when both companies became part of the new LNER. (H. Casserley)

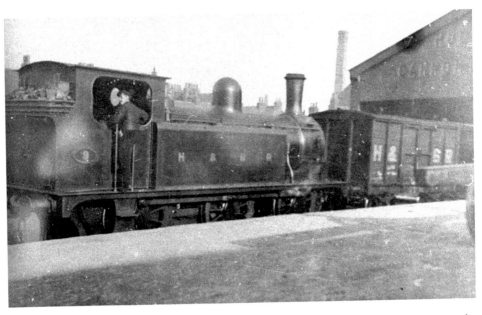

Back in 1905, and Hull & Barnsley Railway 0-6-0T, built by Beyer-Peacock, No. 9 waits at the original H&B station, Cannon Street. As if to illustrate the lack of passengers on the H&B, the line west of South Howden was closed to passengers as early as in 1932. The remainder of the H&B became part of a new Hull & District Interval Service, which provided an hourly service to South Howden. The H&B was finally closed in 1964. (R. Carpenter)

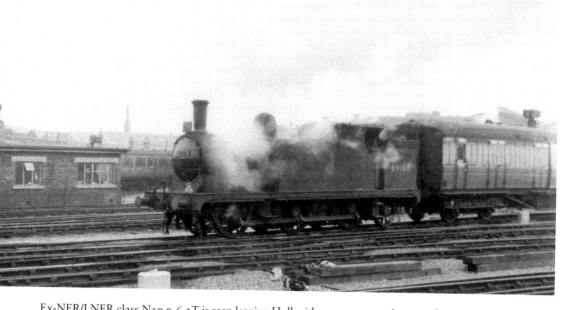

Ex-NER/LNER class N10 0-6-2T is seen leaving Hull with a passenger train on 31 August 1956. By this time, the engine is carrying its British Railways number 69108. (H. Casserley)

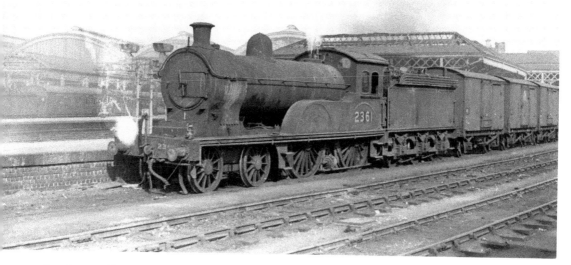

A rather scruffy ex-NER class D20 4-4-0 is about to depart from Hull with a freight train. These engines were built by NER CME W. Worsdell and were designated class R. They were built between 1899 and 1907, and many survived into BR ownership but all had gone by 1957. (H. Casserley)

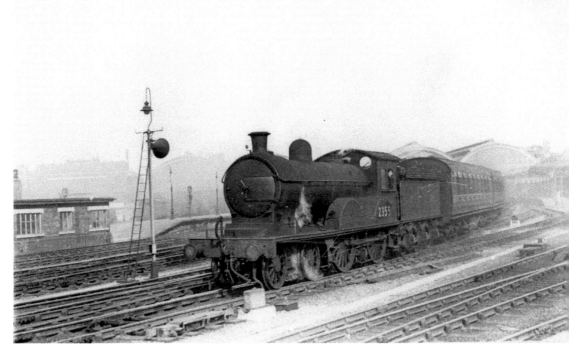

Another ex-NER D20, No. 2355 is seen leaving Hull Paragon with an express on 17 April 1947. (H. Casserley)

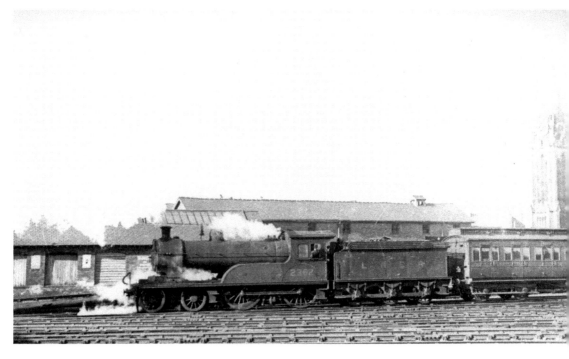

Ex-NER D20 No. 2362 is leaving Hull with a local train, probably for Beverley, Bridlington and Scarborough, on 17 April 1947. (H. Casserley)

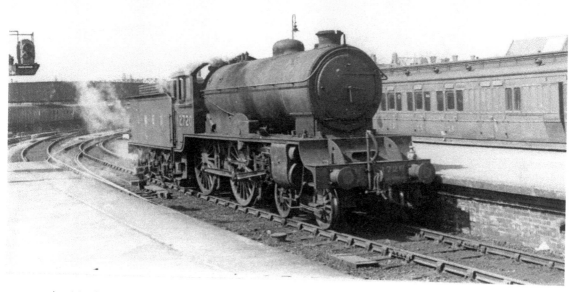

Awaiting her turn of duty, Gresley class D49/1 No. 2720 *Cambridgeshire* rests at the end of Paragon station on 17 April 1947. (H. Casserley)

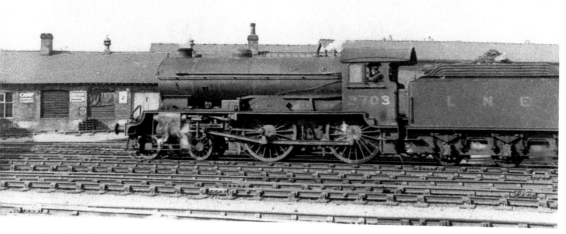

Another of Gresley's D49/1 4-4-0s, No. 2703 *Hertfordshire*, is seen at Hull Paragon station on 17 April 1947. (H. Casserley)

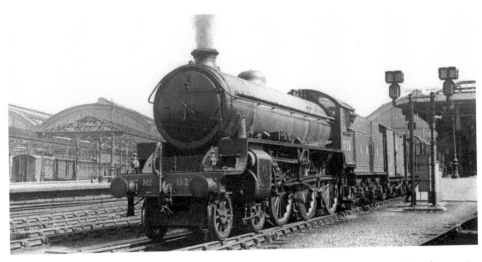

Virtually new when this view was taken on 17 April 1947, LNER Thompson B1 class 4-6-0 No. 1126, in apple-green livery, is seen at Hull Paragon station with an express, probably for Doncaster and Leeds. The loco entered traffic on 7 February 1947, having been built by the North British Loco Works (works No. 25882) and then allocated to Doncaster and Retford from 3 December 1950, where it remained for the rest of its life. She was given her BR number, 61126, from 3 September 1948 and was sold to Rigley's of Bulwell Forest and scrapped in January 1964, having been condemned on 22 September 1963. (H. Casserley)

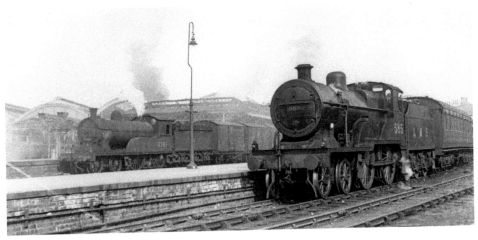

An impostor, in the shape of MR/LMS class 2P 4-4-0 No. 585 at the head of a local train, the 6.37 p.m. to Wakefield, about to depart from Paragon station on 17 April 1947. In the background is ex-NER D20 4-4-0 No. 2361 at the head of a freight train. Many of the views were taken on the same day in 1947 and give a good representation of the sheer variety of motive power which operated both freight and passenger services out of Hull, something that does not occur today as the modern railway has been rationalised and virtually no freight now operates on the railway system in Hull, as lorries take most of this traffic. Although there has been an increase in passenger traffic in recent years, most of it has been in the hands of two-car 'Sprinter' sets and multiple unit express trains. Indeed, most of the branches that had trains operating over them in steam days have long since closed, thanks to the 'dead hand' of Dr Richard Beeching. Even Paragon station has been rationalised due to the closure of so many branches since the 1960s, although the station remains quite busy and is an attractive place to wait for trains. (R. Casserley)

Sitting at Hull on 31 August 1956 are ex-GNR coaches Nos 48601/2, part of that company's 'Quad-Art' set. (H. Casserley)

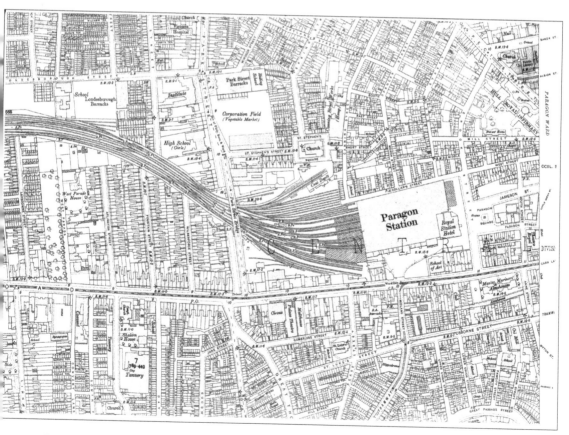

A map of Hull Central, showing Paragon station and its complex of railway tracks as it appeared in 1910. (Beverley Record Office)

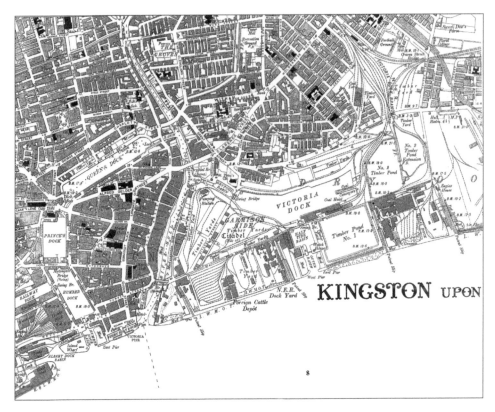

A map of Victoria Dock in 1911, served by the NER and H&B, with the Victoria Dock branch to the right, used originally by the branches to Withernsea and Hornsea. (Beverley Record Office)

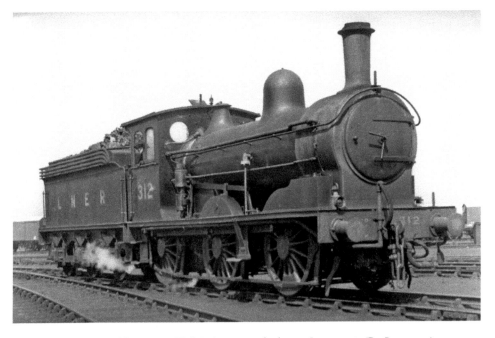

LNER class J21 0-6-0 No. 312 at Hull Dairycoates shed on 4 June 1938. (R. Carpenter)

Hull Dairycoates was the largest shed on the NER and consisted of six roundhouses and two straight sheds. The first mention of a shed here was in November 1857 when Mr Fletcher, CME of the NER, complained of a lack of cover and exposure of locos to the weather. It was, therefore, decided that a locoshed should be built in the area adjacent to the line from Selby, around 2 miles from Paragon station, near to Dairycoates Farm (hence the shed's name). An estimate for the shed alone, in February 1858, was £13,000. Approval for the project was not given until March 1861 when a tender of £31,965 was accepted for the new shed, fitting shop, and cottages. In June 1861, a 42-foot turntable was ordered at a cost of £420, and the building was completed in 1863 (eventually becoming No. 1 shed). The next two roundhouses (sheds No. 2 and 3) were authorised in June 1873 at a cost of £21,753.

These two sheds were to accommodate forty engines and the two turntables came from Cowan Sheldon at £517 each, being 42-feet in diameter. These were replaced by 50-foot turntables in 1914 at a cost of £987 10s each. The two new sheds cost £995 2s 8d over budget and were opened in 1876. At the same time that the new sheds were being built, modifications were made to the earlier shed at a cost of £193 6s 3d. Extensions were ordered in August 1911, due to shortage of accommodation and costs were estimated at £70,000, which included £37,950 for the three sheds, £2,940 for Cowan Sheldon 60-foot turntables, and £5,433 for a mechanical coaling plant. There was also a twin-track elevated wheel drop building, with hydraulic lifts to allow wheels to be lowered and run into the fitting shop at ground level; a hot water boiler, washing out plant, a breakdown train shed, stores, offices and mess room. The coaling plant at Dairycoates was the most advanced on the NER and was designed by the CME's department and built by Spencer & Co. Ltd of Melksham at a cost of £5,433 with work beginning in October 1913. The plant came into use on 27 March 1916, and it was demolished in 1967. When opened, some 135 locos were coaled each day, rising to 166 a day ten years later. A water softening plant was installed at Hessle in 1902, as the Yorkshire Wolds gave a high lime content to local water and all of Hull's water passed through the plant, which was doubled in size in 1908, and meant it could handle a million gallons of water per day, making it the largest water softening plant in the country.

At grouping, there were 150 locos allocated to Dairycoates, mostly used on freight, mineral and for shunting. By 1932 the allocation had increased to 175 locos, largely made up of 4-6-os from twenty-two to thirty-four, o-6-2Ts from twenty-nine to thirty-five, and large tanks (4-6-2T and 4-8-oT) from four to ten. At that time, there were also thirty-seven o-8-os and twenty-two o-6-oTs. By 1954, the allocation was down to 129 engines, the thirty-seven o-8-os had been replaced by twenty-seven WD 2-8-os and the thirty-four 4-6-os by twenty-three K3 2-6-os. The numerous J21 o-6-os were replaced by fifteen 4MT ex-LMS 2-6-os. Diesel shunters began to replace steam locos, followed by main line diesels, until June 1967 when Dairycoates lost its last steam engine. On 24 June, B1

4-6-0s Nos 61002, 61255 and 61289, along with WD 2-8-0s 90262, 90265 and 90450 were withdrawn. The following day B1 No. 61306 and WD 2-8-0 Nos 90009, 90378, 90478, 90627, 90677 and 90695 were transferred away. Dairycoates had dead steam locos for a further two years while awaiting cutting up at Drapers scrap yard. On 5 October 1969, Dairycoates lost its main line diesel locos and a year later on 21 October 1970 its remaining locos, class 8 diesel shunters, were transferred to Botanic Gardens and Dairycoates closed as a loco depot.

Hull Dairycoates Allocation for June 1950

LNER Code: HULL D
BR Code: 53A

Ex-LNER B1 4-6-0	61060, 61068, 61074, 61080
K3/K1 2-6-0	61813, 61814, 61819, 61871, 61872, 61874, 61883, 61892, 61899, 61902, 61903, 61920, 61922, 61923, 61927, 61932, 61934, 61935, 61941, 61945, 61965
O1/O4 2-8-0	63603, 63628, 63664, 63673, 63676, 63712, 63732, 63740, 63753, 63754, 63755, 63760, 63764, 63769, 63770, 63772, 63812, 63816, 63823, 63828, 63835, 63845, 63855, 63856, 63857, 63874, 63881
J39 0-6-0	64864, 64867, 64870, 64897, 64914, 64926, 64927, 64928, 64931, 64939, 64941
J25 0-6-0	65647, 65651, 65654, 65663, 65690, 65698, 65699, 65712, 65713
F4 2-4-2T	67171, 67175
Y1 0-4-0T	68137, 68139, 68140
J71 0-6-0T	68232, 68242, 68252, 68277, 68288, 68296, 68298, 68304, 68311, 68316
J72 0-6-0T	68748, 69010, 69011
N10 0-6-2T	69093, 69094, 69096, 69098, 69099, 69102, 69104, 69105, 69106, 69107, 69108
N8 0-6-2T	69377, 69379, 69381, 69382, 69385, 69386, 69389, 69392, 69393, 69398, 69401
A7 4-6-2T	69770, 69771, 69772, 69773, 69775, 69777, 69778, 69779, 69780, 69782, 69783, 69784, 69788

T1 4-8-0T	69912, 69914, 69915, 69921, 69922
WD 2-8-0	90006, 90008, 90009, 90021, 90022, 90057, 90382, 90409, 90450, 90483, 90567, 90663, 90695
	Total: 143

Between February 1940 and mid-1941, a class Y8 0-4-0T No. 559 (built by the NER in 1890 as K class) was loaned to the military railway at Spurn Point from Dairycoates shed, leaving by low loader from Patrington station to Kilnsea. At that time, there was a severe shortage of motive power (only a Hudswell–Clarke railcar was operational) and rolling stock. Plans were underway to upgrade fortifications in the Humber Estuary and there was need to transport heavy guns and construction materials to many of the fortifications around the Spurn peninsula. The Y8 was transported by road to the Spurn Head Railway using a low loader with a Scammel three-wheeled 'Mechanical Horse' at the front end and a modified Fordson at the back. The LNER followed up with three open wagons, two box vans, and a brake van soon afterwards. The loco received the unofficial name *The Black Sapper* and was popular with the railway.

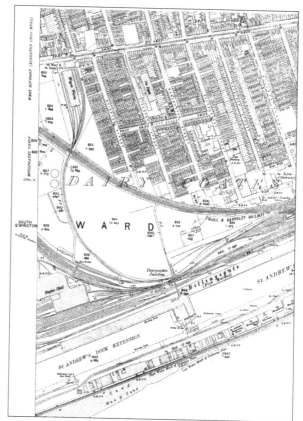

A map showing the locoshed at Dairycoates and a section of the Hull & Barnsley Railway line to its Alexandra Docks and extension. The north side of St Andrew's Dock, seen on the map, had its own fish quays, which in their heyday served some eight daily fish trains. These trains served 1,000 stations and some 4,000 distribution points. The nearby Albert Dock and Riverside Quay were badly damaged during the Second World War and were rebuilt in the 1950s. Shunting locos in the dock areas were usually J72 0-6-0T locos, these working wagons and vans to and from the dock sidings and quays where porters and loaders handled ships' cargoes. (Beverley Record Office)

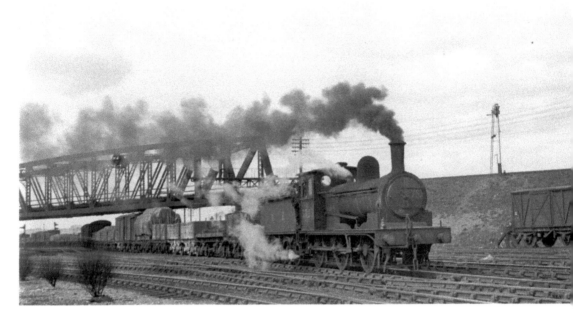

Hauling a mixed freight past Hull Dairycoates is ex-NER class J25 0-6-0 No. 5705, still in wartime livery, on 17 April 1947. These locos were a slightly larger version than the J24s and were built by W. Worsdell between 1898 and 1902. As they were purely freight engine, they were not fitted with continuous brakes. By 1961, some ten examples of the class were still running, but all had gone by 1962. (H. Casserley)

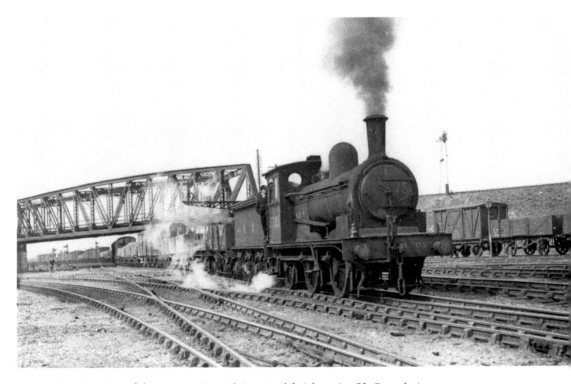

Another view of the same engine with its mixed freight train. (H. Casserley)

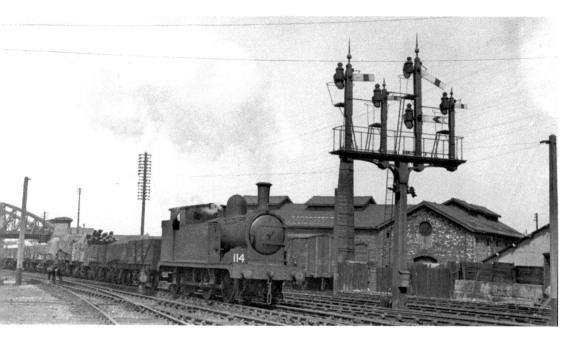

Coming up from the docks is ex-NER class N8 0-6-2T with another mixed freight seen passing Dairycoates. (H. Casserley)

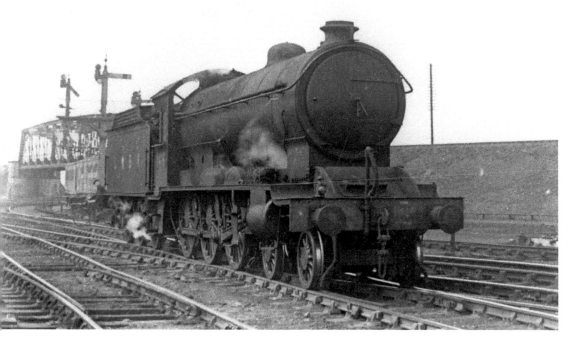

Ex-NER three-cylinder class B16 4-6-0 No. 1416 is seen waiting at the end of Dairycoates locoshed road on 17 April 1947. These engines were a class of some seventy and were built between 1919 and 1924, this one being one of the NER ones, later members of the class being constructed under LNER auspices. Withdrawal of these engines was begun in 1958 and the last survivors had all been scrapped by 1964. (H. Casserley)

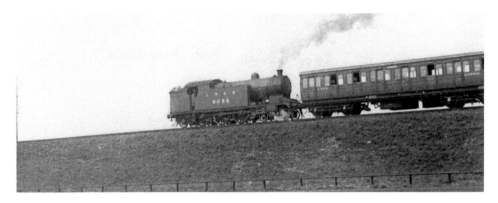

Class A8 4-6-2T No. 9855 is seen on the embankment carrying the old H&B line past Dairycoates with a local train for South Howden. (H. Casserley)

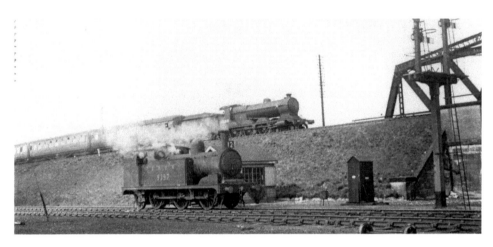

Ex-GCR Robinson B5 4-6-0 with a passenger train on the embankment past Dairycoates on 17 April 1947. Within the next couple of years, this engine, along with the rest of the class, would have gone to the scrap yard. The whole class of fourteen engines was gone by 1950. In the foreground, at the entrance to Dairycoates locoshed is class N8 0-6-2T No. 9397 awaiting its next turn of duty. (H. Casserley)

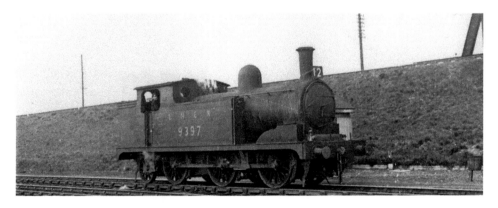

A closer view of No. 9397 at Dairycoates. (H. Casserley)

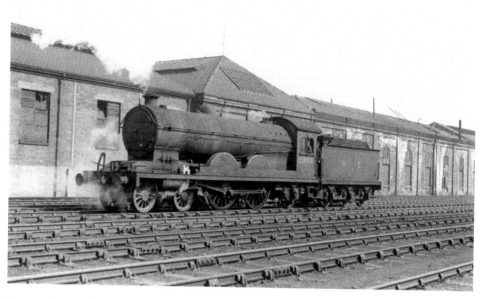

A rare picture of ex-NER Raven class C7 4-4-2 Atlantic No. 2958, still in wartime livery, at Dairycoates shed on 17 April 1947. These locos were originally NER class Z and consisted of fifty engines built between 1911 and 1918. The class was scrapped between 1942 and 1948 and this example never survived long enough to receive its BR number. (H. Casserley)

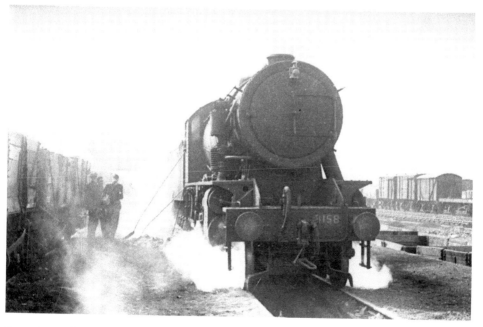

Dropping its fire at Dairycoates shed is ex-Austerity 2-8-0, LNER class 07 No. 3158. The LNER purchased some 200 of these engines after the war, and were allocated in the 60,000 series after nationalisation (this one, therefore, would have been numbered 63158) but they were renumbered into the 90,000 series instead, which included all of these ex-WD engines that came into BR stock in 1948. (H. Casserley)

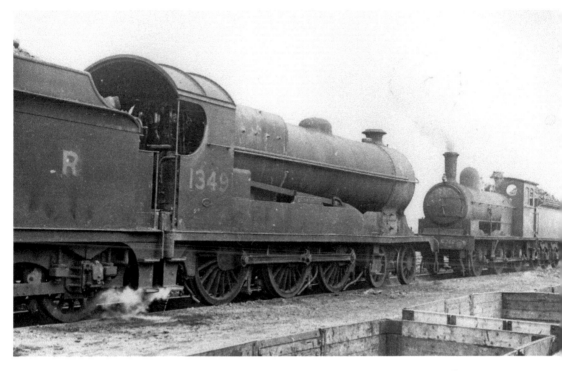

Ex-GCR Robinson class B8 4-6-0 No. 1349 at Dairycoates in 1947 in company with ex-NER J25 0-6-0 No. 5712. (H. Casserley)

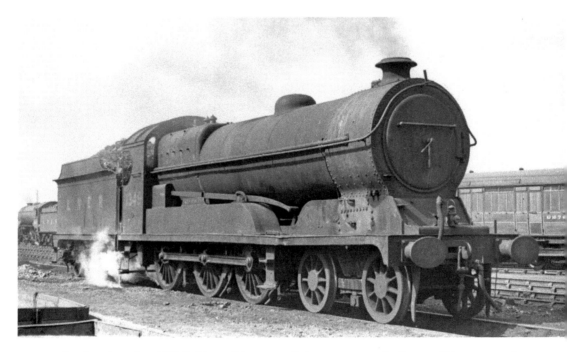

Another view of ex-GCR Robinson B8 4-6-0 at Dairycoates on 17 April 1947. This was one of a class of eleven mixed traffic express engines built for the Great Central between 1913 and 1915 and all had been scrapped by 1949. (H. Casserley)

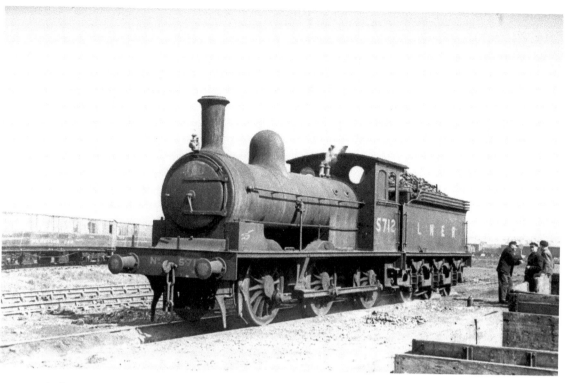

A close-up view of ex-NER J25 0-6-0 at Dairycoates in 1947. (H. Casserley)

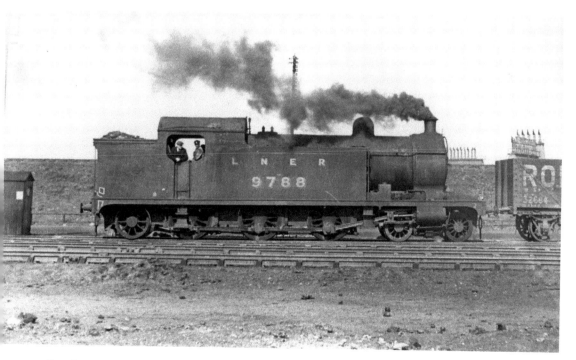

Shunting wagons at Dairycoates is ex-NER class A7 4-6-2T No. 9788, built by V. Raven in 1910/11. All had gone by 1957. This view was taken in 1947. (H. Casserley)

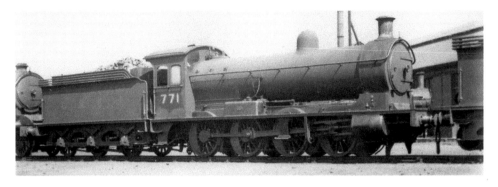

Ex-NER W. Raven, LNER class Q6 0-8-0 No. 771 is seen at Dairycoates shed on 21 June 1931. These locos were built between 1913 and 1921 and featured regularly on heavy freight trains from Hull docks. (H. Casserley)

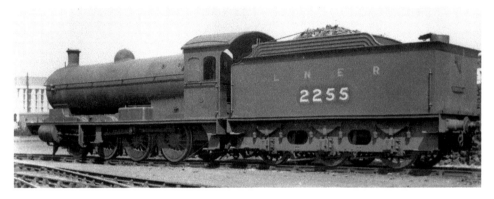

Another Raven Q6 0-8-0, No. 2255 at Dairycoates in June 1931. (H. Casserley)

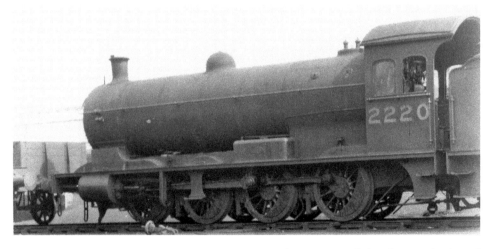

Raven Q6 0-8-0 No. 2220 at Dairycoates in 1931. The majority of the class survived until scrapping began in 1960, a few surviving until 1967 and, along with some J27 0-6-0s, they were the last pre-grouping locos of any railway to remain in service. Indeed, an example of the class has survived into preservation as LNER No. 3395. (H. Casserley)

Inside Dairycoates shed and another Q6 0-8-0, No. 3444 (later BR 63444), is seen at rest on 17 April 1947. (H. Casserley)

Another interior view of Dairycoates shed with ex-NER Worsdell class C6 Atlantic No. 2941 at rest. The engine did not survive to receive its BR number having been scrapped shortly after this view was taken on 17 April 1947. (H. Casserley)

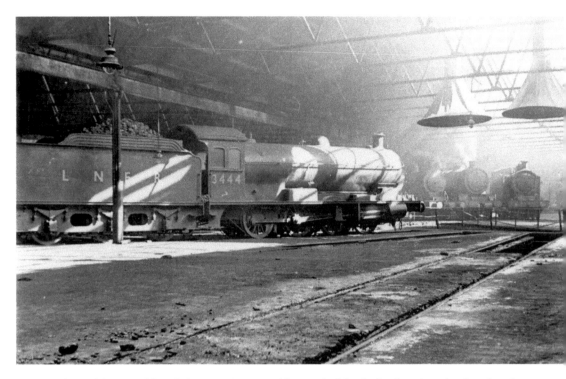

Around the turntable at Dairycoates in 1947 with several of the shed's allocation of tank and tender locos in view. Nearest is Q6 No. 3444. (H. Casserley)

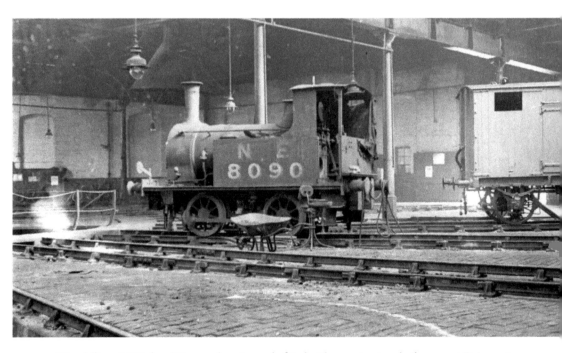

Worsdell's ex-NER class Y8 0-4-0 shunting tank, fitted with a marine-type boiler, seen at Dairycoates shed on 17 April 1947. Only a year later, this engine would be scrapped and her sister engine would become station pilot at York, surviving until 1956. (H. Casserley)

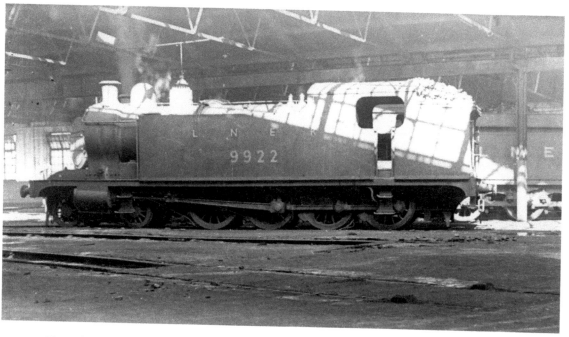

Heavy freight tank class T1 4-8-0T No. 9922 seen at Dairycoates in 1947. This was one of a class of ten engines built for the NER in 1909, with a further five being built under LNER auspices in 1925. Most had gone by the late 1950s. The last survivor, sister engine No. 69921, lasted until 1961. (H. Casserley)

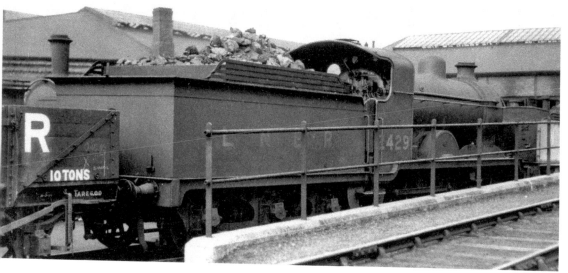

Ex-H&B 0-6-0 No. 2429 is seen at Dairycoates shed on 21 June 1931. After the H&B had been taken over by the NER and then absorbed into the LNER, many of the old H&B 0-6-0 and 0-8-0 locos found their way into unknown territory. Some were allocated to places like Whitby and to various sheds in Hull itself. (H. Casserley)

Above and below: Two views of the Alexandra Dock, Hull, on 13 October 1963. The old 0-6-0 shunting tanks of the NER/LNER/BR have now been replaced by class 08 diesel shunters. (R. Carpenter)

The old H&B locoshed at Springhead as it appeared on 13 October 1963. The shed here housed heavy freight locos as well as shunting tanks and passenger engines during its lifetime, but most of its allocation was freight locos. Coded 53C in early BR days, the shed had an allocation of some fifty-five engines in 1950, including J25 0-6-0s, J72, J73, and J77, 0-6-0Ts, N13 0-6-2Ts, A7 4-6-2s, and ex-WD 2-8-0s. The shed became coded 60B in 1960 and closed in 1961. (R. Carpenter)

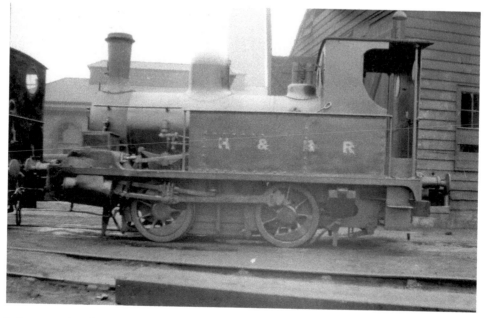

Before transfer of ownership to the NER in 1922, a little 0-4-0T dock shunter sits outside the H&B dock shed at Alexandra docks. These engines were replaced by NER 0-6-0Ts in LNER days. (LOSA)

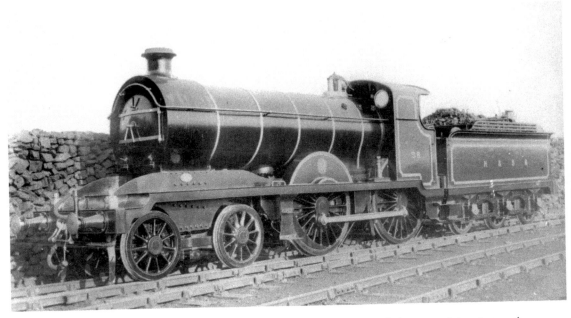

Stirling-built H&B 4-4-0 loco No. 38 at Springhead shed at around the turn of the nineteenth century. These 4-4-0 engines were built for new services between Sheffield and Hull over H&B metals, although it was not a great success. A feature of H&B locos were their domeless boilers, Matthew Stirling following the practice of his uncle on the GNR. (LOSA)

Last of the H&B 0-6-2Ts, No. 69114, inside the roundhouse at Springhead locoshed in 1954. The engine was a member of the N13 class, built between 1913 and 1914; this last member would be scrapped two years later in 1956. The original Stirling domeless boiler was replaced by a domed LNER type in the 1930s. (LOSA)

FOUR

HULL–BRIDLINGTON

A line linking Hull and Bridlington had been planned as early as 1834, when a proposal was made for a route from Bridlington Quay to the Leeds & Selby Railway, but this project came to nothing. However, by 1845/46 lines approached Bridlington from both Hull and Scarborough. The lines from Hull and from Seamer (where a connection was made with the York–Scarborough main line for access to the seaside town) to Bridlington were both authorised on 30 June 1845. The Y&NMR promoted the section from Seamer to Bridlington while the Hull & Selby Railway promoted the Hull–Bridlington section, both lines making a head-on connection at the seaside town, and giving Hull direct access to Scarborough and connections to York. By the time construction was underway, the Hull and Selby had become part of George Hudson's Y&NMR.

The two lines were built quickly, the Hull–Bridlington section being opened on 6 October 1846, a day after the Seamer–Filey section was opened, with due ceremony and a 'sumptuous luncheon' which befitted any extension of the Hudson Empire. It would take another year before the line from Bridlington to Filey was completed, due to more difficult terrain being encountered through which the 13½-mile section ran, and it was not opened until 20 October 1847.

The Hull–Bridlington railway was originally planned as a single-track line, but was completed as double track by Messrs Jackson & Bean, who also installed the new electric telegraph system. The route itself runs through rather flat terrain and there were several level crossings provided, the crossing keepers' cottages being built by the Y&NMR. Many are now privately owned homes.

Traffic in the early years was mostly agricultural, with very few passenger trains. By 1910, there were six through trains between Hull and Scarborough, most stopping at all stations and taking around 2½ hours to cover the 53¾ miles. There was also a non-stop service between Hull and Bridlington, the 30¾ miles taking 40 minutes, this train leaving Hull at 5.30 p.m. A further train left Hull at 4.50 p.m. for Scarborough, calling only at Filey, arriving at its final destination at 6.05 p.m. A semi-fast train left Hull at 4.55 p.m., called at Cottingham, Beverley, Driffield, Bridlington, Flamborough, Hunmanby, and Filey, arriving Scarborough in 1 hour 38 minutes. On Saturdays, this train stopped at Bempton

and Speeton on request. On Sundays there was a 7 a.m. train from Hull and a 5 p.m. from Scarborough, calling at all stations and taking 2 hours 25 minutes for the journey. As tourism grew in the area, services increased accordingly over the years and were supplemented by excursion and holiday trains during the summer months, fully justifying construction of the line.

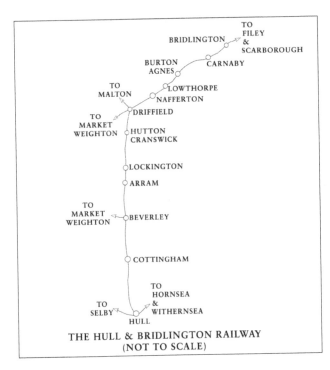

THE HULL & BRIDLINGTON RAILWAY
(NOT TO SCALE)

Left: A map of the Hull & Bridlington Railway. (Author)

Below: Leaving Hull Paragon station in 1963 is Thompson B1 4-6-0 No. 61406 at the head of an express. The loco was built at Darlington and entered traffic under BR auspices on 20 May 1950. The engine was allocated to Immingham from 21 May 1950 and transferred to Doncaster from 6 February 1966. Therefore, at this time, the engine was still based at Immingham and could well have been at the head of a holiday train to Filey Camp, Bridlington or Scarborough. The loco was condemned and taken out of traffic on 17 April 1966, a little over two months since its move to Doncaster, and was sold to George Cohen Ltd of Kettering and scrapped one month later. (R. Carpenter)

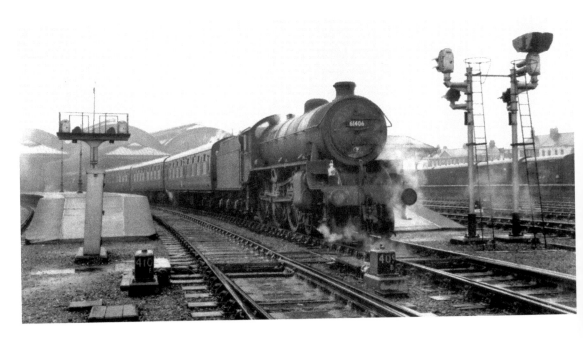

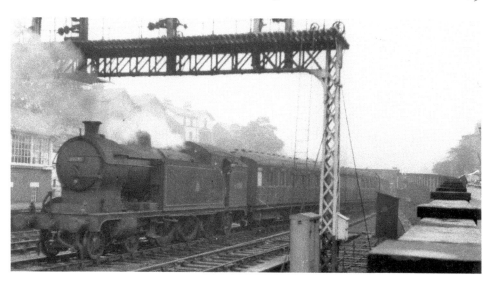

Ex-LNER A8 4-6-2T No. 69881 of Scarborough shed (50E) is at the head of a local train between Hull and Scarborough during 1954. (LOSA)

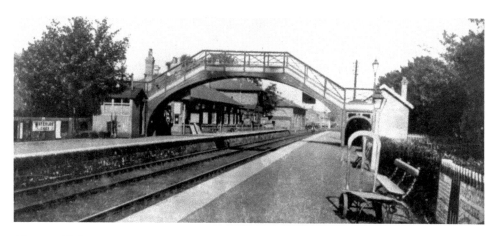

Above and below: From Hull, the first station heading towards Bridlington is at Cottingham. These two views, looking north, show the station in NER days and in 1956, under BR ownership. (LOSA & H. Casserley)

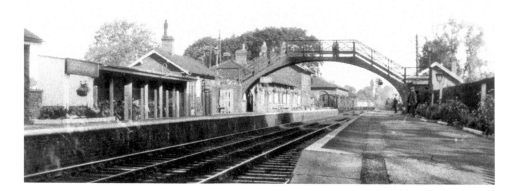

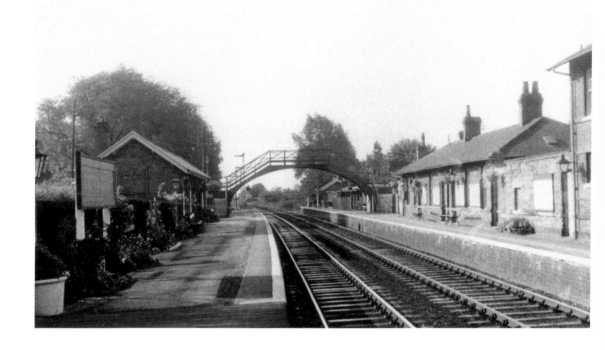

Above: Cottingham station facing south on 31 August 1956. (H. Casserley)

Left: A 1910 timetable for services operated by the NER between Hull, Bridlington and Scarborough. (Author)

HULL, DRIFFIELD, BRIDLINGTON, FILEY, and SCARBOROUGH.—North Eastern.

a Stops on Saturdays when required to set down from Bridlington and beyond.
b Set down when required from York, Selby, and beyond.
b Leaves at 1 50 aft. on Tuesdays.
c Stops when required to set down from Driffield and beyond.
d Stops if required to take up for Bridlington and beyond.
g Sets down only.
* 2¼ miles to Flamborough Village, and 3¼ miles to Flamborough Lighthouse or the North Landing.

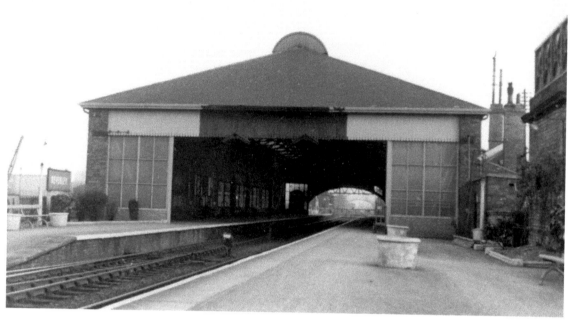

A 1953 view of Beverley station, which serves the county town for the East Riding, the structure representing the importance of the town. In pre-railway days, however, Beverley was an isolated place, except in relation to Hull, 8 miles to the south. In 1834, there were seven daily stagecoaches to Hull, two to Scarborough, and three to York. When proposals were drawn up to build the railway from Hull to Bridlington, the project was supported by Beverley, at a time when the town was stagnating. Once the line was opened, Beverley began to prosper and is still successful today, and, incidentally, the town is still served by the railway with daytime trains calling at Beverley station every half hour. (H. Casserley)

BEVERLEY and HULL.—North Eastern.

Miles	Down.		Week Days.
		mrn mrn mrn mrn mrn mrn mrn mrn aft aft aft aft aft aft aft aft aft aft	
	Beverley..........dep.	6 10 6 50 7 15 7 57 8 33 9 4 9 50 10 15 1045 1127 1233 1 13 1 42 2 0 2 36 3 6 3 32 4 8 0 4 9 4 29 5 37 5 50	
4¼	Cottingham........[765	6 17 6 57 7 22 8 4 8 41 9 11 9 57 10 23 10521241 1 20 1 49 2 7 2 44 3 13 3 39 4 8 7 4 16 4 36 5 44 5 57	
8¼	Hull* 768, 773, arr.	6 27 7 8 7 33 8 16 8 53 9 24 10 8 10 33 11 3 1143 1251 1 33 2 0 2 18 2 54 3 24 3 50 4 18 4 27 4 47 5 54 6 8	

	Down.	Week Days—*Continued.*		Sundays.
		aft aft aft aft aft aft aft aft mrn aft aft	aft aft aft	
	Beverley..........dep	6 25 7 8 7 58 8 27 8 52 9 2 9a37 1036 1055 9 28 2 56 6 53	7 12 9 21 10 0	
	Cottingham...........	6 32 7 16 8 5 8 34 8 599a44....11 3 9 35 3 37 0	7 19 9 28 10 7	
	Hull* 768, 773, 765 arr	6 43 7 28 8 16 8 45 9 10 9 15 9a55 1051 1113 9 45 3 13 7 10	7 29 9 38 10 17	

a Runs 8 minutes later on Saturdays. *s* Saturdays only. * Paragon Station; nearly 1 mile to Cannon Street Station.

Above and below: Timetables for NER trains between Beverley and Hull in 1922. (Author)

HULL and BEVERLEY.—North Eastern.

Miles	Up.		Week Days.
		mrn mrn mrn mrn mrn mrn mrn mrn mrn mrn mrn aft aft aft aft aft aft aft aft aft	
	Hull (Paragon).....dep.	5 40 5 47 7 34 7 55 8 28 25 8 53 9 35 1018 11 0 1138 12 5 1 0 1 2½2 10 2 25 3 0 3 15 4 0 4 25 5 10 5 45	
4¼	Cottingham............	5 49 6 55 7 43 8 4 8 11....9 2 9 43 1026 11 9 1147 1213 1 9 3 3 2 19....3 84 9 4 34 5 18 5 54	
8	Beverley............arr.	5 57 7 6 7 51 8 12 8 19 8 37 9 10 9 53 1036 1117 1155 1224 1 17 4 42 2 9 2 38 3 19 3 28 4 17 4 42 5 27 6 2	

	Up.	Week Days—*Continued.*		Sundays.
		aft aft aft aft aft aft aft	mrn mrn aft aft aft	
	Hull (Paragon).....dep.	6 57 10 7 25 8 25....9 10 1020 11 0	7 0 9 0 10 25 2 27 5 50 9 30	
	Cottingham...........	6 14 7 19 7 34 8 34....9 19 1028 11 8	7 9 9 8 10 34 2 35 5 58 9 38	
	Beverley............arr.	6 22 7 27 7 42 8 44....9 27 1034 1119	7 17 9 19 10 41 2 46 6 8 9 50	

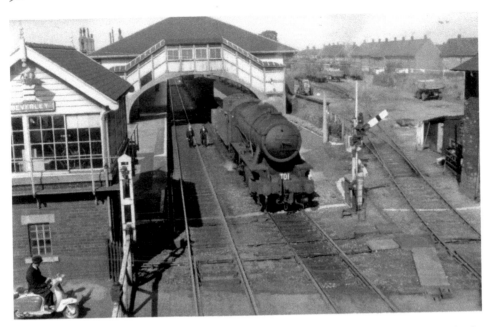

The Hull end of Beverley station in August 1966 with ex-WD 2-8-0 No. 90680 shunting in the station and yard. Along with the Hull and Bridlington services, Beverley station was also at the junction of a branch to Market Weighton, via Cherry Burton, giving access to Selby and the Scarborough–York main line, via the branch from Londesborough and Earswick. (R. Carpenter)

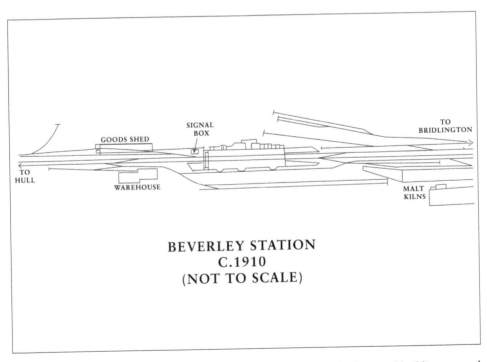

A plan of Beverley station from around 1910, showing the complex of sidings and buildings around it, and giving an idea of the importance of the town. It is interesting to note that access to Beverley station involves passing through three level crossings. (Author)

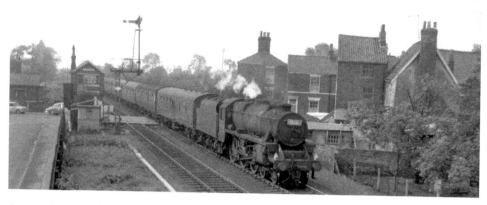

Approaching Beverley is a 'foreign' loco in the shape of ex-LMS Stanier Black Five 4-6-0 No. 44732 passing Flewingate level crossing at the head of a Bradford–Bridlington Saturdays-only excursion on 18 June 1966. While the bulk of motive power passing through Beverley in the 1950s and '60s was usually made up of B1s, B16s 4-6-0s, 049 4-4-0s, K3 2-6-0s, and the odd V2 2-6-2, during the summer months several locomotive types from other regions appeared on special holiday trains and excursions, including ex-LMS Black Five and Jubilee 4-6-0s, Stanier 8F 2-8-0s and even the odd Fowler 0-6-0 operating between Chesterfield and Scarborough. As steam declined in the mid-1960s, even some ex-LMS rebuilt Royal Scot 4-6-0s began to appear. (R. Carpenter)

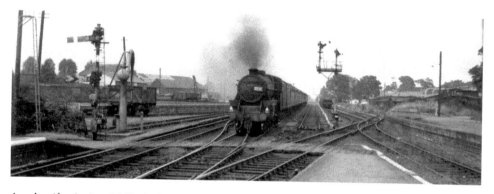

Another 'foreign' ex-LMS Black Five, No. 45385, is approaching Beverley station at the head of a summer excursion in 1966. (R. Carpenter)

A 1910 NER timetable for local services between Hull and Beverley. In these NER days, there was little alteration to local services between the two important destinations over the years. (Author)

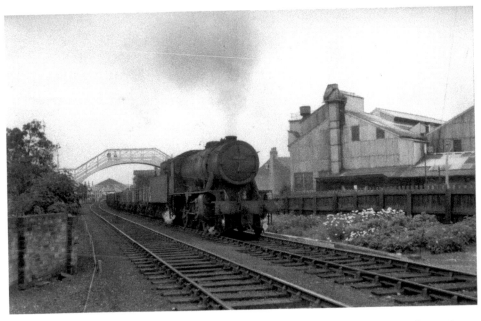

Ex-WD 2-8-0 No. 90352 is approaching Flewingate level crossing after passing Beverley station at the head of a mineral train in 1965. On 14 September 1962, a survey was made of traffic at Beverley station, the result being that a healthy number of passengers were using the station, an average of some 1,419 each weekday, with the average number of trains being 69. (R. Carpenter)

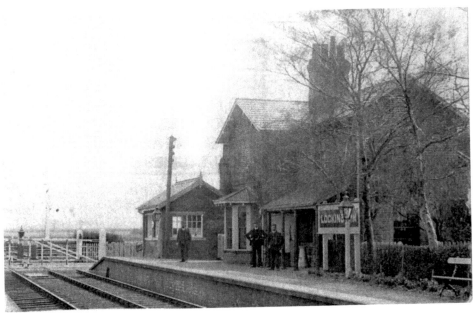

After leaving Beverley, the line passed through Arram station, which was close to RAF Leconfield and over the years the station was used by servicemen and women who were based there. Before the Hull–Hornsea branch was built, plans had been drawn up for a line linking Hornsea with the Hull–Bridlington route at Arram. From Arram, the line then reached Lockington, seen here in NER days with its main building and signal box next to yet another level crossing. (Beverley Record Office)

Another view of Lockington station in NER days. The station survived into BR days, but was an early closure, even before Dr Beeching made his infamous recommendations, and passenger traffic ceased in 1960. Lockington, however, was the scene of an accident on 26 July 1986, when a van was driven through the automatic level crossing into the path of the 09.33 Bridlington–Hull DMU, which was derailed and badly damaged. Nine people were killed, eight of whom were passengers on the train. On the right of this picture is the wooden goods shed, reputed to be the old Hull Drypool engine shed which was removed here in 1866. (Beverley Record Office)

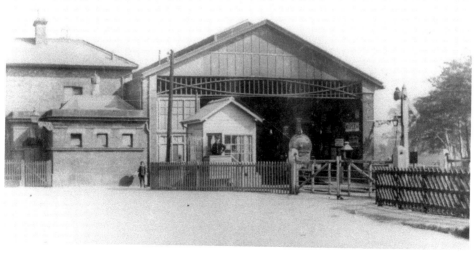

From Lockington, the line passes through Hutton Cranswick before entering the important junction station serving the market town of Driffield. Driffield station is seen here with an NER loco waiting at the station with a passenger train. The station was designed by Y&NMR architect George Andrews and had an overall roof, as seen in this view. The roof has long since gone and canopies protect the platforms, although the original buildings are still inexistence. (LOSA)

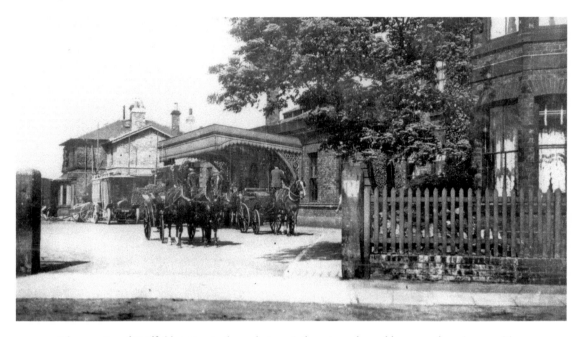

The exterior of Driffield station in the early twentieth century showed horses and carriages waiting at the main entrance, while an early motor car van waits in the background. The station here was important as it not only served the Hull–Bridlington line, but was also the terminus of the line from Selby, via Market Weighton, and the branch between Garton and North Grimston, via Sledmere & Fimber, close to Sledmere House and its royal connections. (LOSA)

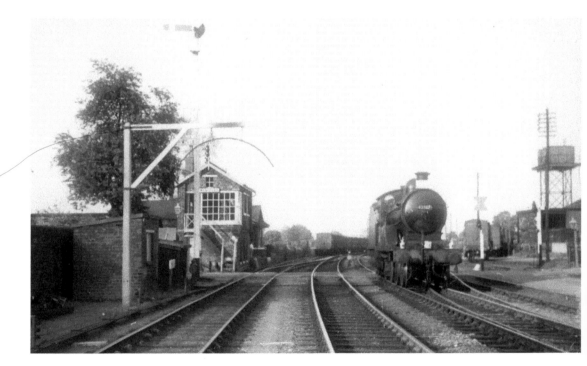

Ex-NER class D20 4-4-0 No. 62387 runs around its excursion train from North Grimston on 2 June 1957. The NER signal box can be seen on the left and the sidings on the right. (H. Casserley)

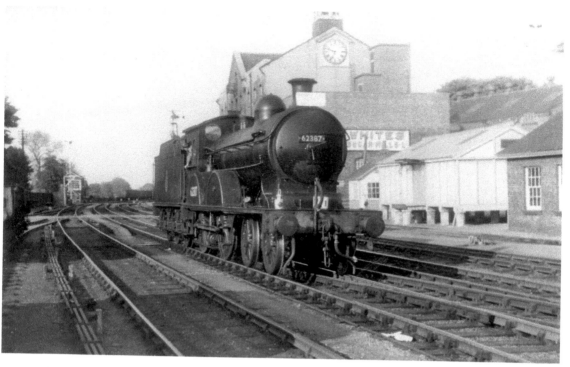

A closer view of 62387 at Driffield station on 2 June 1957. The loco is running past White's sugar mill, now a distant memory. (H. Casserley)

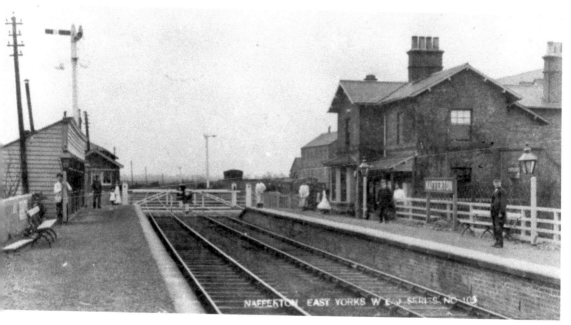

After leaving Driffield, the line passes through Nafferton station, again seen in NER days and complete with ubiquitous level crossing. The main station building is on the right and provides a stark contrast to the simple wooden waiting shelter on the left. Just beyond the level crossing is the small signal box. (LOSA)

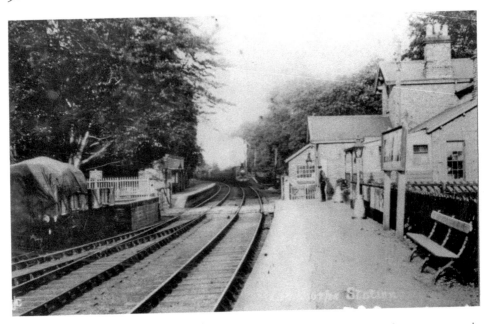

From Nafferton, the line passed through the little station at Lowthorpe, seen with a passenger train approaching. An unusual feature of the station are the staggered platforms, connected by a wooden walkway across the railway tracks. (LOSA)

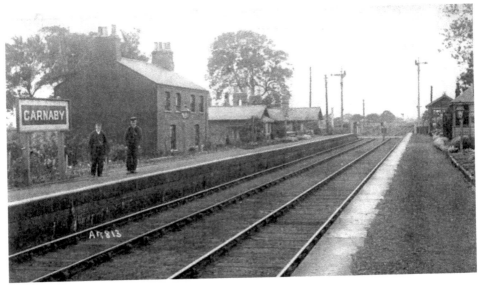

After Lowthorpe came the station at Burton Agnes, with the stately home of Burton Agnes Hall (a GWR Modified Hall class 4-6-0 was named after the hall) close by, followed by Carnaby station – its simple structure in view. In 1968, plans were announced for closure of the line from Seamer to Hull and a public inquiry showed that there were 3,444 objections, including fourteen local authorities, and figures showed that up to 2,300,000 passenger journeys were made each year, covering a total of some 44,000,000 miles. The Minister of Transport, Richard Marsh, was convinced by the arguments put forward, and on 29 July 1969 refused closure, but allowed closure of the stations at Lowthorpe, Burton Agnes and Carnaby, between Hull and Bridlington, the last passenger trains calling in that year. (Beverley Record Office)

An LNER poster advertising the delights of the seaside at Bridlington, which was effective in attracting visitors to the town, the majority using the railways to reach their holiday destinations. (Author)

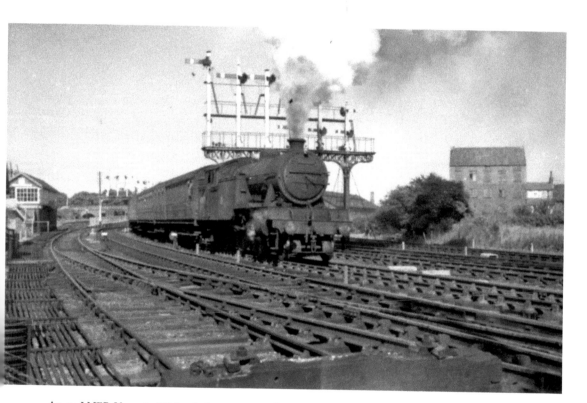

An ex-LNER V3 2-6-2T No. 67677 passes Bridlington South signal box with a local train around 1959. In those days, the station was quite busy, as a survey of 14 September 1949 reveals:

Average Daily Passenger Numbers: 222
Bank Holiday Traffic Nos: 5192
Midweek Summer Traffic: June 860, August 2,895
Weekend Bookings from Hull, Beverley and Driffield: Saturdays 130, Sundays 419

(R. Carpenter)

Summer Traffic at Bridlington, 1959

Whit Monday 18 May 1959

09.50 Hull–Scarborough

09.55 From Normanton

10.05 From Leeds

10.15 From Leeds

10.22 Hull–Scarborough

10.37 Hull–Scarborough

10.45 From York

10.53 From Wakefield Westgate

11.00 Heath–Scarborough

11.08 From Rothwell

11.18 York–Filey

11.25 Hull–Scarborough

11.35 From Rotherham Masborough

11.50 From Armley Moor

11.57 From Leeds

12.05 Retford–Scarborough

12.16 From Huddersfield

12.25 From Kippax

12.33 From Selby

12.40 Hull–Scarborough

12.47 From Wadsley Bridge

13.02 From Wadsley Bridge

13.14 From Leeds

14.10 From Leeds

14.25 From Moorthorpe

14.37 From Bradford Forster Square

14.44 From Guisley

15.00 From Sheffield Victoria

Saturday 20 June 1959

Northbound Traffic through Bridlington	Southbound Traffic through Bridlington
06.21 Hull–Scarborough	06.25 Bridlington–Hull
06.52 Hull–Bridlington	07.15 Bridlington–Hull
08.40 Hull–Scarborough	07.35 Bridlington–Selby
09.27 Hull–Filey Camp	08.00 Bridlington–Hull
09.34 Bolton-on-Dearne–Scarborough	08.11 Scarborough–Hull
09.46 Hull–Scarborough	08.52 Scarborough–Hull
09.52 From Laisterdyke	09.07 Scarborough–Hull
10.12 Rotherham Central–Bridlington	09.25 Filey Camp–Newcastle
10.20 Sheffield Midland–Scarborough	09.48 Filey Camp–Kings Norton
10.30 Selby–Bridlington	09.56 Filey Camp–York
10.40 From Otley	10.08 Filey Camp–Sheffield Victoria
10.50 From Dewsbury Central	10.33 Filey Camp–Leeds
10.58 Hull–Scarborough	10.49 Scarborough–Manchester London Road
11.05 Sheffield Victoria–Bridlington	10.55 Bridlington–Hull
11.18 Leeds–Bridlington	11.33 Filey Camp–Manchester Victoria
11.23 From Laisterdyke	11.50 Filey Camp–King's Cross
11.28 Bradford Exchange–Bridlington	12.04 Scarborough–Hull
11.37 Hull–Scarborough	12.24 Scarborough–Hull
11.44 Oldham Clegg St–Filey Camp	12.38 Scarborough–Leicester Central
12.08 Leeds–Filey Camp	12.45 Bridlington–Leeds
12.12 Oldham Clegg St–Scarborough	13.25 Bridlington–Rotherham Central
12.25 Manchester Exchange–Filey Camp	13.33 Bridlington–Sheffield Victoria
12.33 Leicester Central–Scarborough	13.42 Scarborough–Hull
12.41 Sowerby Bridge–Scarborough	14.00 Bridlington–Leeds
12.54 From Bradford Exchange	14.20 Bridlington–Bradford Exchange
13.00 Sheffield Victoria–Filey Camp	15.40 Scarborough–Hull
13.09 Hull–Bridlington	16.50 Bridlington–Hull
13.25 King's Cross–Filey Camp	1723 Scarborough–Hull
13.35 Hull–Scarborough	18.15 Return to Bradford Exchange

13.45 Liverpool Exchange–Scarborough

13.55 Manchester London Rd–Scarborough

14.12 Newcastle–Filey Camp

14.38 Hull–Bridlington

14.56 Hull–Scarborough

15.24 Leeds–Bridlington

16.04 Gloucester Eastgate–Filey Camp

16.32 Hull–Scarborough

16.40 York–Filey Camp

17.38 Hull–Bridlington

18.15 Hull–Bridlington

18.47 Hull–Scarborough

19:38 Hull–Bridlington

20:30 Hull–Bridlington

21.15 Hull–Bridlington

22.44 Hull–Bridlington

18.25 Bridlington–Hull

18.35 Return to Dewsbury Central

18.50 Scarborough–Hull

19.00 Return to Otley

19.08 Scarborough–Hull

19.22 Bridlington–Market Weighton

19.40 Return to Laisterdyke

19.50 Bridlington–Leeds

20.20 Bridlington–Hull

20.30 Return to Laisterdyke

21.14 Scarborough–Hull

The tables give some idea of just how busy the Hull–Bridlington line and Bridlington station would be during the summer, the railway still being the most important means of travel to the seaside.

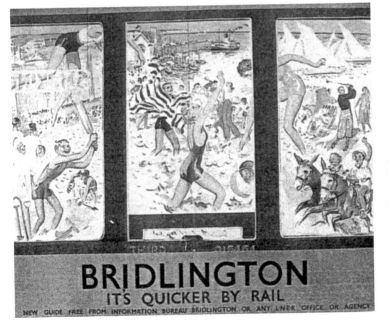

Another poster advertising Bridlington as a seaside destination, emphasising that it would be quicker to travel here by train via the LNER. (Author)

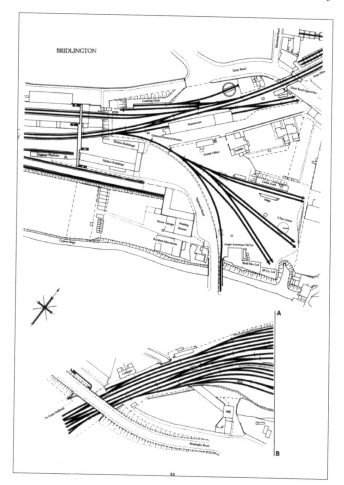

Right: A plan of Bridlington station in the 1950s, showing part of the main station and sidings. (Author)

Below: The western section of Bridlington station with locoshed and coal depot in view. (Author)

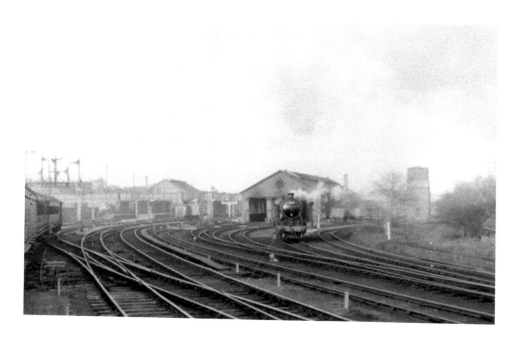

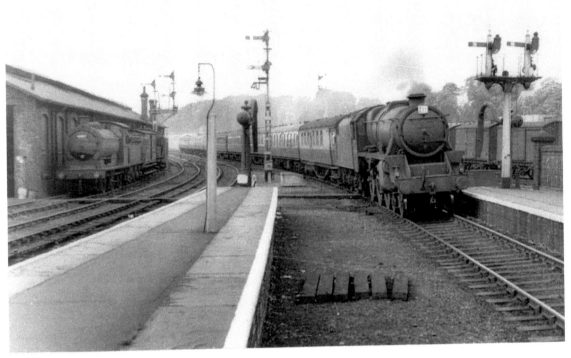

Approaching the western end of Bridlington station is an unidentified ex-LMS Black Five 4-6-0 at the head of a train, probably from the north-west of England to Butlin's Holiday Camp at Filey in the 1950s. To the left is Bridlington locoshed with an unidentified 0-6-0 ex-LNER loco at the side. (Crimlisk-Fisher Archive, Filey)

A shed had almost certainly existed at Bridlington since the line to Hull had been opened in 1846. In 1875, a new shed was authorised to be built at the 'end of the present shed' and a tender of £522 was accepted for the work. In June 1892, a tender of £3,439 was accepted for a three-road locoshed, to hold nine engines, and a new turntable was ordered from Cowan Sheldon at a cost of £385. It was this building (seen in the previous photograph) that remained in use until closure in 1958. The shed, sidings, and turntable were abandoned in October 1968, but the approach road was left *in situ* to provide a shunting neck for the Up sidings. Workings from the shed were mostly passenger trains to Hull, Scarborough, and Leeds. Before the First World War, class 901 and class 1265 2-4-0s were used. From 1914, class G 4-4-0s were in charge of such services, these being replaced by seven – later eight – of the larger class F (LNER D22) until 1925, when they were replaced by class M (LNER D17/1) 4-4-0s. The following year, Smith three-cylinder compound No. 1619 went to Bridlington until withdrawal in October 1930. The D17s proved to be popular with loco crews. In 1934, two new D49/2 Hunt class 4-4-0s arrived at Bridlington from Darlington works; Nos 230 *The Brocklesby* and 238 *The Burton*. These, however, were replaced in 1935 by older D49/3 4-4-0s, Nos 318 *Cambridgeshire* and 335 *Bedfordshire*. In 1939, six C6

4-4-2s went to Bridlington, five in June (Nos 700, 742, 784, 1776, and 1792) and one (1794) at the end of July. They were not liked by Bridlington crews and left some eighteen months later. Also, two LNER D20 4-4-0s, Nos 1234 and 2016, joined the Atlantics. The six Atlantics were replaced by two D20s, Nos 2024 and 2101, as passenger services were curtailed following the outbreak of Second World War.

Also, in the 1930s Bridlington shed had Sentinel steam railcar *Criterion* allocated for local services to Market Weighton. In 1949, D49 Nos 62701 and 62707 came to Bridlington from Botanic Gardens, followed in 1950 by 62703 and 62750 from Hull and 62766 from Gateshead, these working all passenger services until displaced by DMUs in September 1957. Bridlington shed had an allocation of two Sentinel shunters in the 1930s – No. 174 for shunting locally and No. 100 for shunting at Driffield each day. As two men were required on the footplate when going to Driffield, the shunter was trained to ride with the driver, and shunted at the intermediate stations at Carnaby, Burton Agnes, Lowthorpe and Nafferton. These Sentinel shunters were replaced in the 1950s, first by N8 0-6-2T No. 69378, and later by two G5 0-4-4Ts Nos 67280 and 67341; these were the last two locos allocated to Bridlington shed, transferred away on 8 June 1958. The shed did not actually close until 1 December 1958 and for a few years after it provided watering and stabling facilities for engines working summer excursions to the coast. None of these engines, however, were stabled overnight.

The allocation for June 1950 gives an idea of the types of locos at the shed:

LNER Code: BRID
BR Code: 53D

Ex-LNER D20 4-4-0	62353, 62355, 62365, 62375
Ex-LNER D49/1 4-4-0	62701 *Derbyshire* 62707 *Lancashire*
Ex-LNER D49/2	62750 *The Pytchley* 62766 *The Grafton*
Ex-LNER Y1 0-4-0T	68148
Ex-LNER Y3 0-4-0T	68155
	Total: 10

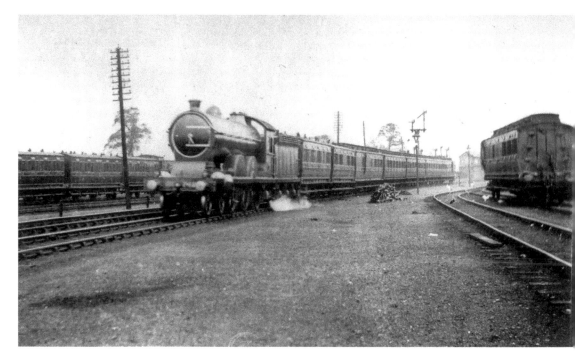

Ex-NER, LNER C6 4-4-2 Atlantic loco No. 742 at the head of a passenger train. This is an example of one of the six C6 Atlantics, which were allocated to Bridlington shed for eighteen months from June 1939. (LOSA)

Ex-LNER class L1 2-6-4T No. 67755 is seen at the south end of Bridlington station as it awaits its turn of duty on 27 April 1954. In the background is the corn mill, which survived in a derelict state until it was recently demolished. (H. Casserley)

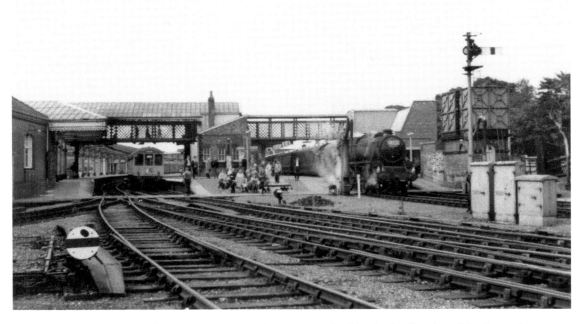

A busy scene at Bridlington station on 26 August 1967. Looking in the direction of Scarborough, the station appears very busy with an excursion train, probably for Leeds, waiting to depart with an ex-LMS Stanier Black Five 4-6-0 at the head. On the left, the replacements for steam traction on local services, a DMU, arrives with a local train for Hull. (H. Casserley)

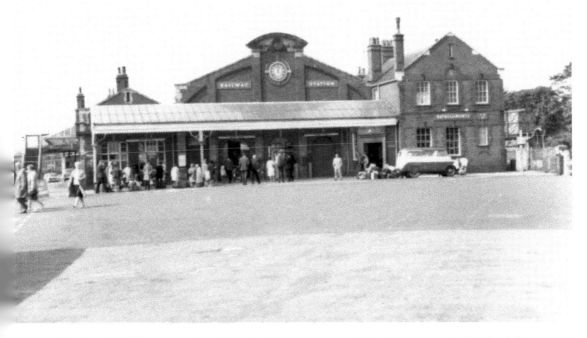

Exterior of Bridlington station during the busy summer period, 26 August 1967. Much of this handsome structure is still *in situ* and maintains its role serving locals and visitors to Bridlington in the summer months. (H. Casserley)

FIVE

HULL–DONCASTER

On 30 July 1869 the NER opened a line between Thorne, Goole and Staddlethorpe, which created a through route for Hull–Doncaster trains. Prior to the opening of this new route, trains for the south ran via Milford Junction. So busy did this line become that, by the start of the twentieth century, it had to be upgraded between Hessle East and Staddlethorpe to four tracks. Widening took place in 1904, involving alterations to the layouts of several stations. Hessle, Ferriby, Broomfleet, and Staddlethorpe had new platforms on the outer slow lines, with Brough having platforms on all four lines. As the major part of the work took place on the south side of the track layout, it allowed some of the earlier buildings to be retained on the north (Down) side.

The Hull freight yards were situated between Dairycoates and Hessle, with Inward and Mineral Yards developed in 1904. The Priory extension was on the north (Down) side of the main line, while the Outward Yard was on the Up (south) side. In 1907, authority was given for rearrangement of the railway entering Hull from the west. This involved construction of a 179-foot-span girder bridge over lines connecting the yards to the north and south of the passenger line. By December 1935, a new Inward Yard opened, equipped with a hump, wagon retarders, floodlights, and a control tower. Each of the six reception roads could hold 100 wagons and the thirty sidings offered a total capacity for 3,000 wagons. This new yard lasted until 1984, and was closed in March of that year following a decline in freight traffic since the Beeching years, when there was a drastic reduction in rail freight traffic from Hull's docks in favour of road haulage. This led to gradual closure of the city's goods yards.

As with most major cities, growth in the population of Hull led to more affluent families moving out to the suburbs. By the end of the 1920s, a suburban rail service was required. The LNER introduced a half-hourly service between Hull, Hessle, Ferriby and Brough from 8 April 1929. The line remained busy even into BR days, with an average of 122 passenger trains and over eighty freight trains per day in the 1950s. Indeed, signal boxes were constantly manned on a three-shift system. The line is still open, though some rationalisation has been undertaken, including removal of some sections of track and closure of signal boxes. Many stations have also become unmanned halts.

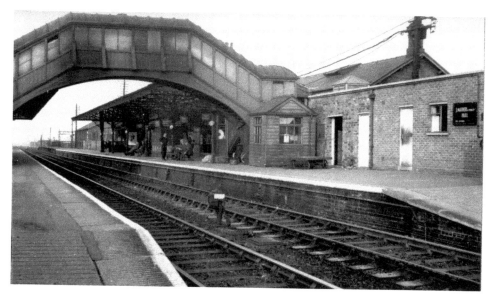

The 1869-built NER station at Goole. It was, in fact, the Lancashire & Yorkshire Railway that reached Goole first when its line from Wakefield was completed and opened on 29 March 1848. A port at Goole had been in existence since the late seventeenth century and the Knottingley & Goole Canal Company reached the port in July 1825, although it would take another year to complete the basin here. A proposal for a railway was first offered by the Stockton & Darlington Railway very soon after opening, but nothing came of it and not until 1845 did Parliament give approval for the Wakefield, Pontefract & Goole Railway. This line was to form a junction with the Manchester & Leeds Railway at Wakefield then pass through Featherstone, Pontefract, Knottingley, and Snaith before reaching Goole. Construction began on 24 September 1845 and progress was steady. The WP&GR was absorbed into the L&YR before the line was completed. At Goole, the L&Y terminus was alongside the Railway Dock where two long platforms were built close to St John's Street, the platforms were covered with a 100-foot-long overall roof. (R. Carpenter)

A 1950s advertisement for the docks at Goole and Hull. With the arrival of the L&YR at Goole, the port expanded rapidly, despite the fact that the port was some fifty miles from the North Sea, and vessels had to use a difficult channel up the River Ouse. The most important traffic dealt with at Goole was coal (the L&YR serving the West Riding coalfields) and one dock alone was designed to handle a million tons a year. The port also handled general cargo. The L&YR also operated its own fleet of steamships to Rotterdam, Amsterdam, Antwerp, Ghent, Dunkirk (now there's a famous name), Hamburg and Copenhagen, 1908 fares being between £1 and £3 a return. (Author)

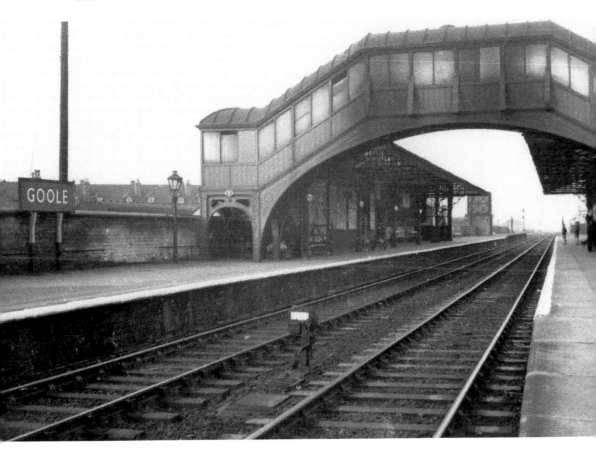

Another view of the NER station at Goole. The NER obtained an Act to construct a railway between Staddlethorpe and Thorne (providing a through route between Hull and Doncaster) after the South Yorkshire Railway (later the Manchester, Sheffield & Lincolnshire Railway, which was to become the Great Central Railway); the L&YR wanted rail access to Hull and the NER wanted a shorter route. Thus, separate Bills were introduced to Parliament, all seeking powers to build lines to Hull. None succeeded and, in October of the same year, the three companies agreed that the NER should promote a Bill seeking powers to build its line between Staddlethorpe and Thorne. The Act was obtained on 28 July 1863, the GCR and L&YR having access to Hull by means of running powers between Thorne and Hull (GCR) and Goole and Hull (L&YR), the NER obtaining running powers over the GCR route between Thorne and Doncaster. A feature of the Thorne line is the swing bridge across the Ouse (which gives access to Goole), lying 2 miles east of the port. The bridge is 830 feet long, made up of five spans of 116 feet each, and one swinging portion, 250 feet long (originally estimated to be 670 tons, but now quoted at 800 or 900 tons). The section between Saltmarshe and Goole, which includes the bridge, was one of the first to receive colour light signalling, coming into use in May 1933, which allowed a signal box at each end of the bridge to be closed, along with one at Goole. The swing bridge has been struck by shipping going up to Selby on several occasions and in 1973 a span fell into the river. In 1984, a plan was made to close the bridge and divert traffic via Selby, but a cash subsidy from Humberside Council caused the plan to be withdrawn. The NER station in Goole was some half a mile north of the dock area to the north and a connecting curve between the two lines was installed where they crossed to the south-west of Goole and in 1869 L&YR passenger trains were diverted over this curve into the NER station. In 1910, a new route was opened into the station from the west. It left the old L&YR line at Rawcliffe Bridge Junction, 3 miles west of Goole and after being joined by the new NER branch from Selby at Oakhill Junction took a more northerly line to avoid the congested area near the docks. It rejoined the old route immediately west of the NER Goole station. (R. Carpenter)

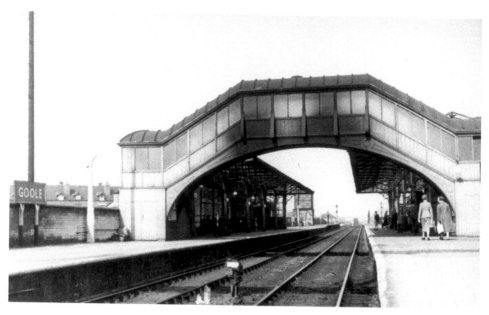

Goole station looking towards Hull on 1 June 1957 with a train departing for the port city. (H. Casserley)

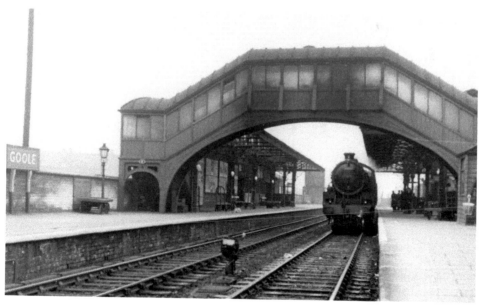

Arriving at Goole station on 22 April 1954 is ex-LNER Thompson class B1 4-6-0, No. 61250 *A. Harold Bibby* at the head of the 7.20 a.m. Hull–Doncaster train. The engine was built at the North British works (works No. 26151) and entered traffic as LNER No. 1250 on 31 October 1947, becoming 61250 on 14 June 1950. The loco started its working life at Doncaster, where it was based when this picture was taken. She then went to Grantham from 16 June 1963, having first been to New England from 16 September 1962. The loco then returned to Doncaster from 8 September 1963, thence to Immingham from 22 September 1965, and then back to Doncaster from 30 January 1966 from where she was condemned on 17 April 1966 and sold to Cohen's of Kettering in May 1966 and scrapped there. (H. Casserley)

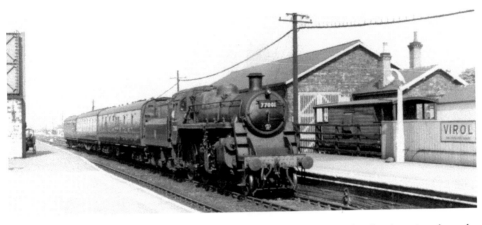

Arriving at Goole on 1 June 1957 is BR Standard 2-6-0 No. 77001 with a local service along the old L&YR to Wakefield. The train was due to depart from Goole at 4 p.m. (H. Casserley)

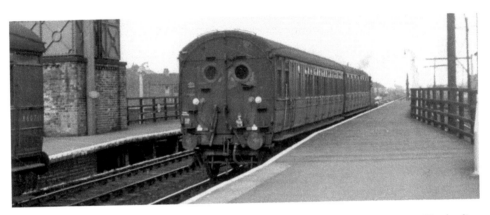

Awaiting departure from Goole is the 4.15 p.m. service to Selby on 31 August 1956. The leading coach is E21900E, built by the NER at York in June 1908. (H. Casserley)

A 1910 timetable for NER services between Hull, Goole, Thorne and Doncaster, where there was a connection for trains of the GNR to King's Cross. (Author)

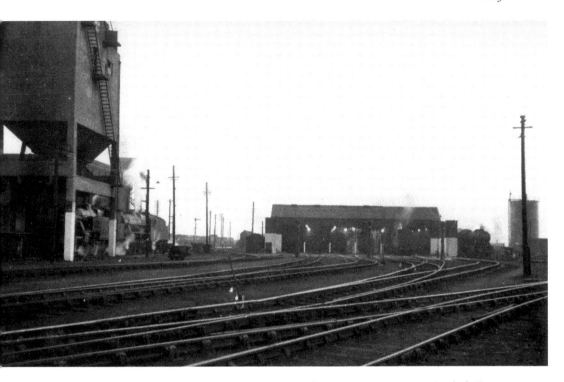

The old L&YR locoshed at Goole as it appeared on 21 April 1954. In view is an ex-LMS Black Five at the coaling stage and an ex-LMS 8F 2-8-0 at the side of the shed. Railway wagons can be seen in the left background. Goole was as far east as the L&YR went (although there were facilities for L&YR engines at Hull) and the company had a locoshed here to serve the docks at Goole and some of these L&YR engines were allocated here to handle traffic emanating from the docks. By the time the LMS had taken control at Goole, the locoshed was in need of repair and by 1933 plans were underway to improve facilities here. The northlight pattern roof, in particular, was in poor condition. In the end, however, new coal and ash plants had been installed but the worst part of the roof was simply demolished and the shed was 'cut back' to leave part of the old shed exposed to the elements. After the Second World War, the LMS decided that a new roof was required and the company approved some £21,206 for the work which, due to post-war labour shortages, was not started until 1955. The shed was in a rather exposed location and suffered the effects of violent and cold gales, making improvements rather desirable. Although the shed could appear bleak at times, well-tended gardens lined the walls, started by a member of staff. In the early 1950s, plants came on request to the shed from the old NER nursery at Cottingham which were used to good effect. Cottingham provided plants for many stations on the NER, and providing for Goole shed presented no problems. Only a year after the roof was replaced, the shed was taken over by the North Eastern Region of BR. The old L&YR saddle tanks allocated to the shed were not popular with the new authorities and they found their way on to pilot duties. Indeed, an NER boilersmith managed to pierce one of the tank loco's firebox with a hammer, which caused some consternation at Hull (now responsible for Goole shed) and all the L&YR engines were replaced by two J39, three J25 0-6-0s and a J72 06-0T. This left a situation where Goole was the only shed on the system that had to order spares from at least seven works – Crewe, Derby, and Horwich (for ex-LMS and BR types), Doncaster and Darlington (for NER types), and Cowlairs (for the J39s). The shed also had a WD 2-8-0 which was serviced at Swindon and, for a time, an A5 4-6-2T which had to have parts from Gorton, and there were even some ex-Midland Railway 1F 0-6-0Ts. Even in L&YR days, Goole shed was unusual in that it had no work to Manchester or Blackpool, the only L&YR shed without such a role. Prior to transfer to the North Eastern Region, the shed had its allocation of ex-L&YR, LMS, and BR (LMR) types as can be seen from the sample allocations from 1949 and 1954 on the next page, giving a contrast to ex-NER and LNER types at other sheds in the locality. (H. Casserley)

BR Code: 25C

1949

Ex-LMS 2P 4-4-0	40589, 40685
Ex-LMS 4P 2-6-4T	42411
Ex-LMS 4F 0-6-0	44062, 44105, 44220, 44485
Ex-LMS 8F 2-8-0	48449, 48738, 48768
Ex-LMS 2MT 2-6-0	46405, 46407, 46408, 46409, 46437
Ex-L&Y OF 0-4-0ST	51207, 51222, 51241, 51244
Ex-L&Y 2F 0-6-0ST	51323, 51361, 51379, 51516, 51521
Ex-L&Y 3F 0-6-0	52133, 52273, 52529
Ex-L&Y 2F 0-6-0	52056
	Total: 28

1954

Ex-LMS 4P 2-6-4T	42477, 42553
Ex-LMS 2MT 2-6-0	46405, 46407, 46408, 46409, 46436, 46437, 46487
Ex-L&Y OF 0-4-0ST	51222, 51241, 51244
Ex-L&Y 2F 0-6-0ST	51323, 51361, 51379, 51432, 51479, 51503, 51516, 51521
Ex-L&Y 3F 0-6-0	52121, 52252, 52273, 52305, 52331
Ex-WD 2-8-0	90135, 90186, 90213, 90228, 90262, 90281, 90300, 90531, 90639
	Total: 34

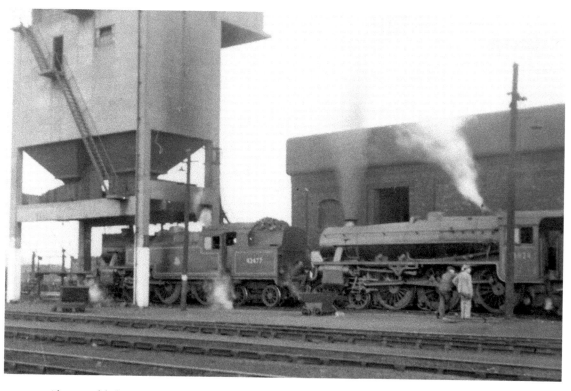

Above and below: Two views of ex-LMS Stanier class 4P 2-6-4T No. 42477 and ex-LMS Stanier Black Five 4-6-0 No. 44825 at the coaling stage of Goole (H. Casserley)

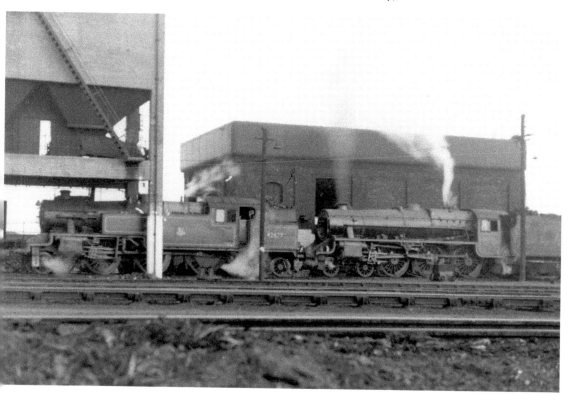

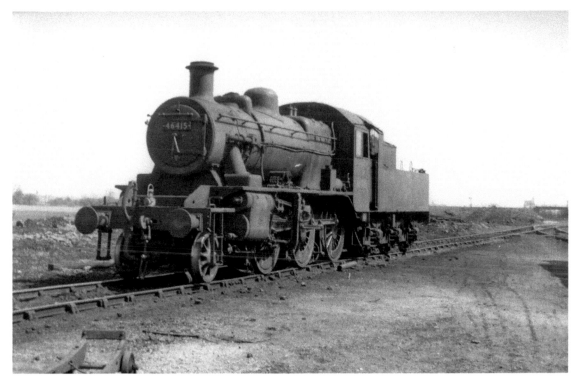

Ex-LMS Ivatt 2MT 2-6-0 No. 46415 at Goole shed in the 1950s. (LOSA)

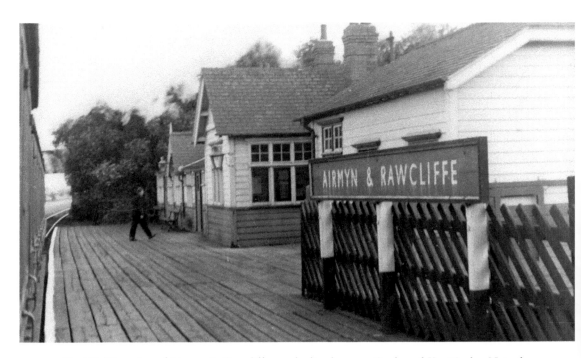

The L&YR station of Airmyn & Rawcliffe, on the line between Goole and Knottingley. Note the all-wooden structure of the station. Even the platforms are of timber construction in this view, looking towards Goole. (H. Casserley)

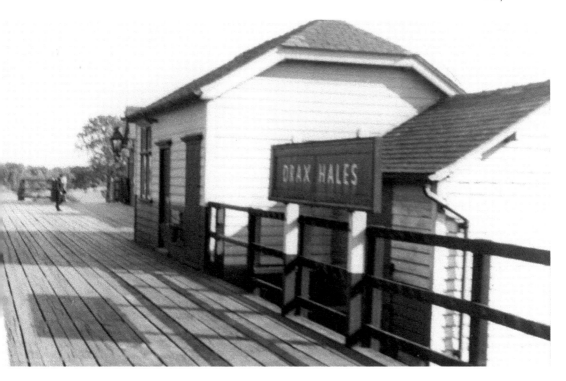

Another of the L&YR stations on the branch to Goole. Here, another of the all-timber stations at Drax Hales as it appeared on 31 August 1956. (H. Casserley)

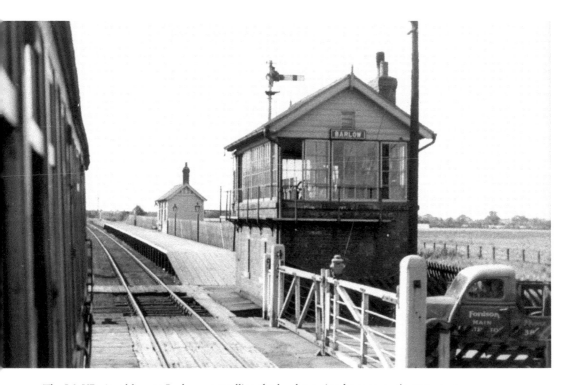

The L&YR signal box at Barlow, controlling the level crossing here on 31 August 1956.

DONCASTER, GOOLE, and KNOTTINGLEY to LEEDS and WAKEFIELD.—Lancashire and Yorkshire.

(Week Days / Sundays timetable — Up services)

Stations listed (Up): Doncaster dep., Askern, Norton, Womersley, Knottingley § 793, Hull (Paragon) dep., Goole, Rawcliffe, Snaith, Hensall, Whitley Bridge, Knottingley § 793 arr., Hull (Cannon St.) dep., Knottingley, Pontefract *, Castleford ¶, Methley Junction, Methley, Woodlesford, Hunslet, Leeds 610, 616, 708, Knottingley dep., Pontefract *, Tanshelf, Featherstone, Sharlston, Crofton [736], Wakefield ‖ 378, 793 arr., Manchester (Vic.) 736, Liverpool (Exch.) 736.

c — Stops at Hessle daily, at Ferriby if required to take up for Wakefield and beyond, and at Brough to take up.

* Monkhill Station; about ¾ mile from the Swinton and Knottingley Joint Station.
§ Station for Ferrybridge.*
‖ Kirkgate Station.
¶ ¼ mile to N. E. Station.

☞ **For other Trains**
BETWEEN PAGE
Doncaster and Wakefield 343 to 347
Methley and Leeds 539 to 547

Timetables for L&YR services between Goole and Leeds, via Knottingley, in 1910.

WAKEFIELD and LEEDS to KNOTTINGLEY, GOOLE, and DONCASTER.—Lancashire and Yorkshire.

(Week Days / Sundays timetable — Down services)

Stations listed (Down): Liverpool (Exch.) 730 dep., Manchester (Vic.) 730, Wakefield (Kirkgate) dep., Crofton, Sharlston, Featherstone, Tanshelf, Pontefract * 793 arr., Knottingley § 793, Leeds (Wellington) dep., Hunslet, Woodlesford, Methley, Methley Junction, Castleford ¶, Pontefract *, Knottingley § 793 arr., 793 Hull, Knottingley dep., Whitley Bridge, Hensall, Snaith, Rawcliffe, Goole 721, 793, Hull (Paragon) 721, Knottingley dep., Womersley, Norton, Askern, Arksey 389, 595, 654, Doncaster 340, 348 arr.

b — Arrives at 6 28 aft. on Saturdays.
c — Leaves at 6 13 mrn.
d — Stops to set down.
g — Stops at Hessle daily, and at Brough and Ferriby if required to set down from Manchester.
i — Leaves at 7 30 mrn. on Tuesdays.
k — Stops on Saturdays to take up for Doncaster.

u — Stops if required to set down from N.E. Stations, also to take up for South of Doncaster.
o — Stops if required to set down from York, also to take up for South of Newark.
p — Arrives at Hull (Riverside Quay) at 5 28 aft.
r — Arrives at 9 15 mrn. on Mondays and Thursdays.

t — Stops on Weds., Fris., and Sats.
u — Stops if required to set down, also to take up for Doncaster and South thereof.
* Monkhill Station; about ¾ mile from the Swinton and Knottingley Joint Station.
‖ Cannon Street.
§ Station for Ferrybridge.
¶ ¼ mile to N. E. Station.

☞ **For other Trains**
BETWEEN PAGE
Wakefield and Doncaster .. 348 to 352
Leeds and Methley 548 to 556

SIX

OTHER BRANCHES

The main Hull–Bridlington–Scarborough line had branches which served many rural areas. Two of these were centred on Driffield, and one terminated at Beverley. A 20-mile line, the Malton & Driffield Junction Railway (the original title had been the Newcastle-upon-Tyne & Hull Direct Railway) had been supported by George Hudson and the Thirsk & Malton Railway, which would meet the new line at Malton's Scarborough Road Junction. The engineer was John Birkinshaw and on-site assistant was Alfred Dickens (younger brother of author Charles). The original proposal would have had junctions facing away from both Newcastle and Hull despite the initial title of the railway company.

Construction difficulties were encountered on the Yorkshire Wolds with Burdale Tunnel. This tunnel was originally planned to be 1,606 yards, but was extended to 1,744 yards during construction. Work commenced in the spring of 1847, but only 150 yards had been dug by August 1848 due to financial problems. George Hudson's empire had begun to collapse. The M&D was struggling to complete its own line, and also needed the T&M to complete construction; otherwise there could be no through route to Newcastle. By 1849, the M&D was almost bankrupt and work on the line was at a standstill. The project survived only because a decision was made to make the line single track, rather than the double track of the original proposal. Work resumed in 1850, although a new Act was required in 1851 to allow completion, which was achieved in 1853. The finished project resembled a branch line, with stations at Settrington, North Grimston, Wharram, Burdale, Fimber (Sledmere & Fimber from 1858), Wetwang, and Garton being built by local contractors. The station buildings looked like farmhouses, with few facilities, and platforms were no more than 18 inches high.

The opening ceremony was shared with the T&M on 19 May 1853. The Board of Trade, however, would not allow public services to start until 1 June. Initial passenger services were three trains each way on weekdays, which remained the pattern for the next ninety-seven years. Very little changed on the line, described as 'the most truly rural branch on the NER'. There were, however, royal trains to Sledmere and Fimber, the station serving Sledmere House, which was regularly

visited by members of the Royal Family. Holiday trains for Butlin's Holiday Camp at Filey ran along the branch between 1947 and 1950, along with scenic excursions from Hull.

Another branch from Driffield ran to Selby via Market Weighton, which was built in stages, the western section having opened nearly forty-two years before the eastern. The Selby–Market Weighton line ran over the relatively level Vale of York and was easily constructed, its only major obstacle being the River Derwent, which was crossed by a wood and cast-iron viaduct. Much of the line followed a straight course. The Y&NMR delayed opening until 1 August 1848 due, in all probability, to disputes over station sites. The only intermediate stations ready were Bubwith and Holme (becoming Holme Moor from 1923). Other stations were added at Cliff Common Gate, Duffield Gate (which was soon closed), Menthorpe Gate, Foggathorpe Gate, and Harswell Gate. The NER dropped the suffix 'Gate', except for Menthorpe Gate, and changed Harswell Gate to Everingham. They also added another station at Bubwith High Field (High Field from 1873). Initial passenger services were two weekday trains each way between Selby and Market Weighton, the line remaining a rural backwater while awaiting extension to Driffield.

The NER was in no hurry to extend the line from Market Weighton to Driffield and were only spurred into action when a rival scheme was proposed in 1884. This rival scheme was put forward by the Scarborough, Bridlington & West Riding Junction Railway, designed to link Scarborough to Howden. Much of the proposed line was never practical, and three years later it was reduced to the Market Weighton–Driffield link. Although built by the SB&WRJ and remaining nominally independent until 1913, train services were operated by the NER from the outset. The line climbed from Market Weighton for 3½ miles at 1 in 100 up Enthorpe Bank to the isolated Enthorpe station, before the long descent through stations at Middleton-on-the-Wolds, Bainton, and Southburn to Driffield. Passenger services began on 1 May 1890 with three trains a day each way and by 1902 a Bridlington–Leeds through train began to operate each way.

Market Weighton became a country junction station due to the opening of the York–Market Weighton–Beverley line. The York–Market Weighton line was built by the Y&NMR and NER across the Vale of York. Opened on 3 October 1847, at a cost £380,000, the line had twenty-two level crossings. Initial passenger services consisted of three trains each way every day except Sundays and intermediate stations were at Huntington (Earswick), Stockton (Warthill), Stamford Bridge, Fangfoss, Pocklington, Burnby (Nunburnholme), and Shipton (Londesborough) – NER names in brackets. There was also an additional Y&NMR station called Gate Helmsley, opened in 1848, and renamed Holtby by the NER. A private halt was provided for George Hudson at Londesborough Hall, which went out of use following Hudson's downfall. Principal stations were at Pocklington and, of course, Market Weighton.

Although the extension across the Wolds to Beverley had been part of the 1846 Act, no progress had been made due to opposition of local landowner Lord Hotham, along with a general railway recession. The extension was actually completed by the NER. At first, a line south-east to Brough was considered but, by 1860, a commitment to the original scheme was made. A new Act was obtained in June 1862 and construction began later that year. Even then, Lord Hotham opposed a station at Goodmanham in favour of one at Kiplingcoates and insisted on no Sunday trains, which never did run. The line opened on 1 May 1865 with an increased service of four York–Hull trains a day, and another intermediate station at Cherry Burton was opened. For a century, the line continued as a secondary route between York and Hull, with a peak of nine weekday trains each way.

All three branches survived into the 1950s, the Malton–Driffield line closed in 1958, while the other two closed in 1965.

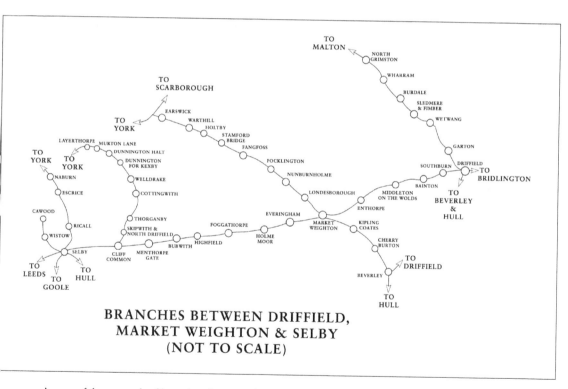

BRANCHES BETWEEN DRIFFIELD, MARKET WEIGHTON & SELBY (NOT TO SCALE)

A map of the network of branches that served rural communities and provided a rail link connecting Driffield, Market Weighton and Selby with York and Hull. (Author)

Leaving Malton with an excursion for Driffield, which ran along the Malton & Driffield Junction Railway, following the route of the *Malton Dodger* local train, with an ex-NER D20 4-4-0 at the head. (R. Casserley)

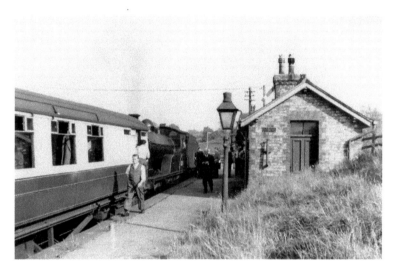

Arriving at North Grimston station on 2 June 1957 with ex-NER D20 4-4-0 at the head of a special train. (R. Casserley)

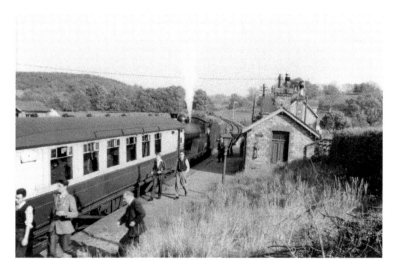

A general view of the platform and station buildings at North Grimston in 1957. (R. Casserley)

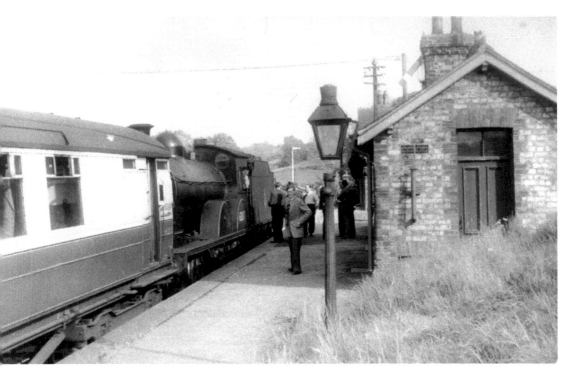

A view of ex-NER D20 4-4-0 awaiting departure from North Grimston station on 2 June 1957. (R. Casserley)

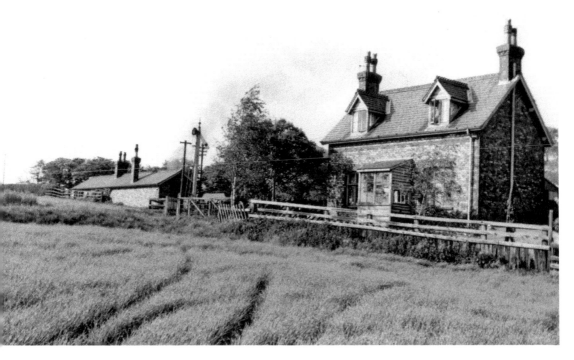

The main station building at North Grimston in 1957, which had the appearance of a local farmhouse. (R. Casserley)

Wharram station on the M&DJR with a local train having just arrived. Between Wharram and North Grimston there was a gradient of 1 in 73 and trains from North Grimston to Wharram faced a very stiff climb indeed. In the 1950s, the line was used as part of a scenic excursion that ran during the summer months from Hull through the North Yorkshire Moors to the coast. The tour left Hull at 10.30 a.m. and cost 13s (65p). Heading north, it branched off onto the Driffield–Malton line, and then went along the Malton–Pickering–Grosmont–Whitby line, arriving at Whitby to allow a 1½-hour stay. The train then returned home via the coastal line through Robin Hood's Bay to Scarborough, for a 3¾-hour stay, thence to Hull, via Bridlington, arriving back at Paragon station at 8 p.m. It would be wonderful to be able to make this rail trip again today, but only the preserved section between Pickering and Grosmont, often extending to Whitby, and the line from Scarborough to Hull, via Bridlington, remain open. At least, however, a steam-hauled trip between Pickering and Whitby can still be made, through the North Yorkshire Moors, as a way of recalling the great days when the steam railway ruled. (LOSA)

Running past Wharram station on 2 June 1957 and heading towards Driffield. The main station building is in view, along with the wooden goods shed and small siding. (R. Casserley)

Heading toward Driffield, the train is running close to Burdale and through a very rural location, giving some idea of why the line was finally closed as it would, undoubtedly, have run at a loss. This view was taken in June 1957. (R. Casserley)

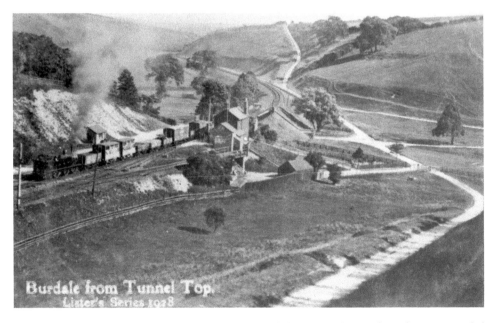

Burdale station looking from the long Burdale tunnel. Chalk quarries here and at Wharram provided 100,000 tons of freight a year for steelworks at Teesside; this traffic kept the line open until October 1958, although local passenger services had ceased in 1950. In January 1958, rural roads in the area were blocked by snowdrifts and, on 12 January, BR sent out special relief trains to provide badly needed supplies for stranded villagers and farmers. In this view at Burdale, a local goods train is running past one of the local quarries and appears to be headed by an NER 0-6-2T loco. (LOSA)

Sledmere & Fimber station on 2 June 1957 as the special runs past. Sledmere & Fimber station was close to Sledmere House, which had royal connections and was often served by royal trains, headed by 'top-link' locos, which would arrive with members of the royal household during visits to the area. From Sledmere & Fimber, the line ran through Wetwang and Garton before arriving at Driffield, on the main Hull–Bridlington line. (LOSA)

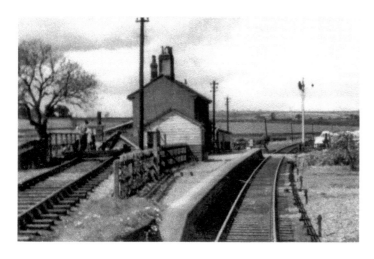

A rural setting for Wetwang station after closure to passengers. The station was something of a mile away from the village and was reached via Station Hill, which was rather steep and could be a difficult climb during bad winter weather. (Sue Bannaghan)

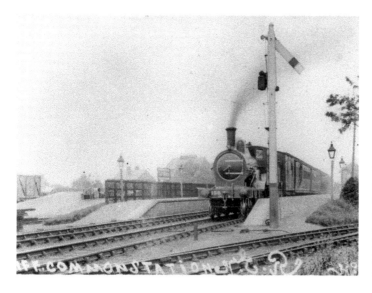

Cliff Common station, on the Selby–Market Weighton branch, seen here in the early twentieth century. Waiting at the station is an NER T. W. Worsdell 4-2-2 loco No. 158. The line was built by the Y&NMR at a cost of some £156,000. (LOSA)

A branch ran from Cliff Common to York, with stations at Skipwith and North Duffield, Thorganby, Cottingwith, Wheldrake, Elvington, Dunnington, Dunnington Halt, Murton Lane, Osbaldwick and Rowntree Halt, presumably serving the chocolate factory here. In this view is Murton Lane station, with plenty of passengers waiting for a local train. The footbridge appears to be of the standard NER type and the platform has substantial station buildings. (LOSA)

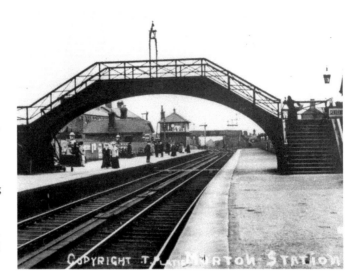

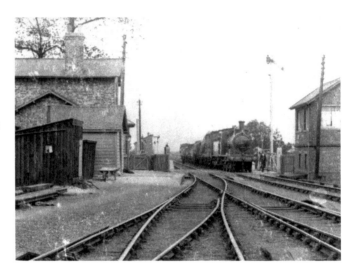

After leaving Cliff Common station back on the Selby–Market Weighton line, the route passes through Menthorpe Gate and Duffield Gate before reaching Bubwith station, seen here in the early twentieth century. In view is NER 0-6-0 No. 821, a Worsdell class P, on a local freight train. (LOSA)

From Bubwith, the line passed through High Field and then entered Foggathorpe station, seen here in NER days with its simple wooden waiting rooms. (LOSA)

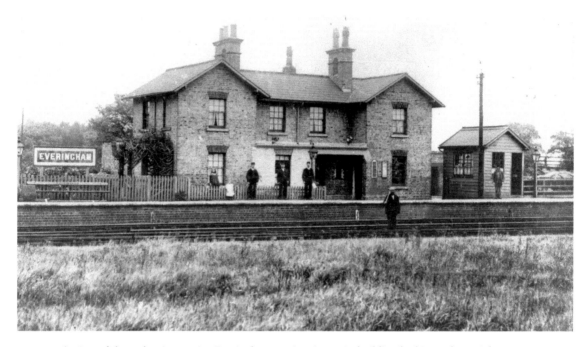

A view of the rather impressive Everingham station, its main building looking substantial next to the little wooden hut on the right. There appear to be only five members of staff on the station. Everingham station was reached after the line had left Foggathorpe and passed through Holme Moor. (LOSA)

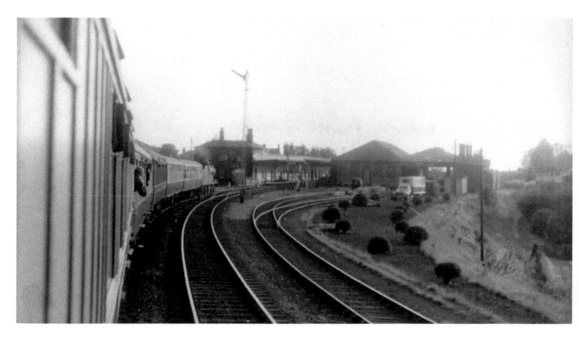

Approaching Market Weighton station from Driffield on 2 June 1957, a special train is awaited by no-one. The substantial station was provided with a large goods shed and sidings as it was a junction for trains to Driffield, Selby, Beverley and Earswick, for connections to York and Scarborough. (R. Casserley)

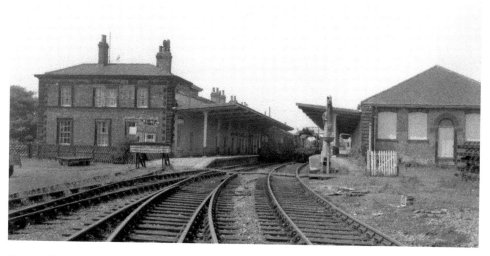

Market Weighton station as it appeared on 31 May 1968, with a demolition train at the platform, after closure some three years earlier. Before the line was extended to Driffield, this was the terminus from Selby and a locoshed was provided here which opened with the branch from York on 4 October 1847. The line from Selby opened on 1 August 1848. Market Weighton remained a terminus until the line to Beverley was opened on 1 May 1865. Only one loco was kept at the shed and, by 1908, was operating the Market Weighton–Driffield–Selby–Market Weighton–Selby–Market Weighton duty. The shed was situated adjacent to the station and had a 50-foot turntable. It was closed as a wartime measure on 1 March 1917 and never reopened. The original Market Weighton station had an overall roof but the LNER dismantled it and BR placed simple canopies over the platforms. The ornate passenger footbridge can just be seen in the background and a water tank, which supplied water cranes on the station and also provided water for the locoshed until closure, was situated next to the footbridge. In this view, the main station building is on the left and the goods shed was on the right. On the right are the remains of the locoshed with a water crane at the end of the right-hand platform. (R. Carpenter)

A 1910 timetable for train services between Selby and Bridlington, via Market Weighton and Driffield. (Author)

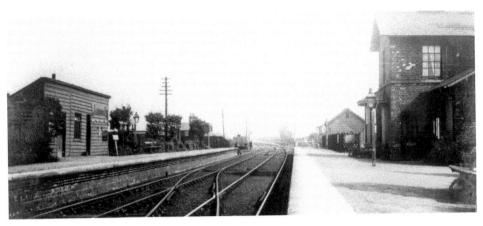

From Market Weighton, on the branch to York, the first station was at Londesborough, its substantial main building is on the right, with the goods station in the background. In contrast, on the left is a little wooden waiting room. (LOSA)

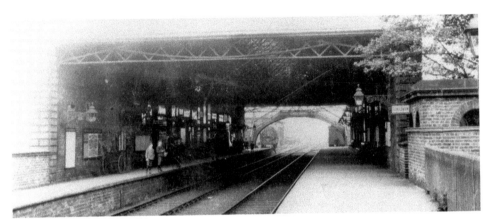

After leaving Londesborough station, the line passed through Nunburnholme station before entering Pocklington station. As can be seen in this view, the station had an overall roof, the whole station having been designed by Y&NMR Architect G. T. Andrews. When the line closed, from 29 November 1965, the end portion of Pocklington station was bricked up and used as a gym by Pocklington School and local members of the public. (LOSA)

A 1922 timetable for passenger services between York and Beverley to Hull, via Market Weighton. (Author)

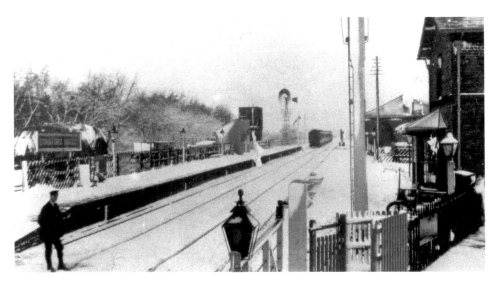

On leaving Pocklington, the line passed through Yapham Gate and Fangfoss before entering Stamford Bridge, the station seen here after snowfall in an early twentieth-century view with a local train departing in the distance. Stamford Bridge was the site of a famous battle when, in 1066, a Viking invasion was defeated here. However, King Harold's troops then had to march south to meet the Norman invasion in Sussex and were worn down by the time they arrived and so lost the Battle of Hastings in 1066, allowing William the Conqueror to take over England for the Normans. (LOSA)

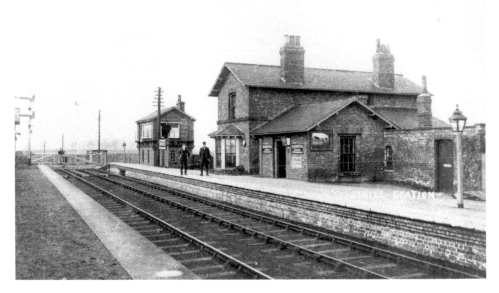

From Stamford Bridge, the station at Holtby was passed before the line entered Warthill station, seen here in NER days. For a century, the line was no more than a secondary route between Hull and York with a peak of nine trains a day each way, operated by DMUs as late as 1960. In the same year, a modernisation plan was announced, with single-line working and colour light signalling to be installed at a cost of £83,036, the investment being approved by BR. However, the line had been listed for closure under Beeching proposals and, despite a vigorous campaign and seven-week reprieve, the line was closed on 29 November 1965.

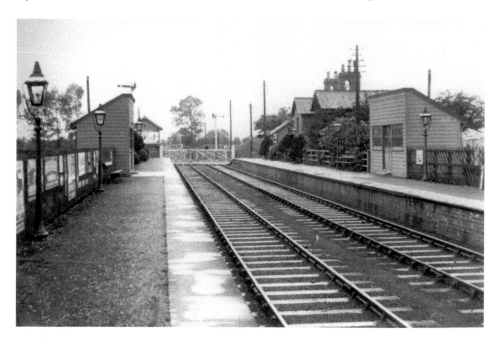

Last station on the branch before meeting the main line from Scarborough to gain access to York was at Earswick with its simple wooden platform buildings and substantial stationmaster's house next to the level crossing. Before the line was finally closed, several stations disappeared from the railway map on the little branch. The first to go was Holtby, closed to passengers in 1939 and to freight in 1951. In the same year, Nunburnholme station was closed, and by 1959 the stations at Fangfoss and Warthill were also closed. (LOSA)

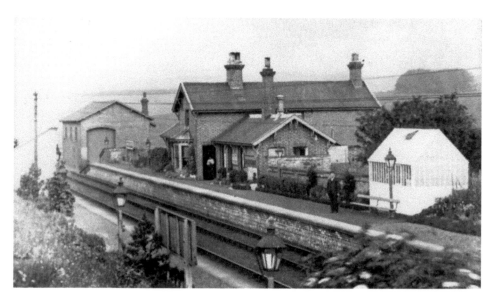

The little line from Market Weighton to Beverley had two intermediate stations, the first was at Kipling Coates, seen here in NER days, showing the main station building and goods shed. In 1959, the station became an unmanned halt, while Cherry Burton, the next station on the route, was closed to passengers in the very same year. Like the line to York from Market Weighton, the branch to Beverley closed on 29 November 1965.

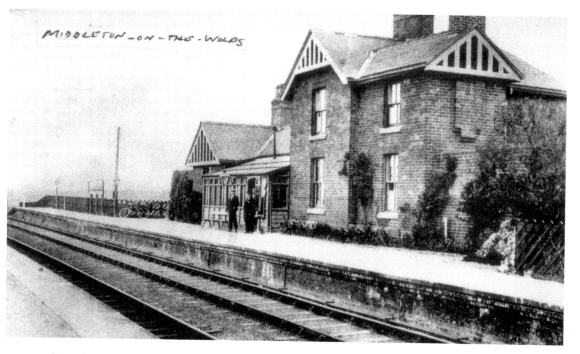

Once the section from Market Weighton to Driffield had opened to traffic, the first station was Middleton-on-the-Wolds, seen here with its imposing station buildings in NER days. (LOSA)

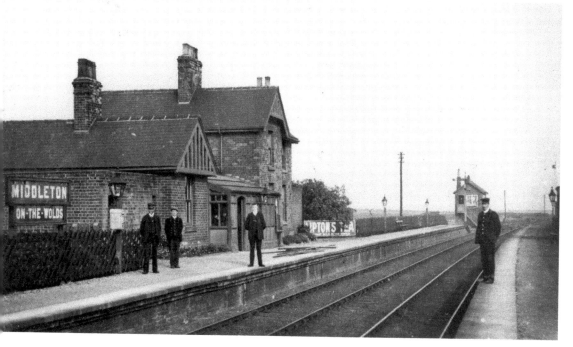

Another view of Middleton-on-the-Wolds station. Passenger services over the line consisted of three trains each way a day and began from 1 May 1890. By 1902, a through train between Leeds and Bridlington was included in the timetable. (LOSA)

Between Middleton-on-the-Wolds and Bainton the line became very rural as can be seen in this 1957 view. (R. Casserley)

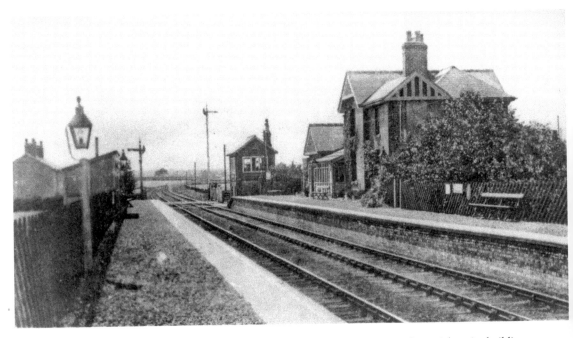

From Middleton-on-the-Wolds, the next station was at Bainton; its substantial main building is in view. After the Second World War, local traffic was virtually non-existent and the line was completely closed to passengers from September 1954. All intermediate stations, except Market Weighton, were closed (Menthorpe Gate station had already closed in 1953). (LOSA)

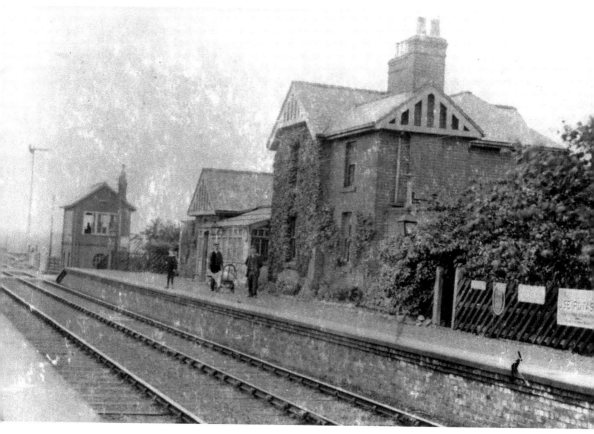

Another view of Bainton station in NER days. (LOSA)

A 1922 timetable for local services between Selby and Bridlington, via Market Weighton and Driffield. Even at this time, passenger services were rather thin on the ground. (LOSA)

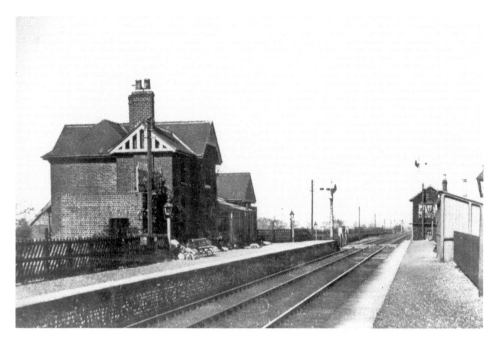

The final station before reaching Driffield was Southburn, seen here in NER days; its imposing station building gave an impression that the railway company hoped that the line would be a great success. However, by 1960, there were only two weekday trains running between Selby and Driffield and only one ran in the opposite direction. It soon became clear that these trains could run via Hull, including a reduced number of holiday trains. The end for the line as a through route came on 14 June 1965, just before the start of the summer season. Freight continued on the Selby–Market Weighton section until August of the same year. (LOSA)

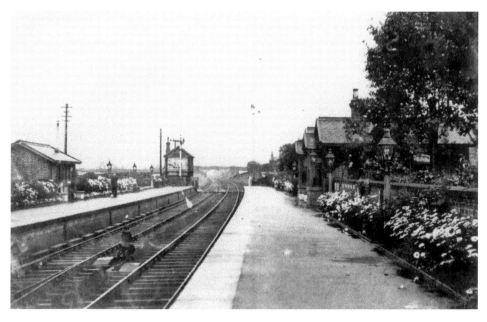

Riccal station on the little branch between Selby and York. The branch had stations at Riccal, Escrick, and Naburn before joining the main Leeds–York line. (LOSA)

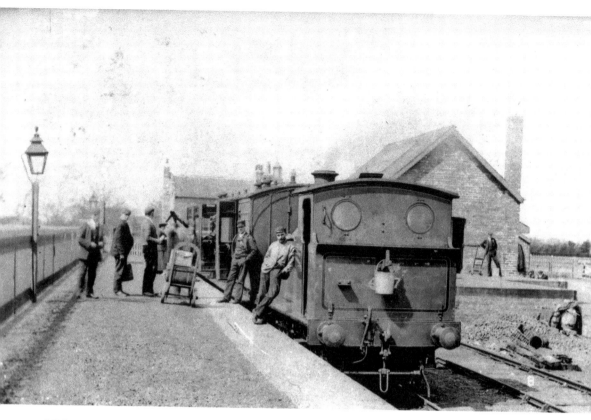

NER H2 (LNER J79) 0-6-0T No. 407 at the head of a single-coach passenger train at Cawood station, terminus of the little branch, shortly after the NER had taken control. The Cawood, Wistow & Selby Light Railway, to give the branch its full title, was started on 11 July 1896, when the first sod was cut by Mrs Henry Liversedge of York, wife of the chairman. The contractor started work at Selby on 12 September and a connection was installed to allow material to pass from the NER. The line was opened on 16 February 1898 and in its first half-year it carried 15,777 tons of freight and 6,819 passengers. As an independent company, the railway had its own terminus at Selby, adjacent to the Leeds–Selby line of the NER. Trains were originally worked by the company's own loco, a 0-6-0 saddle tank named *Cawood* built by Manning-Wardle in 1897. The line was originally planned to meet the Hull & Barnsley Railway at Drax, but the NER opposed this and plans were defeated, leaving only the five-mile line to Cawood. The NER took control of the branch on 1 January 1900 and extended the line into its own station. The five-mile line was single and laid across rich, flat land. The 0-6-0ST was housed in a little wooden engine shed close to the junction of the branch with the NER main line, but the NER disposed of it in 1901, although it was used for many years as a locomen's Mutual Improvement classroom until demolition at the end of 1963. As previously mentioned, petrol-electric railcars were used over the line for passenger services, which ceased to exist from 31 December 1929. Freight traffic continued, the line serving local farms, and its traffic was mainly agricultural. This traffic, however, declined to such an extent that the line was completely closed on 2 May 1960 and no evidence of the line now exists. (LOSA)

SEVEN

THE WITHERNSEA BRANCH

The branch to Withernsea was built by the Hull & Holderness Railway and opened on 27 June 1854 as a truly independent line. The route was mostly low and close to the River Humber, which allowed quick construction, the line being completed in only eleven months. Access to Hull, however, was not so straightforward. Hull's first rail link was west from a terminus on Manor House Street, built by the Hull & Selby Railway in 1840, and leased to the Y&NMR in 1845. In 1853, the Y&NMR opened a line from Manor House Street and around Hull's northern suburbs to Victoria Dock, with intermediate stations at Stepney, Sculcoates, and Southcoates. There were various other stopping points, one of which, Cemetery Gates, became an additional station in 1866, eventually being renamed 'Botanic Gardens'. The Hull & Holderness Railway used this branch's eastern section to Victoria Docks for its first access to the city.

The opening ceremony for the Withernsea branch was on 26 June 1854 with public services commencing the following day. Services were made up of five or six trains each way per day, calling at Marfleet, Hedon, Rye Hill, Keyingham, Ottringham, Winestead (closed to passengers in 1904) and Patrington. In the first four months over 63,000 passengers were carried, but development was handicapped because the line was single and the terminus was inconveniently located. The line was leased to the NER in 1860 and absorbed in 1862. It was the NER who solved the access problem into Hull by doubling the Victoria Dock branch (except for the bridge carrying the railway over the River Hull at Wilmington) and building a new connecting curve, allowing trains from Withernsea to use the Victoria Dock branch westwards into Hull Paragon station. Suburban services, which had been withdrawn in 1854, were revived and incorporated into services to Withernsea as well as Hornsea.

The bridge at Wilmington continued to be a bottleneck as trains had to be guided across its single-track span by a pilotman. In 1907, the NER replaced it with a new double-track bridge and also doubled most of the branch to Withernsea. Only the Hedon–Rye Hill and Ottringham–Winestead sections remained single track, which continued to hinder further development.

The heyday of the branch was probably in the 1930s following introduction of the Hull & District Interval Service in 1929. This new LNER timetable was based on departure at regular intervals to Beverley, Brough, South Howden, Withernsea

and Hornsea. These latter two destinations had an hourly service at forty and fifty minutes past the hour respectively, with about half of the journeys being made by Sentinel steam railcars. The first year of operation over the whole area showed an increase in passenger journeys of 16 per cent and revenue of 6 per cent. However, increased bus competition and the Great Depression killed off the scheme; the branch, however, continued to see passenger trains until the mid-1960s.

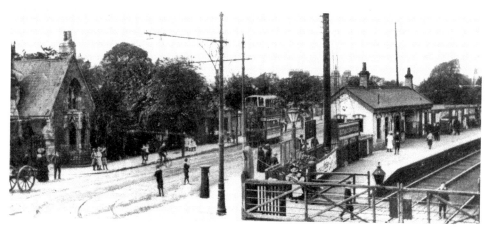

Hull Botanic Gardens station at the turn of the twentieth century, with a tram in view. Over the next forty years, the scene in the area would change a fair bit. The building on the left would be demolished and a row of shops would be built in its place. Trolleybuses would replace the trams by the mid-1930s and cars would replace horse-drawn transport seen here. The Hull & Withernsea line was developed by Alderman Bannister, who hoped to develop a fashionable seaside resort at Withernsea. A great deal of money was invested in development of the little seaside town by the construction of a large hotel and laying out of extensive gardens, and a long pier (long since disappeared). Despite this investment, the town failed to attract the types of resident who could have made Withernsea a success. (LOSA)

HULL and WITHERNSEA.—North Eastern.

NER timetable of 1910 for train services between Hull and Withernsea. Despite the poor outlook for Withernsea, the stations on the branch within Hull were quite well used. Indeed, by 1911, some 44,915 passengers used Botanic Gardens, 45,569 used Stepney, and 51,275 used Southcoates. (Author)

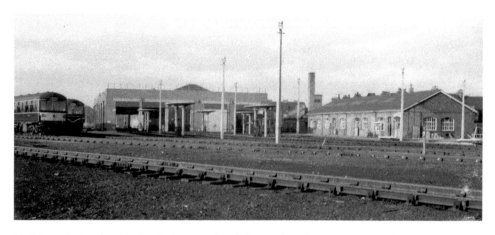

Hull Botanic Gardens shed, which was a diesel depot when this picture was taken on 13 October 1963. (R. Carpenter)

When the line to Withernsea was first opened and the terminus was on the Victoria Dock line, a locoshed was erected at a cost of £140. This was probably Drypool shed whose building was taken down and re-erected as a goods warehouse at Lockington station at a cost of £79. When Paragon station was under construction, a new locoshed was authorised on 20 January 1848 and a tender of £2,100 accepted. A further shed was authorised in 1865 and tender of £549 16s 7d accepted, with a further expenditure of £826 6s approved for enlargement. On 13 August 1874, a tender of £11,092 11s 8d was accepted for a further shed to hold twenty locos, which was completed at the end of 1876. A plan to extend Paragon station in November 1897 meant the locoshed would have to be removed and a new one constructed. Approval was given for a shed to accommodate forty-four locos and an estimate of £30,428 for construction was accepted. Two 50-foot turntables were to be supplied by Cowans Sheldon at a cost of £638 each, which allowed access to twenty-four roads each. With an allocation of some fifty locos, Botanic Gardens was one of the few sheds where few engines had to stand outside. A tender of £21,355 was accepted for construction in August 1898 and the shed was completed early in 1901. Named after the nearby pleasure gardens, the shed housed the majority of passenger engines that operated in the Hull area, and the shed also supplied engines for workings to Doncaster, Leeds, York, Scarborough, Hornsea, and Withernsea. In NER days, most of the longer services were worked by 4-4-0 tender engines, which had replaced 2-4-0s at the turn of the century. Local services were usually worked by 2-4-2T and 0-4-4T locos. In LNER days, many local services were worked by Sentinel steam railcars and ex-GNR 4-4-2Ts. Five S1 4-6-0s spent a few weeks at Botanic Gardens at the end of 1924 before moving to Dairycoates and, except for trials with K3 2-6-0s Nos 1108 and 1119, along with B16 4-6-0s

Nos 848 and 849 on the heavy Sheffield trains in 1930–31, the shed relied on 4-4-0 engines until the arrival of B1 4-6-0s Nos 1010, 1071, 1074, 1080, and 1084 in 1946. Thus, all of Hull's main line passenger services were in the hands of 4-4-0s for some fifty years. In 1932, a new coaling plant was built to replace the NER coal stage, at a cost of £6,239, by Babcock & Wilcox Ltd. Coal wagons were hoisted up and the contents were tipped into a bunker. In 1956–57, extensive alterations were undertaken and new buildings were erected over the existing turntables and stalls. Within a couple of years, the turntables had been removed and pits filled in. The shed was converted to a straight road to house new diesel railcars and was reopened in this form on 13 June 1959, recalling the days when steam railcars operated out of Botanic Gardens between 1927 and 1946. During that period, an Armstrong-Whitworth diesel-electric car, *Lady Hamilton*, was also allocated to Botanic Gardens and worked trains to York and Pontefract. In early BR days, large passenger tanks began working passenger trains in the Hull area, including A5 4-6-2T, L1 2-6-4T, and V1 and V3 2-6-2T. Eight ex-LMS 3MT 2-6-2Ts arrived in 1954, but were not a great success. The first DMUs arrived in Hull on 9 August 1956 and began regular working in January 1957 after trials. For a while, these DMUs were stabled at Springhead shed until Botanic Gardens had been converted into a diesel depot in 1959. In happier times, the allocation at Botanic Gardens shed for June 1950 was as follows:

LNER Code: HULL BG
BR Code: 53B, becoming 50C in January 1960

Ex-LNER B1 4-6-0	61010 *Wildebeeste* 61304, 61305, 61306
Ex-LNER D20 4-4-0	62345, 62383, 62396
Ex-LNER D49/1 4-4-0	62700 *Yorkshire* 62703 *Hertfordshire* 62710 *Lincolnshire* 62720 *Cambridgeshire* 62722 *Huntingdonshire* 62723 *Nottinghamshire* 62724 *Bedfordshire*
Ex-LNER D40/2 4-4-0	62737 *The York and Ainsty* 62741 *The Blankney* 62743 *The Cleveland* 62754 *The Berkeley* 62757 *The Burton* 62767 *The Grove*

Ex-LNER G5 0-4-4T	67254, 67256, 67280, 67282, 67301, 67311, 67321, 67340
Ex-LNER C12 4-4-2T	67354, 67371, 67391, 67392, 67393, 67394, 67395, 67397
Ex-LNER Y1 0-4-0T	68151
Ex-LNER J77 0-6-0T	68401
Ex-LNER A6 4-6-2T	69796, 69798
Ex-LNER A8 4-6-2T	69854, 69855, 69859, 69866, 69876, 69878, 69880, 69894
	Total: 48

The final steam allocation at Botanic Gardens was:

B1 4-6-0	61010 *Wildebeeste* 61068, 61080 61215 *William Henton Carver* 61289, 61304, 61305, 61306
D49 4-4-0	62701 *Derbyshire* 62707 *Lancashire* 62710 *Lincolnshire* 62717 *Banffshire* 62720 *Cambridgeshire* 62722 *Huntingdonshire* 62723 *Nottinghamshire* 62760 *The Cotswold*
V1 and V3 2-6-2T	67635, 67638, 67640, 67663, 67677, 67682, 67684, 67686
J73 0-6-0T	68363
BR 3Mt 2-6-0	77001
	Total: 26

Opposite below: Thompson B1 4-6-0 No. 61289, another of the class to spend time at Botanic Gardens. She was another example to have been built by the North British Loco Co. and entered service as E1289 on 18 February 1948, being renumbered 61289 on 24 November 1949. The loco was first allocated to Darlington and transferred to Botanic Gardens on 13 January 1957, moving to Dairycoates on 14 June 1959 from where she was condemned on 24 June 1967 and sold for scrap to Garnham, Harris & Elton of Chesterfield in August 1967, after a life of less than twenty years. (LOSA)

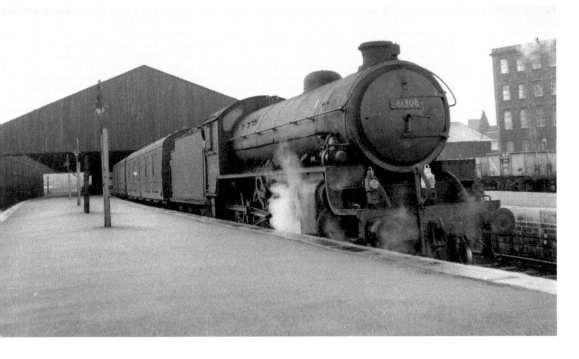

Above: BR Eastern Region Thompson B1 4-6-0 No. 61306, one of Botanic Garden's allocation. The engine was built by the North British Locomotive Company and entered traffic on 5 April 1948. The loco started life at Dairycoates shed and was transferred to Botanic Gardens on 16 May 1948 where she remained until transferred back to Dairycoates on 14 June 1959. From there, she went to Low Moor on 25 June 1967 and was condemned on 30 September 1967. The loco was sold for preservation in working order on 1 February 1968. (LOSA)

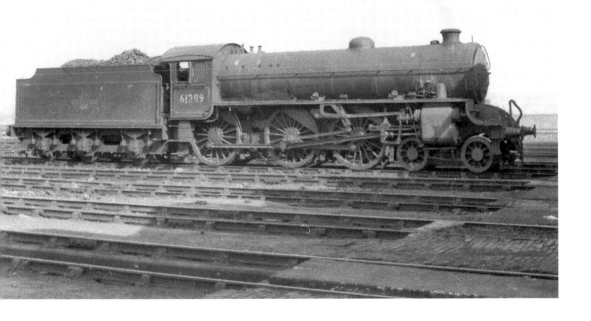

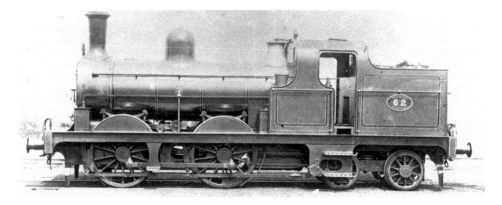

An example of the NER Worsdell 5-foot 1-inch 0-4-4T, later to become LNER G5 class. This is No. 62 and one of a class of 110 built between 1894 and 1901, used extensively on local trains in the Hull area as well as others in the NER. Thirty of these engines were taken out of service between 1948 and 1954, and the remainder had all gone by 1958. (LOSA)

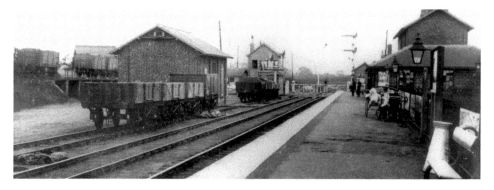

Hedon station on the line to Withernsea as it appeared early in the twentieth century. In BR steam days, stations on the line were served by Botanic Garden shed's allocation of A8, C12, L1, V1, and V3 tank later (as was the Hornsea line) and rolling stock was usually vintage non-corridor coaches. (LOSA)

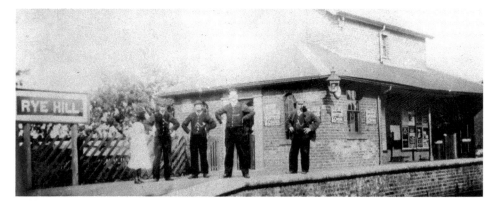

Rye Hill station, with its small number of staff, towards the end of the nineteenth century. When the line to Withernsea was proposed, the Hull & Holderness Railway Company was capitalised to the tune of £150,000 in £20 shares. (LOSA)

HULL and WITHERNSEA.—North Eastern.

Down.	Miles.	Week Days.															Sundays.		
		mrn	mrn	mrn	aft	aft	aft	aft	aft	aft	aft		aft	aft	aft		mrn	aft	aft
Hull (Paragon).....dep.	—	5 47	7 30	10 5	12 10	12 45	1 8	1 58	4 34	5 23	5 32		6 40	9 8		10 33	8 7	2 15	7 15
Botanic Gardens	1	5 51	7 34	10 10	12 14	12 49	1 12	2	2 4	38			6 44	9 12		10 37	8 12	2 20	7 19
Stepney	1¾		7 37	10 15	12 18	12 53	1 16	2	6 4	42			6 47	9 16		10 41	8 16	2 24	7 22
Wilmington †	2¼	5 56		10 18	12 21	12 57	2	9 45		5 38			6 50	9 19		10 46	8 19	2 27	7 25
Southcoates	3¼		7 42	10 21	12 24	1 0	1 21	2 12	4 50	5 30	5 41		6 53	9 22		10 46	8 23	2 33	7 28
Marfleet	5		7 47	10 28	12 29	1 5	2	17	4 55		5 46		6 58	9 27		10 51	8 28	2 38	7 33
Hedon	8¼	h	7 54	10 35	12 36	1 10	2 24	5	2	5 53			7	5 9 34		10 58	8 35	2 45	7 40
Keyingham	10¾		8 0	10 41	12 42		2 30	5	8	5 59			7 11	9 40		11 4	8 41	2 51	7 46
Ottringham	12¾		8 5	10 46	12 47		2 35	5 13	6	4			7 16	9 45		11 9	8 46	2 56	7 51
Patrington	13¾	6 22	8 9	10 50	12 51		1 40	2 39	5 17	6 8			7 20	9 49		11 13	8 50	3 0	7 55
Withernseaarr.	17	6 28	8 15	10 56	12 57			2 45	5 23	6 14			7 26	9 55		11 19	8 56	3 6	8 1
	20¾	6 37	8 25	11 8	1 7		1 55	2 56	5 31	6 0	6 24		7 36	10 5		11 29	9 8	3 21	8 11

Up.	Miles.	Week Days.																		Sundays.			
		mrn	mrn	mrn	mrn	mrn	aft	aft		aft	aft		aft	aft	aft	aft				mrn	aft	aft	aft
Withernseadep.	—	6 50	7 47	8 18	8 45	11 25	1 25		3 15	5 48		6 50	7 45	8 5	10 20				9 22	5 16	8 26	8 48	
Patrington	3¾	6 57	7 54	8 52	11 32	1 32		3 22	5 55		6 57		8 12	10 27				9 29	5 23	8 34	8 56		
Ottringham	7	7 48	1	8 59	11 39	1 39		3 29	6	2	7	4	8 19	10 34				9 36	5 30	9 3			
Keyingham	8¼	7 8	5		11 43	1 43		3 33	6	7	8	8 23	10 38				9 40	5 34	9 7				
Rye Hill	10	7 13	10	9 6	11 48	1 48		3 38	6 11	7 13		8 28	10 43				9 45	5 39	9 12				
Hedon	12¼	7 19	16	9 13	11 54	1 25	1 54	3 44	6 17	7 19		8 34	10 49				9 51	5 45	8 50	9 19			
Marfleet	15¼	7 26	8 23		12 1	13	1 2 1	3 51	6 24	7 26		c	c				9 58	5 52	9 26				
Southcoates	17¼	7 31	8 28	8 45	9 23	12 7	1 36	2 6	3 56	6 29	7 31	8 14	8 46	11 1			10 3	5 57	9 29	9 33			
Wilmington †	18¼	7 35	8 32		12 11	1 40	2 10	4 0	6 33	7 35		8 50				10 7	6 1	9 6	9 37				
Stepney 773	19	7 38	8 35		12 15	1 43	2 13	4 3	6 36	7 38	8 19	8 53	11 6			10 10	6 4	9 10	9 40				
Botanic Gardens...[768	19¾	7 41	8 39		12 18	1 46	2 16	4 6	6 39	7 40	8 22	8 55	11 9			10 12	6 6	9 13	9 42				
Hull*760, 761, 765, arr.	20¾	7 47	8 45	8 55	9 34	12 25	1 53	2 23	4 13	6 47	7 47	8 30	9 2	11 16			10 17	6 12	9 17	9 48			

c Stop when required.
h Stops when required to set down.

* Paragon Station; nearly 1 mile to Hull (Cannon Street Station).

† Over ¼ mile to Hull Station (H. & B.).

An NER timetable of 1922, just before the grouping, showing the extent of services over the little branch. (Author)

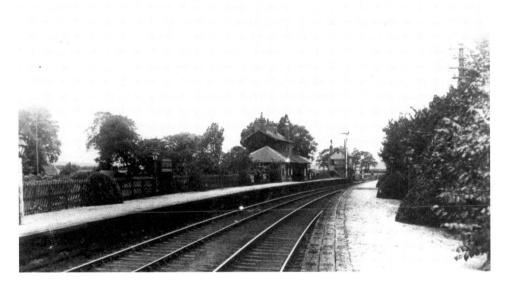

Keyingham station as it appeared in the early twentieth century. Although the Depression years of the 1930s brought a decline in traffic over the branch, efforts were made after the Second World War to revive the line. There had been proposals to revive Hedon racecourse, which had been in existence in the early 1900s, with its own station and a speedway track, built in the 1940s. Traffic research done in 1949 showed that there was potentially profitable traffic during the summer months. On the Withernsea branch, Bank Holiday traffic attracted some 1,558 passengers that year, with midweek summer traffic to the resort showing an average number of passenger journeys reaching some 298 in June and 1,861 in August, and weekend bookings to Withernsea from Hull and its suburban stations amounted to 459 in June and 1,988 in August. (LOSA)

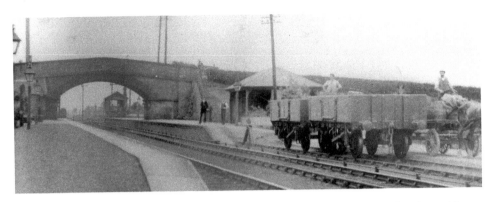

Otterington station in the late nineteenth century, showing the very small goods siding with two open wagons *in situ* and horse-drawn transport on the roads. By 1957, new DMUs were introduced which, it was hoped, would help to make the line potentially profitable. To assist, new 'Paytrains' were introduced in 1960, which allowed intermediate stations to become unmanned halts, but the line still lost money and was scheduled for closure under the 'Reshaping Report' of Dr Beeching in 1963.

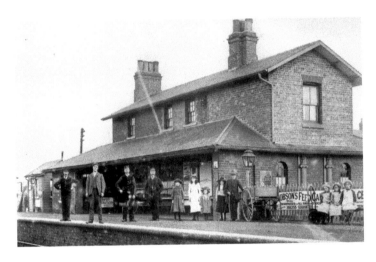

An Edwardian view of Patrington station, with several young female passengers and station staff posing for the camera. (LOSA)

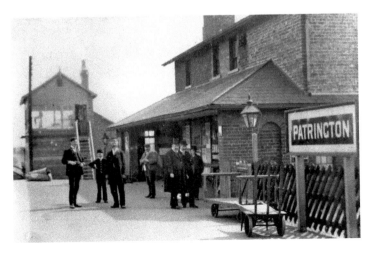

Another view of Patrington station in NER days with staff, including what appears to be the stationmaster, posing for the picture. (LOSA)

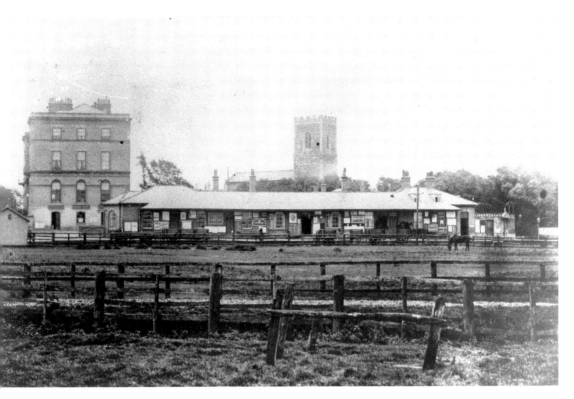

Withernsea station, terminus of the branch, as it appeared in the early twentieth century. The original station layout here was unusual in that there was a turntable at the end of the line. When opened, the Hull & Holderness Railway was unique in that it was one of the few small independent companies with its own locomotives and rolling stock, these being shedded at the Victoria station. To the left of the view, behind the station, is the hotel which, it was hoped, would attract well-heeled customers to the town and help to encourage 'quality' people to populate the town. This dream was never realised and the hotel was purchased by Sir James and Francis Reckitt in 1902. It was then presented to Hull Royal Infirmary as a convalescent home. (LOSA)

A 1928 LNER advertisement promoting the Yorkshire coast as an ideal holiday destination, which would bring some holiday trade to Withernsea. (Author)

The buffer stops at Withernsea in the 1950s. Despite local objections to closure, the Transport Users Consultative Committee heard over eighty objections backed by some 15,000 signature petitions from holidaymakers. The main argument was that Withernsea relied on the large number of day trippers who were attracted to the resort because of the convenience of rail travel from local pick-up points. Some 35,000 passengers per month travelled in peak season, with an annual passenger total of around 132,000. Also, some 200 locals used the trains to commute to work in Hull. Further, substantial goods were carried on the line, including an estimated 800 tons of coal being carried each month. Closure was scheduled for 17 October 1964, and the last passenger train left for Withernsea from Paragon station at 6.25 p.m. Goods services east of Hedon survived for a further seven months. In 1968, Hedon goods depot was closed and all remaining freight was switched to the former Hull and Barnsley high-level route round northern Hull, allowing closure of the Victoria Dock branch with its six level crossings. The last section of the Withernsea branch to remain open between Southcoates and Marfleet remained in use for freight until 1972. Since closure, the Victoria Dock branch has become a footpath, and the Withernsea branch from East Hull to Winestead is now a poorly maintained cycle path and has become difficult to follow, particularly at its eastern end. (LOSA)

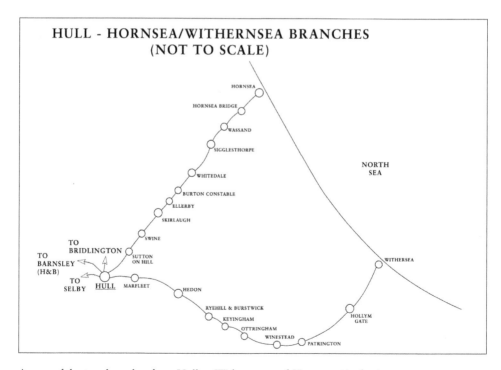

A map of the two branches from Hull to Withernsea and Hornsea. (Author)

EIGHT

THE HORNSEA BRANCH

Opened in 1864, the 13-mile branch to Hornsea was difficult to build due to glacial clays over which the line was constructed. These clays provided unstable foundations, which meant that embankments and a viaduct needed rebuilding. The Hull & Hornsea Railway was only nominally an independent company and trains were worked by the NER from the start. The NER took control of the whole line in 1866. Initially, there were problems gaining access to Hull (like the Withernsea branch); trains had to terminate at Wilmington, just before the junction with the Victoria Dock branch. It was from here that the first train of sixteen coaches started out for Hornsea at the opening ceremony, Easter Monday, 28 March 1864. Within four months of opening, trains from Hornsea were able to run into Paragon station.

The new line did not tap into the expanding dock area east of Hull, but headed north-east across farmland to Hornsea, an already established town which did not welcome the railway as much as nearby Withernsea. There were quite a few stations, with many closures and name changes. From Hull, the original Wilmington station closed in 1912 and was replaced, together with Sculcoates on the Victoria branch, by a new Wilmington station. Next stations were Sutton-on-Hill, Swine, and Skirlaugh, these remaining unaltered during the line's existence. Ellerby closed in 1902, its name being reused in 1922 for the next station, which had previously been called Marton, then Burton Constable. Next came Whitedale and Sigglesthorne, followed by Goxhill (renamed Wassand in 1904), this being one of the last 'Market Day Only' stations in north-east England, with just a single train each way, and calling on Mondays only. Hornsea had two stations; Hornsea Bridge, which was meant to be the original terminus, but a half-mile extension, built with some difficulty, took the line to a new terminus at Hornsea (becoming Hornsea Town from 1950).

In the 1900s, the line was doubled, allowing services to increase to fourteen each way on weekdays, and two on Sundays, a Sunday service being unusual on NER branches. The Hull & District Interval Service of 1929 gave an hourly service, but the number of trains was reduced to nine or ten a day by 1942. The little branch, however, was important in bringing large numbers of people from Hull for a day at the seaside in Hornsea. Similarly, passengers were also attracted to Withernsea.

Wilmington station was the original terminus of the Hornsea branch, albeit for only four months before terminating at Hull Paragon. Between 1905 and 1907, the whole layout at Wilmington was rearranged so that eight level crossings could be dispensed with. This involved building a new swing bridge over the River Hull, followed later by closure of Sculcoates station and the original Wilmington station (the one pictured here). In their place, a new Wilmington station was opened, midway between the two, in 1912. Wilmington's swing bridge remains as a public right of way and is still manned at tide time to allow ships to pass through. In LNER days, Wilmington station, along with Botanic Gardens, was looked after by the stationmaster at Stepney. Following the transfer of Hornsea and Withernsea trains to Paragon station, the Victoria Dock line suburban stations were gradually reopened, and a new station built at Cemetery Gates, which was later renamed 'Botanic Gardens'. (LOSA)

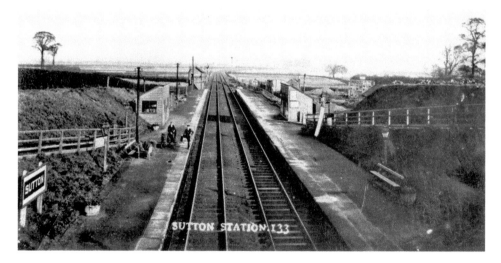

Sutton-on-Hull station on the Hornsea branch. A prospectus for the new branch to Hornsea was issued in 1861, with the terminus being at Wilmington. However, legislation which precluded level crossings and the construction of expensive embankments at Hornsea, along with the necessity to extend Paragon station, caused considerable increases in costs, which meant that there was always a shortage of funds. This necessitated an amalgamation with the NER who had operated train services from the start. Formal takeover of the Hull & Hornsea Railway by the NER was under an Act of 16 July 1866. (LOSA)

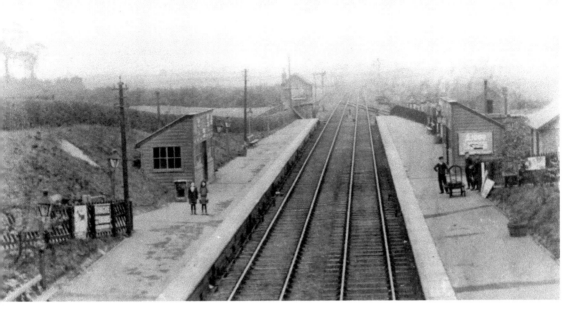

Another view of Sutton-on-Hull station, complete with its wooden waiting rooms and the signal box in the background. (LOSA)

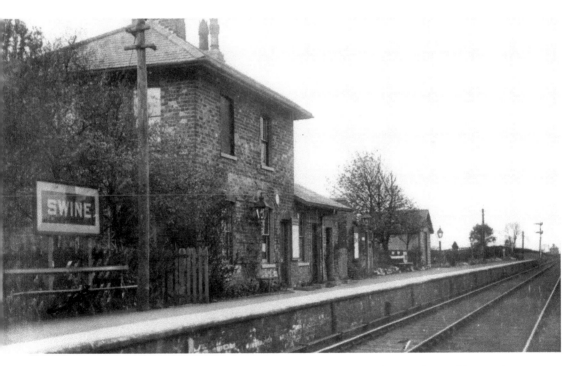

Swine station as it appeared in NER days. The stations on the branch were designed by Rawlins Gould of York, who had been working on the old York & North Midland Railway under their architect G. T. Andrews, and Gould's architecture on the Hull & Hornsea Railway showed similarities to buildings designed by Andrews on the Y&NMR. (LOSA)

HULL and HORNSEA.—North Eastern.

Down. — Week Days. — Sundays.

Miles	Paragon Station,	mrn	mrn	mrn	aft	aft	aft	aft	m	aft	aft	aft	aft	aft	aft	aft	aft	mrn	aft
	Hull..........dep.	5 55	8 0	9 37	12 10	1 20	2 8	3 20	3 20	4 15	5 7	5 18	5 50	6 12	7 13	9 0	10 52	8 0	4 12
1	Botanic Gardens....	5 59	8 49	4 11	12 14	2 4	2 12	3 24	3 24	4 19				6 16	...9	4	10 56	8 44	16
1¼	Stepney............	6 2	8 7	9 44	12 17	1 27	2 15	3 27	3 27	4 22				6 19	7 18	9 7	10 59	8 7	4 19
2¼	Sculcoates	6 5	8 10	9 47	12 20		2 18	3 30	3 30	4 25				6 22	...9	10	...	8 10	4 22
2¾	Wilmington........	6 8	8 13	9 50	12 23	1 31	2 21	3 33	3 33	4 28	5 13		5 56	6 25	7 22	9 13	11 3	8 13	4 25
4½	Sutton-on-Hull.....	6 13	8 18	9 55	12 28	1 36	2 26	3 38	3 38	4 33	5 18	6	1 6	6 30	7 9	18 11 8		8 18	4 30
7	Swine.............	6 19	8 24	10 1	12 34		2 32	m	3 44	4 39	m			6 36		9 24	11 14	8 24	4 36
8½	Skirlaugh.........	Sig.	8 28	10 5	12 38		2 36		3 48	4 43				6 40	7 34	9 28	11 18	8 28	4 40
9¾	Burton Constable...	Sig.	8 32	10 9	12 42		2 40		3 52	4 47				6 44	7 38	9 32	11 22	8 32	4 44
10¾	Whitedale	6 30	8 35	10 12	12 45		2 43		3 55	4 50				6 47		9 35	11 25	8 35	4 47
12½	Sigglesthorne.......	6 34	8 39	10 16	12 49		2 47		3 59	4 54				6 51		9 39		8 39	4 51
13	Wassand																		
15	Hornsea Bridge......	6 40	8 45	10 22	12 55	1 50	2 53		4 6	5 0		c	6 16	6 57	7 46	9 45		8 45	
15¾	Hornsea......arr.	6 45	8 50	10 28	1 0	1 55	2 58		4 10	5 5		5 42	6 20	7 1	7 50	9 51	11 35	8 51	5 0

Up. — Week Days. — Sundays.

Miles		mrn	mrn	mrn	mrn	mrn	aft	aft	aft	aft	aft	aft	aft	aft				mrn	aft
	Hornsea.........dep.	7 50	8 30	8 50	9 0	10 40	1 10	3 8			5 15	6 30	7 10	10 5				9 0	5 10
¾	Hornsea Bridge	7 53	8 33	b	9 3	10 43	1 13	3 11			5 18	6 33	7 13	10 8				9 3	
2¾	Wassand	d																	
3¾	Sigglesthorne......	8 0			9 9	10 49	1 19	3 17			6 39	7 19	Sig.					9 9	5 18
4¾	Whitedale	8 4	8 40		9 10	53	1 23	3 21		5 26		7 23	Sig.					9 13	5 22
5½	Burton Constable....	8 8			9 14	10 56	1 26	3 24		5 29	6 45	7 26	10 20					9 16	5 25
7½	Skirlaugh.........	8 12			9 18	11 0	1 30	3 28		5 33	6 49		10 24					9 20	5 29
8½	Swine.............	8 16				11 4	1 34	3 32	m	m	5 37		7 32	10 28				9 24	5 33
11	Sutton-on-Hull......	8 21	8 49		9 24	11 9	1 39	3 37	4 10	5 24	5 42	6 56	7 37	10 33				9 29	5 38
13	Wilmington	8 26	8 54		9 28	11 14	1 44	3 42	4 15	5 29	5 47	7 1	7 42	10 38				9 34	5 43
13¼	Sculcoates	8 28	8 56		11 16	1 46	3 44	Sig.	5 31		7 3							9 36	5 45
13¾	Stepney *(below)*....	8 31			11 19	1 49	3 47	4 20	5 34	5 50	7 6	7 46	10 41					9 39	5 48
14½	Botanic Gardens	7 24	8 33	8 59		11 21	1 51	3 49	4 22	5 36	5 52	7 8	7 48	10 43				9 41	5 50
15¾	Hull	6 54, 7 16, 7 21,	8 41	9 6	9 18	9 37	11 27	1 58	3 55	4 27	5 41	6 0	7 15	7 56	10 49			9 47	5 57

b Stops when required to take up. **c** Stops when required to set down. **d** Stops on Tuesdays to take up for Hull.
f Stops to set down from Hull. **m** Auto-car. ‡ Paragon Station ; nearly 1 mile to H. & B. (Cannon Street) Station.

A 1910 timetable for trains operated by the NER over the Hornsea branch. (Author)

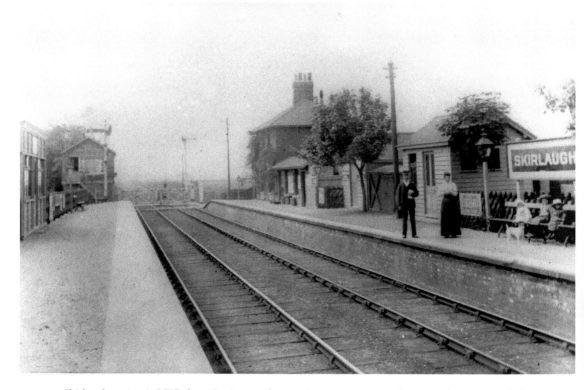

Skirlaugh station in NER days. Again, wooden waiting rooms seem to dominate the scene, with the stationmaster's house in the background. (LOSA)

Top: A 1920s poster advertising Hornsea, with its slogan 'Lakeland by the Sea' due to the existence of Hornsea Mere, a lake situated to the south-west of the town. The railway companies designed posters in an effort to attract holidaymakers to locations such as this in order to generate revenue for the railways from such tourist traffic. (Author)

Middle: A local train made up of LNER G5 0-4-4T No. 1839 and elderly suburban stock, often a feature of such services along the Hornsea branch. (LOSA)

Bottom: 1922 NER timetable for trains over the Hornsea branch less than a year before being absorbed into the LNER system. (Author)

HORNSEA EAST YORKS

LAKELAND BY THE SEA

FREE ILLUSTRATED BOOKLET FROM COUNCIL OFFICES
OR ANY L N E R OFFICE OR AGENCY

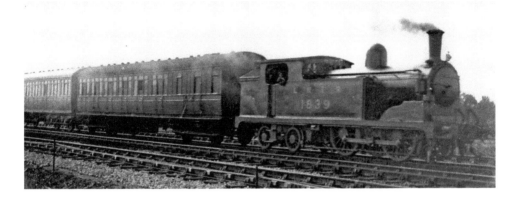

HULL and HORNSEA.—North Eastern.

Down — Week Days and Sundays timetable

Up — Week Days and Sundays timetable

Footnotes:

ʀ Stops on Tuesdays to set down from Hull.
b Stop when required to take up.
c Stop when required.
d Stops on Tuesdays to take up for Hull.
ʜ Stops when required to set down.
***** Paragon Station; nearly 1 mile to Hull (Cannon Street Station).
† Over ½ mile to Hull (Cannon Street Station).

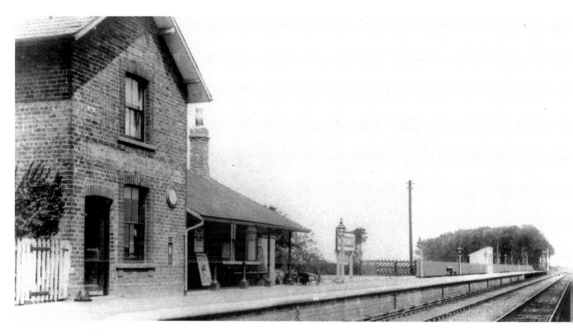

Whitedale station in NER days, showing the stationmaster's house in the foreground. In early BR days, a survey was done of traffic operating over local routes during the summer of 1949. The survey found that the average daily passenger use over the branch to Hornsea was some 147, while numbers increased to 841 during the August Bank Holiday. Midweek summer traffic over the line showed that some 274 passengers used the line in June, climbing to some 1,178 in August. Weekend bookings from Hull and other suburban stations to Hornsea amounted to 741 on Saturdays and 998 on Sundays, a relatively healthy level of traffic at this time. However, as the private car and motor coaches began to compete with the railways for such traffic, passenger numbers began to decline during the 1950s and 1960s with severe consequences for the Hornsea branch, along with many others on the British Railway network. (LOSA)

In happier times, a 1930s LNER poster for Hornsea, which would bring many tourists to the town via the railway at a time when the economic slump of the period deprived the LNER, along with the other railway companies, of vital traffic. Indeed, in order to attract railway passengers the King's Cross company would have to offer cheap excursion tickets in order to generate much-needed traffic, often at a loss, which would have further negative consequences for the railways as they emerged from the Second World War in a rather parlous state. This would lead to a run-down network and no money to bring the system up to date. The only real way out was nationalisation, a preferred option of the newly elected Labour government of 1945, which came to fruition on 31 December 1948. The railways, however, never fully recovered and wholesale closures were seen as inevitable by the early 1960s, as envisaged by Dr Beeching and his infamous 'Reshaping Report', produced under the Conservative government of the day, who traditionally did not support any nationalisation of industries. (Author)

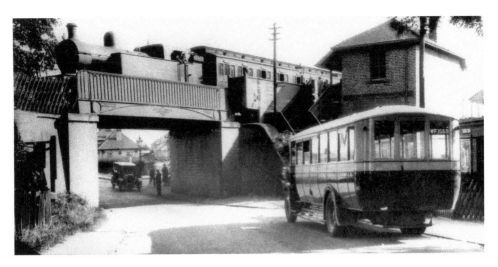

The Hornsea branch was listed for closure by Beeching and BR planned to end passenger services on 9 September 1963, but objections caused withdrawal. Objections to closure of the Hornsea branch were backed by a 3,000-signature petition and traffic figures for 1962 showed that the two stations at Hornsea issued around 60,000 tickets and collected some 120,000 (mainly day trippers). Also, 340 local residents used the railway here on a daily basis. As well as coal traffic, some 3,000 chests of goods from the local pottery were carried by the railway during the first three months of 1963. Despite advice from the Transport Users Consultative Committee that closure would lead to hardship for local communities, closure was scheduled for Saturday 17 October 1964, the last train leaving Hull Paragon at 6.55 p.m. On the return working, the train's buffers were adorned with wreaths as communities mourned the loss of its railway. Goods services, however, lingered on until 30 April 1965. Here, in better times, a train hauled by what appears to be an LNER C12 4-4-2T waits at Hornsea Bridge station with its train of celestory stock. In the foreground is a Leyland-bodied Leyland Lion single-decker bus, of East Yorkshire Motor Services (registration No. WF 1069) possibly on a competing Hull–Hornsea service. Just beyond the bridge, further future competition for the railway, in the shape of an Austin Seven motor car, is quietly parked. (LOSA)

A reflection of how important the railway was to Hornsea, with another LNER poster advertising the pleasures of the seaside here and also emphasising that it was 'quicker by rail'. Something that could well have been emphasised today as cars create ever longer traffic jams. (Author)

NINE

THE NATIONAL RAILWAY MUSEUM

Perhaps the most famous of all museums in York is the National Railway Museum. An idea to preserve famous locomotives began following the 1925 centenary of the Stockton & Darlington Railway (which had been swallowed up by the NER at the time of the fiftieth anniversary and which brought the famous Locomotion No. 1 back into steam). By 1925, the old S&D was now part of the LNER, who celebrated the centenary by having a cavalcade of famous and new locomotives between Shildon and Darlington. It was from this point that the LNER began to investigate the preservation of famous steam locos and a new museum was based at the tourist venue of York. By 1926, the famous GNR No. 1 arrived at the new museum.

The other 'Big Four' companies took a more cavalier attitude to the preservation of its own engines, while the LNER took such matters quite seriously. Indeed, it is due to the LNER that the first loco reputed to have reached 100 mph, the Great Western Railway 4-4-0 *City of Truro*, found its way into preservation. The Paddington company were prepared to send the engine for scrap.

Over the next few years, locos from other railways found their way into the museum, including ex-London, Brighton & South Coast Railway 0-4-2, No. 214 *Gladstone*. However, as would be expected, the LNER tended to choose examples from its own region, including Ivatt Atlantic No. 990 *Henry Oakley*, along with NER 4-4-0 No. 1621.

After nationalisation, BR took a more methodical approach to preservation and the end of steam in the 1960s saw examples of locomotives from all over the network. Today, along with steam, there are examples of diesel and electric engines and trains from all over the world. The museum also preserved famous rolling stock and relics of the old British railway system.

Many of these preserved locos are housed in the old LNER locoshed and are brought back into steam at the museum and often feature on steam excursion in the north-east of England and beyond.

Above, left and right: Now part of the National Collection and part of the exhibits of the NRM is ex-Midland Railway three-cylinder Compound loco No. 1000. This was one of a batch of some forty-four engines built by Johnson & Deeley between 1901 and 1909. All were withdrawn between 1948 and 1953, but No. 41000 was retained for preservation and, in 1959, it was restored to its original MR condition, renumbered 1000 and was used on enthusiasts' specials. The engine is seen at Manchester in 1975 as part of the celebrations for the 150th anniversary of the Liverpool & Manchester Railway in 1975. The engine has since been housed at York. (Author)

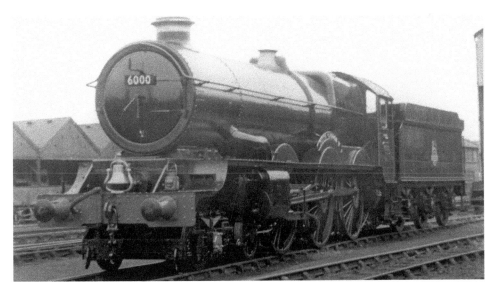

Perhaps one of the most famous of the Great Western 4-6-0s, the Collett King class, built between 1927 and 1930. This example, No. 6000 *King George V*, was built in 1927 and was sent to the USA for a celebration of the centenary of the Baltimore & Ohio Railway in that year. The engine put up a faultless performance while there and was awarded her buffer bell and medals on the cabside in appreciation of her performances while in the USA. Therefore, her preservation was virtually guaranteed and, on withdrawal in 1962, she was kept at Swindon until transfer to York. Since preservation, she has run several enthusiasts' trains, but she has now become a static exhibit at the NRM. (D. Ibbotson)

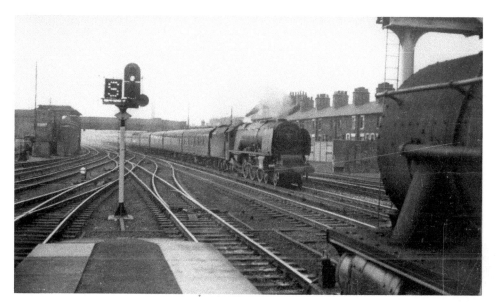

Seen at Stafford on the Up Midday Scot on 6 May 1959, ex-LMS Duchess Pacific No. 46229 *Duchess of Hamilton* passes an unidentified Black Five only a few years before withdrawal, such work going to diesel and electric locos over the next few years. The class was streamlined when new, but casings were removed between 1946 and 1949 and *Duchess of Hamilton* was preserved in de-streamlined form in the early 1960s. However, she was re-streamlined in the first decade of the twenty-first century, the work being carried out at Tyseley locomotive works in Birmingham. She was turned out in LMS red and gold of the streamline period and is now a static exhibit at York. (R. Carpenter)

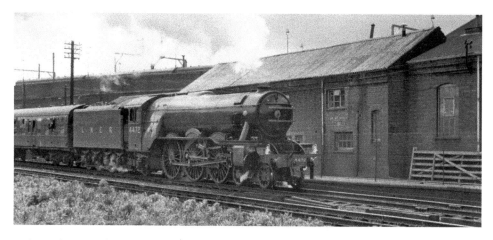

Perhaps the most famous of all steam locos is ex-LNER Gresley A3 Pacific No. 60103 *Flying Scotsman*. She was purchased for preservation by Alan Pegler, who used her on specials in the UK, one of which is seen here at Wolverhampton in 1965. As can be seen, she was put back into her 1930s LNER condition of apple-green livery and numbered 4472. She ran in this condition for many years. Mr Pegler then sent her to the USA but was unable to repatriate her when the visit was over. However, she was eventually brought back and became part of the national collection at York. Since that time, she has run in her LNER livery and has recently been seen in BR green, carrying her number of 60103 and fitted with German-style smoke deflectors. At present, she is a static exhibit at York. (Author)

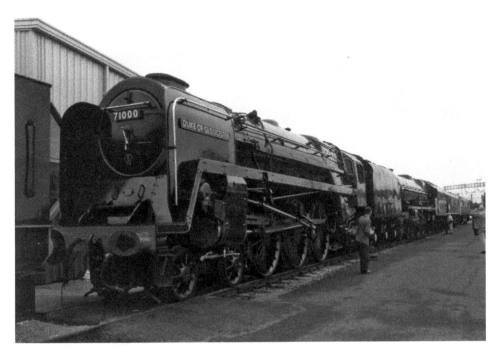

Above and below: The only Pacific built by BR to have three cylinders, No. 71000 *Duke of Gloucester*, is seen on exhibition at Crewe works in the 1980s. The engine was classified 8P and was fitted with Caprotti valve gear, the only BR loco so fitted. Before withdrawal, the engine is seen at the head of an express on the North Wales Coast on 21 June 1962, the year of her demise. She languished at Barry scrap yard until 1974 when she was rescued and restored, operating main line excursions in the 1980s/90s. (Author)

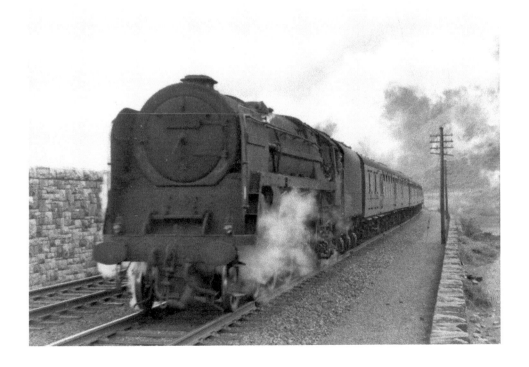

ACKNOWLEDGEMENTS

Without the assistance of several people, this book would have been extremely difficult to put together and I should like to express my thanks to them. Special thanks go to individuals whose assistance has been invaluable, including Jane Bowgen, Bernard Unsworth, Roger Carpenter and Richard Casserley. Organisations who offered valuable assistance include Beverley Record Office, Scarborough and Filey Libraries and LOSA. I should also like to thank Joe Pettican of Amberley Publishing for having the patience to edit this book and to everyone at Amberley for their expertise in helping to produce and market the work; I know it cannot be easy. I hope that our relationship continues to remain fruitful for more years yet. Finally, thanks to my wife, Hilary, who offers constant support, along with copious cups of tea while I busy myself with this and other work, and to my son, Gary, for his continued criticism and support. May I also thank anyone who I may have missed, along with my apologies.